Jackie Ormes

Jackie Ormes in the early 1950s

INTRODUCTION

We are in the midst of a significant revaluation of the importance of cartoons and comic strips to American commerce, culture, and politics. A recent *New York Times* article, "Manga for Girls," describes how a type of Japanese cartooning is capturing a vast new, young female audience in America.[1] In a hefty book–*The Complete Cartoons of the* New Yorker–literary luminaries such as John Updike and Calvin Trillin argue that cartoons are central to American culture. Both the *New York Times Magazine* and the *Los Angeles Times*'s Comics II section have introduced weekly cartoon strips featuring hard-hitting political and psychological insights aimed at adult readers. The increasingly popular genre of the graphic novel, as well as books on historical cartoons and comics are regularly reviewed in the *New York Times Book Review.* "Masters of American Cartooning," an exhibit of the work of fifteen artists, opened in Los Angeles in 2005 and toured other cities through 2007. The *Virginia Quarterly Review* now publishes on a regular basis comics with discussions and analyses, chosen by contributing editor and cartoonist Ross MacDonald, and other erudite journals have focused on artists such as Will Eisner, Art Spiegelman, and Scott McCloud and how they have transformed comics into graphic narratives and essays.

But close readings of the comic form are not altogether new. Over the years many book-length histories of comic strips and cartoons have appeared, documenting with gusto the characters, stories, and art from drawing boards of a legion of comic artists over several hundred years of the form. For years, mainstream American newspaper comics of the 1940s and 1950s, like Al Capp's *Li'l Abner* and Walt Kelly's *Pogo*, have been collected, reprinted, and examined by popular culture scholars, as well as by social scientists and psychologists. Mary Petty, Helen E. Hokinson, and other women cartoonists whose work appeared in magazines such as the *New Yorker, Collier's,* and the *Saturday Evening Post* have also been anthologized and made the subject of commentary. The life of at least one female newspaper cartoonist, Nell

Brinkley, has stirred sufficient interest for a book.[2] But largely missing from many of the scores of histories, retrospectives, and anthologies of comics and cartoons is work that documents and surveys the artistic production of African Americans.

Once a week in the mid-twentieth century African American families reading papers such as the *Pittsburgh Courier* and the *Chicago Defender* to catch up on the news would find in the funny papers a special take on the human comedy. As Langston Hughes noted in his column Colored and Colorful in the *Defender*, people looked forward to their favorite funnies: "If I were marooned on a desert island, . . . I would miss . . . Jackie Ormes's cute drawings. . . ."[3] After scanning headlines that were often distressing, readers could turn to the funnies to savor the conflicts and triumphs depicted by the papers' black cartoonists, well spiced with irony and sweetened with humor.

Jackie Ormes has received modest attention in several anthologies and encyclopedias on notable women, as well as in African American *Who's Who* volumes and reviews of women cartoonists, and there are creditable accounts of her life and work in two doll history books, but for the most part she has been incompletely studied. A few good articles have appeared that focus on Ormes's later comic strip, *Torchy in Heartbeats.*[4] These overviews devote most attention to the strip's 1953–54 episode in which Torchy becomes an environmental muckraker and fighter for racial justice. In the course of researching this book I have discovered that some encyclopedia entries, articles, and obituaries contain inaccuracies that have unfortunately been perpetuated, vexing readers and biographers (see "Correcting the Record").

I begin this study with an overview of Jackie Ormes's life, from her birth in western Pennsylvania in 1911 to her death in Chicago in 1985, outlining the major events in her career and shedding light on her progressive social and political interests, subjects that have been mainly overlooked in previous accounts. Examining her intellectual life more closely will allow readers to make fresh appraisals of her work.

Subsequent chapters focus on newspaper comics, with special emphasis on the black press. *Torchy Brown in "Dixie to Harlem,"* Ormes's first effort, ran for one year in the *Courier*, from May 1, 1937, to April 30, 1938. *"Dixie to Harlem"* was the comic strip story of a young Mississippi teen who found fame and fortune as an entertainer at New York's

Cotton Club. Seven years later, Ormes's *Candy*, a single panel cartoon set at the home front of World War II and featuring a wisecracking housemaid, appeared in the *Defender* for four months, from March 24 to July 21, 1945. Ormes's longest running cartoon, *Patty-Jo 'n' Ginger*, was a big sister–little sister setup that featured gags about domestic life, while at the same time satirizing society and politics and protesting racial injustice. It ran in the *Courier* from September 1, 1945, until September 22, 1956. Her final comic strip, *Torchy in Heartbeats*, chronicled the adventures of a mature, independent woman who took on serious issues of race and environmental pollution as she sought true love.[5] *Torchy in Heartbeats* ran in the *Courier* from August 19, 1950, until September 18, 1954.

Not all of Ormes's prodigious output could be reproduced in this book, due to space and financial constraints. The single panel *Patty-Jo 'n' Ginger* cartoon came out fifty-two weeks a year for eleven years, resulting in about five hundred Patty-Jo cartoons. The book, however, does contain a generous sample of cartoons and comic strips from *Torchy Brown in "Dixie to Harlem,"* *Candy*, *Patty-Jo 'n' Ginger*, and *Torchy in Heartbeats*, as well as twenty-five original *Patty-Jo 'n' Ginger* drawings. Almost all of the comic strips and cartoons in the book are published here for the first time in over half a century. They have been chosen to illustrate Ormes's evolving artistic style and to represent the wide range of her interests as well as her ongoing commitment to social, political, and cultural issues. A comparatively large number of *Patty-Jo 'n' Ginger* cartoons are included because this cartoon series offered fascinating interpretations of numerous controversies from the postwar years 1945–56, and selections from the nearly five hundred cartoons were made on that basis. Readers will get only a glimpse of the multitude of *Patty-Jo 'n' Ginger* cartoons that dealt with humorous domestic situations, romance, and fashions.

Few of her contemporaries broadcast the kind of provocative messages in the pages of the funny papers as did Jackie Ormes. Even in her first professional effort, *Torchy Brown in "Dixie to Harlem,"* Ormes tells an uplifting story with extraordinary inventiveness. She chronicles Torchy's journey from the rural South to the urban North with charming drawings, lively dialogue, and humorous antics in an allegorical account of the Great Migration that had occurred in the

United States some twenty years before. The poor were a particular concern to Ormes, and she was probably the first cartoonist anywhere in the country to address industrial pollution's effects on underclass communities, as she did in *Torchy in Heartbeats*. In one episode, Ormes shows readers worried-looking African American mothers bringing their babies, sickened by toxic waste from a factory in the neighborhood, to a shabby, meager clinic—a comic-strip theme that was unheard of in its day.

In *Torchy in Heartbeats* and *Patty-Jo 'n' Ginger* Ormes's characters also directly confront racism. This book includes a Patty-Jo cartoon that attacks restrictive racial covenants, depicting five-year-old Patty-Jo challenging a little white girl who has excluded her from the neighborhood's "Little Lilly Club." Another has Patty-Jo warning of danger when a "little white tea-kettle just whistled at me," alluding to the murder of Emmett Till, which shocked the nation and galvanized the black community. Especially remarkable is the extent to which Ormes in *Patty-Jo 'n' Ginger* boldly critiques American foreign and domestic policy during the cold war years. One cartoon has Patty-Jo taking on the House Un-American Activities Committee (HUAC) hearings that were taking place in Congress at the time: "You'll be glad we came as witches—wait an' see!" Patty-Jo says to Ginger at a Halloween party, "I understand some Hollywood scouts are simply HUNTING them these days!" But Ormes's interests and creative reach were amazingly broad, encompassing elements of glamour fantasy, romantic adventure, domestic humor, political satire, cultural commentary, and protest comics—making any easy categorization impossible.

Regardless of their subject, many of Ormes's cartoons and comics served to advance the cause of racial uplift, important to the *Courier*'s editors and columnists, community leaders, and other African Americans. The *Courier*'s comics page became a venue for her to extend these messages and to encourage personal advancement and racial pride.

The story of Jackie Ormes would not be complete without a chapter on her Patty-Jo doll. As representations of the human body for children, dolls have long served as markers of self-identity. However brief its production the creation of the beautiful and fashionably attired Patty-Jo doll was an important landmark in black history and a cause for celebration by African American children and their parents.

Although reproductions and likenesses of the doll have been made in recent times, the original Patty-Jo doll was produced from late 1947 to late 1949. Some have speculated that in creating a little girl doll like Patty-Jo a decade after the death of her only child, a daughter, Ormes was able to turn her sad memories into a joyful creative venture that made a positive contribution to the material culture of African American children.

"Every one of these beautiful things were made for a 24-hour news cycle. . . . they weren't made to last," Art Spiegelman, a 1992 Pulitzer Prize–winning cartoonist, said about the transitory nature of twentieth-century newspaper comics.[6] Artists at African American weeklies and their counterparts at mainstream daily papers lavished surprising detail and painstaking craft on work that would be thrown out by consumers with the next day's trash. The cartoons' visual and verbal messages were so vital at the time that a few series ran for decades, some passed in relay fashion from artist to artist. A parade of characters like Samuel Milai's little boy Bucky, Wilbert Holloway's genial Sunnyboy Sam, and Bill Chase's glamorous Betty waits in the wings for inevitable rediscovery by future researchers. An encyclopedic study of African American cartoonists needs to be undertaken. As the only black woman cartoonist of the time, Jackie Ormes seems an exceptionally fitting subject with whom to begin that effort.

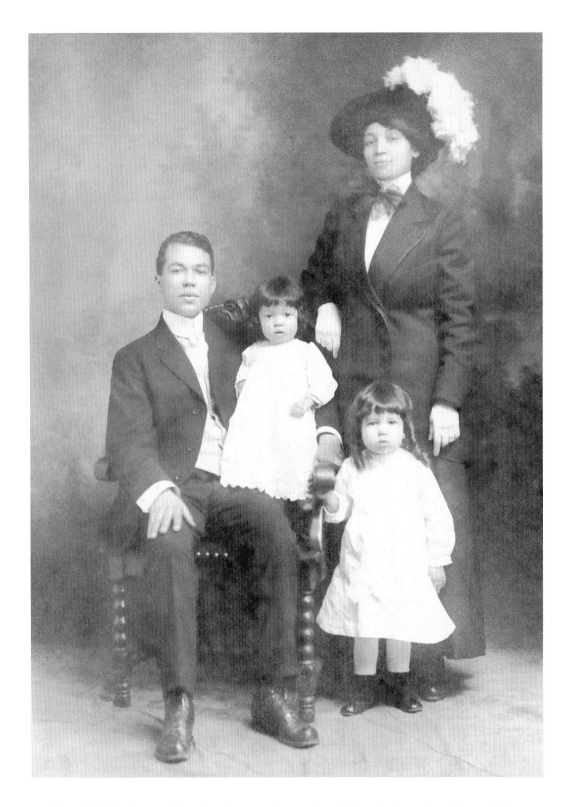

William Winfield Jackson and Mary Brown Jackson, with daughters Zelda Mavin (in arms) and Delores Kathleen, around 1912. *(Collection of Judie Miles.)*

Chapter 1

SMALL-TOWN ROOTS, BIG-CITY AMBITIONS

Jackie Ormes grew up in Monongahela, Pennsylvania. Valley towns are commonly described as being "nestled," and this one is, precisely in the heart of the wooded Mid Mon Valley. The word *Monongahela* is a Delaware Indian place name, describing a "river with sliding banks." Strung along the banks of the Monongahela River and up its hilly sides, the quiet little town lies only seventeen miles from Pittsburgh. A historical marker proclaims that this town was a setting-off point for pioneers, as the Monongahela joins its sister river, the Allegheny, a little farther on to form the Ohio River, surging west. In this region Ormes's talent was nurtured and she developed the strength of character and confidence that allowed her to venture to join the ranks of celebrity in the larger world. The settings, down-home humor, and images in Jackie Ormes's drawings can often be traced to her early life in Pennsylvania.

Zelda Mavin Jackson, the girl who was to become Jackie Ormes, was born on August 1, 1911, in Pittsburgh, where her parents, William Winfield Jackson and Mary Brown Jackson, had wed and started a family. Her sister, Delores, relates that their father owned and operated a printing business. William Jackson also was the proprietor of a Pittsburgh open-air movie theater situated on a vacant lot, and in good weather customers would sit on benches in front of the big screen and watch silent movies. William was also a member of the Masons and earned a high degree in the order. Mary Jackson's work as a homemaker centered on her two daughters. Zelda and Delores were light skinned, with soft, dark curls that Mary shaped into long ringlets falling to their shoulders, in the fashion of the day for little girls. Their mother was a skilled seamstress who made many of their clothes, often redesigning patterns with self-taught expertise. The girls learned "yes, ma'am," and "yes, sir," along with their Baptist church lessons and mother's-little-helper tasks. Mary also set aside plenty of

time and materials for drawing and for music, which both Zelda and Delores enjoyed and showed talent for. But when William was killed in an auto accident in 1917, life changed drastically for the Jackson family.

Delores related that the girls lived with an aunt and uncle briefly while Mary took a job as head housekeeper for a wealthy widow in Norristown, domestic service being one of the few employment possibilities for African American women at the time. Before long, Mary met and married her second husband, Porter M. Simmons (or "P. M."), whose family lived in Monongahela, and in 1918 he brought Mary and the girls to the valley town. The sisters flourished in their new home, where they were, and would forever be, each other's best friend and confidante. Mary was now secure in raising her daughters in a loving, proud family, one that adhered to the values of education, hard work, and community service.

As part of a respected local family, P. M., or "Pop" as the girls called him, was a leader in the Bethel African Methodist Episcopal (A.M.E.) Church, where he was renowned for his beautiful tenor voice. For a time, the church, built in 1871, was used as a separate public school for "colored folk," but by 1882 schools were beginning to be integrated. Its tall steeple rises over the red brick building that still serves its original role as a house of worship and meeting center for the African American community in Monongahela. P. M. operated a dairy farm located some miles from town where they lived. The girls would sometimes accompany him across the green hills of Pennsylvania. This landscape, with its wide plank fences, farm animals, and insects, likely served as inspiration for the backgrounds and humor in some of Ormes's later art.

The 1920 census shows that the population of Washington County where they lived included 7,428 "Colored" citizens and 188,992 "Whites." However, if P. M. Simmons had one of the 261 state of Pennsylvania "Farms Owned by Colored" in 1920 (153,237 were "Owned by White")—as well as owned his house—we can assume this was a financially comfortable family.[1] P. M.'s brothers Frank and Perry Simmons earned special prominence in Monongahela as partners in McPherson & Simmons Bros., contractors and builders, and later, Paul A. Simmons, a nephew of P. M.'s, became a district court judge.

The sisters blended into their new extended family and blended their voices as well, taking active parts in the A.M.E. church choir. It was about this time that the family began calling Zelda "Jackie," short for "Jackson" and an ungendered name that would later prove useful in the largely all-male newspaper profession. Delores especially excelled in music, and this talent spurred her mother to arrange for voice lessons. Vocal performance eventually became Delores's profession, and as a young adult, she signed a contract with Decca Records. Her specialty was torch songs, a vocal style that she believes was partly responsible for Ormes naming one of her comic strip characters Torchy. She went on to explain that Ormes chose Torchy's last name, Brown, to emphasize skin color and also to please their mother, whose maiden name was Brown.

From 1960 to 1980, Delores lived in Durham, North Carolina, where she and her husband, Murray Marvin, were involved in public relations work for a life insurance company. She was also an accomplished sculptor; two of her notable commissions were busts of Mary Duke Biddle Trent Semans, grandniece of the founder of Duke University, and her husband, James Semans, both important art patrons and Duke University supporters. Eventually, Delores was widowed and later married Henry Arlington Towles, an attorney in Chicago.

P. M. was able to provide both security and amenities for his family. The Jackson/Simmons family lived in their own home in a mixed-race, middle-class neighborhood on a brick-paved street a few blocks from Monongahela High School. Within walking distance were the Bethel A.M.E. Church, a public library, the city square with its band pavilion and Civil War cannons, and the homes of friends and family. There was never a shortage of young men visiting the Simmons parlor. Almost every Sunday a group of high-spirited youths would ride the train from Pittsburgh to visit, "so many of them that we would never get into any trouble," Delores once recalled with a smile, hinting that the youths chaperoned each other.

A sizable African American population lived in Monongahela in the 1910s and 1920s. Pittsburgh and its outlying parts had been a destination for tens of thousands of blacks migrating from the South to work in jobs created by the burgeoning steel and aluminum industries. Other ethnic groups came also, including the Italian, Polish,

and Irish, creating the area's mix of languages and culture, ethnic restaurants, and shops. But the region was not a melting pot for some; there were plenty of opportunities to be rejected or made to feel like an outsider because of racial prejudice. Delores remembers worrying whether she would be asked to dance at the mostly white high school parties to which they were invited and recalls that Jackie handled this worry differently: she asked the boys first. Her sister recalls that even in high school this pretty young woman, with her sunny disposition and a dash of moxie, was impossible to resist. Outwardly, at least, she may have seemed shielded from slights; but clearly Jackie took in all the possibilities for humiliation, because later she would satirize painful situations in some of her comics.[2] And being light skinned with soft curly hair, as the Jackson girls were, gave no sure protection from such hurt. Both the sisters would often be taken for white when away from their own community. Delores described once losing a job when the employer learned she was black, a fact she did not feel was necessary to declare when she applied. It could be dangerous indeed to pass for white, especially for a protected innocent like Jackie.

From an early age, Jackie was a budding artist. Her mother would good-humoredly chide the girl for using up all the paper in the house and dulling all the pencils with her constant drawing. Bars of Ivory soap would disappear, to be fashioned into fanciful carvings. Delores vividly remembers that when Jackie was about ten years old she carved a rickshaw, painstakingly polished with a soft cloth to a finish smooth and shiny as real ivory. Her sister explained, "We could never see the reason why Jackie should take art classes—she could do it all, already." Jackie may have actually benefited from having no formal art training. Art instructors sometimes insist on traditional exercises that have the potential to change a unique, innate style. Her first comic strip, *Torchy Brown in "Dixie to Harlem,"* clearly retains a novel innocence and verve, albeit at times crammed with detail that seems to distract from the central story line.

Although Monongahela High offered no art or music classes in 1926, the school's curriculum excelled in other areas. Jackie studied four years of English, reading the poetry of Coleridge, Shakespeare, and Matthew Arnold, as well as stirring romances by Hawthorne, Cooper, and Sir Walter Scott. Her good public school education and natural ear for language gave her ample foundation upon which to

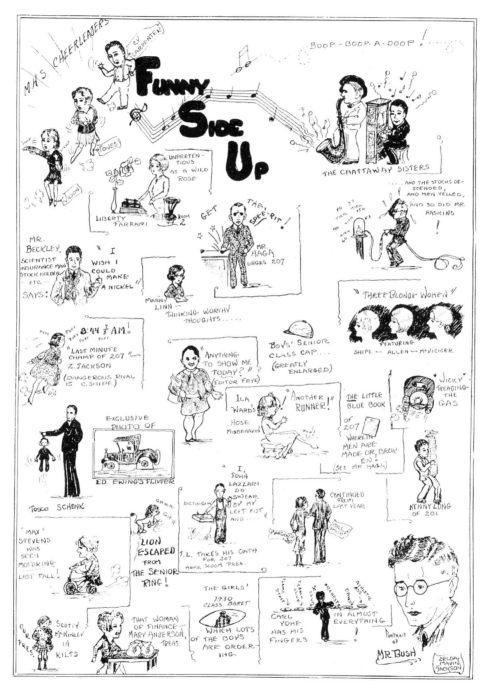

The 1930 Monongahela High School yearbook, *The Flame,* carried two pages of caricatures with quips by art editor Zelda Mavin Jackson. *(Collection of Monongahela Area Library.)*

build her own narrative style—it's no wonder Ormes never used a ghost writer to invent ideas for her comic strips, as other artists often did.[3]

In 1929 the high school yearbook staff recognized Jackie's talent and tapped her to produce the art for their annual, *The Flame*, a year before she was a senior and hence officially eligible. The name of her sister, who really did graduate that year, appears at the bottom of those drawings, but they are unmistakably Jackie's. The following year would be Jackie's senior year, and she could take full credit as the art editor, drawing not only the traditional caricatures of students and teachers but also austere cartoon frontispieces of classical scenes, such as Socratic teachers surrounded by tunic-clad students. Her photograph appears with the yearbook staff. In that photograph, she is shyly smiling in a dainty flowered dress, hands folded across her five-foot one-inch, ninety-five-pound frame. A caption below her senior picture reads, "The load is light which is cheerfully borne."

Her earliest known cartoons cover several pages in the 1929 and 1930 yearbooks, drawings in which Jackie began to build the visual vocabulary she would use throughout her career. Delicate line drawings of various individuals at Monongahela High capture the essence of each, accompanied by humorous mottoes that highlight quirks of their personalities. The figures are flat, with no attempt at shaping or modeling, the forms seemingly frozen in space. Details of characters' accouterments are rendered with care, their clothing accessorized by the hand of one who would later take up fashion design. One caricature in the "MHS 1930–Funny Side Up" page is a self-portrait of a high-heeled, perfectly coiffed young woman—"Last-minute champ of 207—Z. Jackson"—dashing into class, sending up little puffs of dust around her feet to beat the tardy bell. Another sketch alludes to a catastrophic event, with the cheerful insouciance of youth: a man sweating bullets, holding a stock market ticker tape, with the words "and the stocks descended, and men yelled, and so did Mr. Haskins!" Jackie's talent for combining visual and verbal storytelling in a reduced space and with amusing characters would one day find full expression in her cartoons and comic strips. And with no formal training in the intervening time, her *Torchy Brown in "Dixie to Harlem"* seven years later would show more carefully sculpted characters, now with perspectival depth, in complex and sustained narrative.

Jackie also shows up in the French Club photo; an accompanying essay describes Le Cercle Française gatherings at members' homes to practice their French. Her flair for language is obvious in this ballad in the annual:

A Seniors Heaven

It's gilded bliss to enter class
And know you know your French.
You wave your hand most recklessly;
Your parlez-vous's a cinch.
Another taste of heaven is
To know your P. O. D.
You boom with utter confidence;
Can argue violently.
And when you've got your English done,
With margin drawn just so,
The feeling that you have is nice,
I tried it once, I know.

But Ah! to show your stuff in "Chem"
Is paradise in pink!
It's scientific blessedness;
At least, that's what
I think.
 Zelda Jackson[4]

Other poems written in Ormes's mature adult hand were found in her personal effects when she died. One of them, a bittersweet memory of youthful days, reveals her sympathy and disdain for some black men who attempted to ingratiate themselves with their white bosses:

The Clowns in Our Town Were Brown

His lurching frame
Bent double
Exploding loud,
To moaning,
"Lawdy . . . Lawdy!"

The point obscure
But what's for sure
The BOSS
Had made a FUNNY.
Hilarity
Now reached
Its peak—
Degrading HIM
The DUMMY.

Another poem, unattributed and untitled but likely composed by her, also comments on black manhood:

Lived
A BOY
Yet NOT a BOY,
Whose limitations
Guaranteed
One thing, it seemed
And that
To be
In wrong
with RIGHT
and right was
White!!!

An especially informative interview article by David Jackson, "The Amazing Adventures of Jackie Ormes" was published in the *Chicago Reader* five months before her death. In it she recalled later that "Monongahela was like suburbia: spread out, and simple. Nothing momentous ever happened there. Nobody had much, but we were OK. We grew up around music—nice sounds!—and no bad language and no violence. So we thought the world would be a pretty nice place to go chop up. I was ready for it, honey."[5]

AN ASPIRING JOURNALIST

While still a high school student, Jackie wrote to Robert L. Vann, publisher of the *Pittsburgh Courier*, the African American weekly news-

paper, asking him for a job. Her persistence with the *Courier* resulted in a few reporting stints. Chuck Washington, the paper's sports editor, passed her mother's scrutiny and escorted young Jackie to her first assignment to write about a boxing match. "It wasn't a ring at all. It was a square—square as all git out. The sportswriters were sitting around the edges. They were getting splattered. With sweat. It was nasty, and I was enjoying it!" Her nice girl persona had begun to blossom into a more complex sensibility, and by the time she graduated from high school in 1930 Jackie was ready for the wider world. She moved to Pittsburgh, where she was hired to proofread for the *Courier*. At the same time, she did what apparently was some freelance reporting on police beats, court cases, and human interest angles on the fights, building what she called "a great career running around town looking into everything the law would allow, and writing about it." Although Ormes would later assert that "I was anti-war—I was anti-everything that's smelly," it is clear that she found the gritty side of Pittsburgh life, with its political intrigues and the sweat and blood of boxing matches, riveting.[6]

Few bylines appear on any *Courier* articles, and none with her name can be found. Of course in that era, the name "Zelda Jackson" on the byline of a feature story about a boxing match might not be the image a *Courier* sports editor would wish to project. Her experience as a newspaper reporter provided rich material for this future humorist, and she drew upon this knowledge quite effectively later in her career. Elements of street-savvy language, images, and situations from these days would one day make their way into her comic fictions. A *"Dixie to Harlem"* comic strip, for instance, shows Ormes's alter ego Torchy at a Joe Louis bout, jumping on another spectator in her excitement, pounding his head and yelling, "Yoo-hooCHES! Atta Joe—Poke 'im—He's down—Whee!" Her feathered hat is askew, and her hand is held aloft by a chagrined seatmate who declares Torchy "De Champ!"

MARRIAGE AND FAMILY

A friend and would-be matchmaker introduced Jackie to Earl Clark Ormes, a soft-spoken divorcé seven years her senior. They married in 1931 and lived for a few years in Pittsburgh, with Earl attending the Pittsburgh School of Banking and working for Steel City Bank and

Earl Ormes, probably in the late 1940s. *(Courtesy of Delores Towles.)*

Jackie Ormes around 1932. *(Courtesy of Delores Towles.)*

Jackie Ormes

Jackie working at the *Courier*. In these dismal days of the Depression, they began to build what would be a forty-five-year marriage that lasted until Earl's death in 1976.

A stylish world of entertainers and artists began to open to the attractive young couple. The Ormeses became friends with Pittsburgh native Billy Eckstine, who later became a successful singer and bandleader. Lena Horne, who sang in Pittsburgh jazz clubs, was another friend. Milestones in Horne's career—dancing in Harlem's Cotton Club as a young adult, blossoming into a nightclub singer, and later becoming an aspiring movie actor—may have inspired story lines for "*Dixie to Harlem,*" though with Ormes's original comic twists and caricatures.

Within a few years Jackie and Earl's daughter, Jacqueline, was born. "Little Jackie" had her mother's big eyes and her parents' light-toned brown skin and soft hair. Ormes was a doting mother, taking the baby for walks, to the downtown shops, or to visit friends nearby. Family members described how Ormes took pride in dressing her little girl in the nicest clothes she could afford or make, and if Jacqueline begged to have her fingernails painted like her mommy's, of course Ormes would oblige. When they observed signs of the toddler's unusual behavior, Earl and Jackie took Jacqueline to Montefiore Hospital, where she was diagnosed with a brain tumor. The location of the tumor made it necessary for her eye to be surgically removed and replaced with a glass prosthesis. Treatments for childhood cancers were not advanced in the 1930s, and at the age of three and a half, Jacqueline died while cradled in her mother's arms. According to her sister, Delores, Ormes was determined not to bear more children or to go through heartache like that again. She was always to keep her sorrow to herself, never speaking about Jacqueline, except once to tell Delores, "I will never lose my empty arms." Nine years later, when she first began the *Patty-Jo 'n' Ginger* cartoon, some family members worried that the little girl character was a kind of substitute for Jacqueline and that the motivation for creating the cartoon might not be emotionally healthy for Ormes. But the family's fears were apparently unfounded. To all appearances Ormes enjoyed her relationship with the joyful and lively Patty-Jo, a fictional child who never aged and was always in the pink of health.

RETURN TO DRAWING

Patty-Jo 'n' Ginger wasn't Ormes's first nationally published cartoon work. Exactly how she arranged to draw for the *Courier* is unclear. In her sister's account, Ormes simply convinced the editors that she could make people laugh and that she could draw, and they finally gave in, allowing her to go ahead and try a comic strip. In 1937, about a year after Jacqueline's death, Ormes began *Torchy Brown in "Dixie to Harlem."* In 1985, Ormes described her inspiration: "I had never been to Dixie, but I worked in a newspaper office, and I read everything that was in the paper. It was a whole lot about struggles. Segregation."

Daily newspapers of the time rarely carried stories about the African American community or showed a black face in photographs, except perhaps in the sports section. As Earl's sister Vivian Ormes Mason explained, it was essential for families like the Ormeses to subscribe to black newspapers such as the *Courier*, delivered to their mailbox weekly. A touchstone for black families throughout the nation, the *Courier*, which started in 1907, provided a distinctive and important angle on the news, championing black citizens' causes and advocating their interests. Importantly for Jackie, the *Courier* also had the funnies. For a few hours a day in her writing and drawing she slipped away to a lighthearted and glamorous place of her own design, the world of Torchy Brown, a nightclub star.

"Dixie to Harlem" was a big hit with readers, Ormes recalled. *Courier* staffers in the art room would check her work, saying, "Looks all right, looks all right. Think you got something there—but it won't hold on, it won't hold on." Why she quit drawing for the *Courier* in 1938 is unknown. The *"Dixie to Harlem"* story line reached a dramatic conclusion after its twelve-month run, and this sequence may have been all that was called for in her original contract. It's possible that her contract simply ran out or that the strip was not renewed because its subject matter—the escapades of a madcap young woman—was not to a particular editor's liking. Another possible scenario is that Ormes envisioned other projects for herself and thought she could not continue this one at the same time. Seven years would pass before she would again draw professionally, resuming in 1945 with a brief run of *Candy* and starting her eleven-year production of *Patty-Jo 'n' Ginger*, which

Salem, Ohio, located one hundred miles west of Pittsburgh, is a city proud of its Quaker and abolitionist history. At the time of its founding, the Quakers were among the most liberal and progressive Christian denominations. Travel today to Salem and you will find in inns and antique shops a tourist map that locates a dozen sites of the Underground Railroad. Abolitionist families built homes with added features such as concealed nooks behind brick fireplaces or fake walls to hide slaves on their escape route north to freedom. One story describes some of Salem's early citizens rescuing from a stopped train a young woman slave traveling north with her southern master; another recounts a white Salem boy regularly taking a trip of many miles, driving a wagon with a false-bottom compartment carrying escaping slaves.

A grave in Hope Cemetery bears an obelisk headstone with the inscription "EDWIN COPPOCK, 'A MARTYR TO THE CAUSE OF LIBERTY.'" Coppock was executed in 1859 at the age of twenty-four for joining John Brown's raid on Harpers Ferry. Salem was also the site of the Western Headquarters of the Anti-Slavery Association, formed in 1836. A replica of their meeting house, Freedom Hall, houses one of the Salem Historical Society's museums. In the same building, the first Women's Rights Convention west of the Allegheny River took place in 1850. Such examples of progressive activism and tolerance are among the most distinguished and proudest aspects of Salem's history. However, as in most other northern communities in the antebellum era, forces of racism were also at work. Mercenary slave hunters often

Jackie Ormes

overlapped in the early 1950s with a reprise of a quite different Torchy Brown character.

About midway in the run of *"Dixie to Harlem,"* Zelda Jackson Ormes's name appeared in the *Courier* on an illustration for a serialized romantic story. Done in an uncharacteristically painterly style, probably with a brush, the woman's face is shaded and modeled, departing from the crisp pen drawing of her cartoon strip. However, only one such piece can be found, suggesting that this style of illustration, as well as the work of illustrating other people's stories, was not to her liking. But according to her 1985 interview, she continued writing, sometimes sending material to the *Philadelphia Afro-American* newspaper, which was headquartered in Baltimore with editions in the northern and mid-Atlantic states.

Earl and Jackie's new life in the big city allowed her to match her potential with the best professionals in the black newspaper world. Her friendships with other talented African Americans, the solidarity of a larger black community, and the vibrant cultural diversity of Pittsburgh were especially compelling to her. When the bank Earl worked for failed during the Depression, he tried other jobs: advertising manager of a newspaper, grocery store manager, real estate salesman, and hotel waiter. But the stresses of big-city life apparently became too much for the couple. In early 1938, Earl and Jackie relocated in Salem, Ohio, where his family lived. Their move occurred a few months before her one-year contract for *"Dixie to Harlem"* ended, and she drew the last episodes while living in Salem.

The Ormeses' middle-class house on South Union Street was ample enough for them to live with Earl's parents, John and Anna; Earl's sister Vivian; and Earl's brothers, Melvin and Lloyd. Earl's sister Winefred and her husband, William Hous-

ton, lived in Pittsburgh, where she worked for the *Courier*. Vivian remembers Ormes laughing when they first met her, and they teased Earl, "Why did you bring home such a tiny little girl?" But she fit right in, enjoying the give-and-take of a big household, sharing their interests, and doing the homemaking chores along with the other women. They loved her immediately, embracing her as one of their own. Few people had much extra money in the Depression years, but the Ormes household was able to live at a level comparable to the one Jackie had known in her youth, secure and comfortable.

Earl was working as a crane operator at a local mill, "but it wasn't for him, too dangerous, and Earl didn't like getting his clothes dirty," Vivian explained with a laugh. She recalls that "Jackie could work like a horse," pitching in with the necessary cooking and cleaning. (Jackie remained a tireless worker over the years. In the early 1950s she composed a weekly cartoon, as well as a comic strip, sometimes drawing paper dolls to accompany the strip, while at the same time organizing fund-raising events and keeping up a busy social life and household.) When they shared a house in Salem, Ormes would stay up late into the night drawing *Torchy Brown in "Dixie to Harlem."* Vivian recalls one story with amusement. Before retiring for the night, the young men of the family charged Jackie with the duty of checking the flame under a still they had hidden in the basement. When Mother Ormes discovered this little factory, she took an axe to it and pelted them with a barrage of stern words.

During this era, social custom in the middle class—both black and white—discouraged women from working outside the home. Vivian recalled that the most common work opportunity for a woman of color would have been as a domestic, an unappealing prospect for the Ormes women. The Depression scoured the area, sometimes on tips from a few reactionary locals who got wind of the doings of the Underground Railroad. Empowered by the Fugitive Slave Act of 1850, hunters reaped bounties by returning runaway slaves. Persons aiding escaping slaves could be tarred and feathered, and many townspeople confronted this danger. This shameful legacy continued into modern times; in 1923, a Ku Klux Klan meeting and march, complete with a KKK women's auxiliary, took place in Salem.

The recently published book People of Courage: African Americans in Salem, Ohio, *edited by Jacqueline F. Rowser (Kent, OH: Kent State University, 2001), brought together oral histories, vital records, scrapbook clippings, and family photographs into a thoroughgoing account of the history of this community. The Ormes family figures prominently in the volume, with William Ormes, a freedman, arriving from Virginia around 1837. The original manumission papers of his wife, Rachel, are kept today as a family treasure. A number of marriages among the Cyrus, Ormes, and Manzilla families have occurred over the years and are celebrated with regular reunions of their descendants. A plaque from the city of Salem commemorates the Ormes family's first gathering in 1890 near the reunion meeting place in Centennial Park. A notation describing Jackie Ormes's career appears in the Ormes family's section of* People of Courage. *Indeed, she remained close to family in Salem, often returning by train to visit.*

Small-Town Roots,
Big-City Ambitions

hit black men especially hard, as the barriers of racism blocked them from higher-paying jobs. The Ormes men were always employed, though usually in lower-paying positions such as factory watchmen, jobs far below their skills and ambition. Once, a supervisor apologized to brother Melvin, telling him that a promotion he rightly deserved must be offered to a white man, a person of admittedly lesser ability. In 2001, a group of African American residents of Salem compiled family histories and anecdotal accounts into a volume, *People of Courage: African Americans in Salem, Ohio.* One entry titled "Growing Up Black in Salem" recalled life there in the 1930s: "Not that I want to portray a bleak and dismal period of time, but the fact is that blacks had very little access to recreational outlets, public eating facilities, or social gatherings other than those provided by our local black church affiliations."7

Like the Jackson/Simmons families from which Jackie Ormes came, many in the Ormes family and their children would later earn college degrees, own businesses, become educators, and have both military and professional careers. But it became obvious to Jackie and Earl in 1942 that their own great expectations must be satisfied elsewhere and in a big city. Jackie's sister, Delores, lived at the time in Chicago, where she was pursuing a singing career, and had described in letters the expanding job opportunities and vitality of life she found there. Jackie had begun to feel stifled in Salem, and although "Earl wanted to be near his family, to feel secure," Jackie recalled years later, "I needed Chicago. I talked him into it."

Chapter 2

THE CHICAGO YEARS

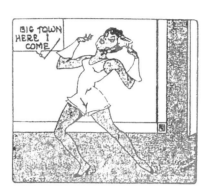

Native Son, the powerful 1940 novel by Richard Wright, depicts the living and working conditions of many African Americans in Chicago. Wright portrays Chicago as "an indescribable city, huge, roaring, dirty, noisy, raw, stark, brutal: a city of extremes: torrid summers and sub-zero winters, white people and black people, the English language and strange tongues, foreign born and native born, scabby poverty and gaudy luxury, high idealism and hard cynicism!"[1]

The diversity of lives and ideas that Wright describes, as well as the abundance of culture to be found in Chicago, added to the attraction that the city exerted on Jackie Ormes. In addition, the United States had entered World War II only months before Jackie and Earl arrived, and the steel mills of nearby Gary, Indiana, the giant railroad lines, and the food processing plants were mobilized for war.

Bronzeville, where Jackie and Earl settled in 1942, provided a welcoming neighborhood for all classes of African Americans. This "Black Belt," the term commonly used to identify the African American community on Chicago's South Side, was seven miles long and one and a half miles wide, hemmed on its edges by whites' restrictive property covenants. Thousands of people looking for better jobs and living conditions had migrated from the rural South in the 1910s, making Bronzeville their home. Since blacks were frequent victims of job discrimination, the Depression of the 1930s had hit this part of Chicago especially hard. A second wave of newcomers would by 1944 swell the black population to 337,000, one-tenth of Chicago's total population and two times what it was before the war.[2] Photographer and writer Gordon Parks remembers that Chicago's South Side "offered mostly hunger, frustration, and anger to their tenement dwellers."[3] But better conditions existed in single-family homes and larger apartments for the minority of African Americans who could afford them, and entertainments drew whoever could come up with the dime or six

bits to go to a movie or a matinee dance. Renewal efforts such as the Ida B. Wells Homes housing project, which opened in October 1940, brought hope to many that the federal government's New Deal programs might after all ensure opportunity for Americans of every race.

In their landmark 1945 sociological study, *Black Metropolis*, St. Clair Drake and Horace Cayton called Bronzeville the "second largest Negro city in the world."[4] Other writers claim that Bronzeville surpassed Harlem as the cultural center of black America and was the new crucible for a black political power base. Thanks to connections from their Pittsburgh days and the know-how and confidence they acquired in that city, Jackie and Earl soon joined the ranks of Bronzeville's emerging black leadership and entrepreneurial class.

Earl's administrative and banking experience led to a position as manager of the DuSable Hotel after a brief stint as clerk there. The Ormeses lived in an apartment in the DuSable, one of several Chicago hotels that catered to African Americans, who at that time would not have been permitted to register at most white-owned establishments. The DuSable, as well as the Vincennes and Grand Hotels, among others, was well known for its celebrity clientele, including entertainers performing at the Regal Theater or Savoy Ballroom a few blocks away. It's likely that Jackie and Earl joined their new acquaintances at nearby taverns and jazz clubs, taking in the music, language, and festive mood of the crowd. When wartime rationing caused clubs to shorten their evening hours, people flocked to matinee performances by the great dance bands, including those of Count Basie and Duke Ellington. Ormes's sister, Delores, reported that "Jackie loved to dance, but Earl didn't." Her sister's tribute to Earl that "anything Jackie wanted to do was all right with him" is borne out in the story that Earl would call a friend to take her dancing whenever she wanted to go.

Along with managing the DuSable Hotel, Earl also worked as assistant comptroller for the Supreme Life Insurance Company, one of the leading African American-owned businesses in the country. In fact, life insurance companies, newspapers, and cosmetics firms were some of the largest African American-owned businesses. Supreme Life honed one of its missions—to provide "financial assistance in obtaining decent housing"—by offering affordable mortgages to blacks who might be turned down at other lending institutions. "The altru-

Jackie Ormes

22

ism must not be overstated," cautioned one economist, since "These mortgages yielded 7% for the most part," whereas other investments were required to bring in a minimum of 3.5 percent.[5] But for life insurance policyholders, "Most of the customers were old-style people who were looking for burial insurance," according to a black press journalist. "They could have charged them 50 cents a month for a life policy of $250 to $500 and still made money off them."[6] Supreme Life at one time also invested in cemetery real estate, perhaps to address concerns about restrictions in whites-only cemeteries.[7] Sometimes life insurance companies partnered with African American funeral and burial associations when it was necessary to convey the deceased's remains back to a family burial plot in the South.

Ten years later, Earl would manage the Sutherland Hotel, one of the classiest hotels in the area. The Sutherland was previously off limits to African Americans, but the owners, Messrs. Rubin, Gould, and Cohen, saw the potential for an upscale hotel for all races. In 1956 they pumped three hundred thousand dollars into modernizations and put the future of the hotel into Earl's hands. "We are trying to maintain a hotel that the community can be proud of," Earl said in a *Chicago Tribune* interview. "We want it to be a place where my own friends can come and be happy, and get service comparable to what they would receive in the Loop."[8] The Sutherland was like a small city. It had a drug store; a beauty shop; at least one designer-label shop, "Fine Furs"; and also its own jazz club downstairs and ballroom and supper club upstairs, with headline stars appearing regularly. Notable entertainers would bring their entourage to stay when they had a show in Chicago. The Ormeses moved to the Sutherland in 1952, and one can imagine Jackie there meeting business travelers, rubbing elbows with musicians, and talking with political and cultural leaders. By this time she had earned her own prominence, and with Earl as manager the couple fit comfortably into friendships with the guests and entertainers who frequented the prestigious hotel.

Although they lived and worked in the black part of the city, Ormes also traveled on the El to the mixed-race areas to shop at Marshall Field's department store or to lunch at a favorite restaurant. In the early 1940s, Ormes took some classes at the School of the Art Institute of Chicago. A parody of herself as an ego-inflated student in a

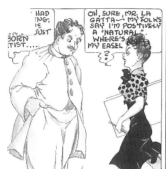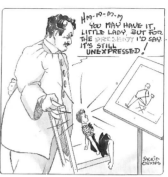

Ormes sweats bullets in this self-parody, drawn possibly at the time she attended the School of the Art Institute of Chicago in the early 1940s. Mostly self-taught, here she admits to the benefits of formal art training. The upper left corner has been torn. Sixteen and a half inches by four inches, original drawing of india ink on Bristol board paper. *(Collection of the DuSable Museum of African American History, Chicago.)*

figure modeling class shows Ormes getting her comeuppance, possibly based on experience from her Art Institute days. Saturday and evening adult education classes available at the Art Institute included figure drawing and painting, figure construction, dress design, and layout and lettering. The 1940–41 catalog notes that "The School does not teach cartoon technique, but it enables those whose ideas are adapted to the cartoon type of expression to draw convincingly and confidently and thus develop a personal and distinctive style."

After the Harlem Renaissance of the 1920s faded with the onset of the Depression, a comparable "Chicago Renaissance" took root in the mid-1930s and lasted through the early 1950s.[9] Commonly associated with black literary artists, such as Richard Wright and Gwendolyn Brooks, this era saw a flowering of visual arts as well. Art historian Melanie Anne Herzog describes the progressive aims of artists working and exhibiting at the South Side Community Art Center: "This was the period of the 'Chicago Renaissance' in the literary and visual arts, characterized by writers, playwrights, and visual artists who came together on Chicago's South Side to produce incisive, socially critical forms of cultural expression for a predominantly African American audience." Herzog quotes painter Bernard Goss: "I want to do murals and paintings to influence people. I might be called a revolutionary painter. I'm not satisfied with social and economic conditions. My aim is to do something about them."[10]

The late 1940s marked the start of Ormes's lifelong friendship with Margaret Burroughs, who was formerly married to Bernard Goss. Burroughs, an educator, artist, writer, and, later, founder of the DuSable Museum of African American History, and Goss, a painter and writer, were both progressive political leaders and were instrumental

Jackie Ormes

in starting the South Side Community Art Center. Ormes shared interests and socialized with other politically active artists and writers as well. The topics that she chose for her cartoons reveal that Ormes had much in common with others who were using their art to address the many obstacles facing African Americans. At some point she began meeting with artists at the South Side Community Art Center, and in 1953 she was elected to its board of directors.[11] Throughout her career she continued to imbue her work with the same social consciousness as did the artists of the Chicago Renaissance.

Although artists and authors influenced her, Ormes realized that her talent lay in drawing and in "making people laugh," as she put it. Her strongest desire was to find work in newspapers, historically a platform where writers could reach a larger and more varied audience. By late 1943 she approached the editorial desk of the African American *Chicago Defender*. At this time the *Defender* was a weekly paper, running neck and neck for fame, advertising, and subscriptions with the *Pittsburgh Courier*, the *Afro-American*, and a few other smaller African American papers.

The *Defender*'s home office was located in Bronzeville, and it published editions in several other cities. According to her sister, Ormes simply walked into the *Defender* office and presented herself, along with a packet of her cartoons and other work on the *Courier*, and was hired on the spot as an occasional writer and reporter. She submitted personality profiles and news articles and, for a period of seven weeks in the spring of 1945, authored a women's page column titled "Social Whirl" under the byline "Zelda J. Ormes."

In a breezy, florid style, the column recounted the comings and goings of fashionable people and promoted community affairs as well. She reported on such events as dinner parties for out-of-town guests, welcome-home parties for college students on vacation, salutes to military servicemen or servicewomen home on leave, and of course engagements and weddings. One interesting note describes "a visiting debutante feted at the home of Miss Lorraine Hansberry." Daughter of a well-to-do Chicago real-estate broker, Hansberry would have been fifteen years old at the time. (A decade and a half later her play *A Raisin in the Sun*, set in a two-room South Side kitchenette apartment, won the New York Drama Critics award for the best American play of 1959.)

Spicing up the Social Whirl column are names famous at the time, some included for the purpose of promoting a benefit event. Ormes never seemed to miss a fashion show, especially when it involved Mrs. Joe Louis: "Marva Louis . . . brown America's favorite mannequin . . . with a glamorous array of Bronzeville's own 'naturals' as her satellites" (March 3).

POLITICAL AWAKENING

During the war years, American newspapers sounded a patriotic tone, calling for victory over fascism abroad. The "Double V" campaign, initiated by the *Courier* and taken up by the *Defender* and other black papers, added to America's "V" symbol for victory a call for victory over racism at home. Ormes's Social Whirl column featured patriotic and interracial topics that backed the "Double V" cause, like soldiers' welcome-home parties and mixed-race wartime fund-raising events.

Immediately after the death of President Franklin Delano Roosevelt on April 12, 1945, Ormes invoked a fight on yet another front, the fight to improve women's prominence in society. She devoted most of her April 21 FDR eulogy to praising Eleanor Roosevelt, a champion of women's rights as well as a crusader for racial equality.

> F.D.R. IS DEAD! LONG LIVE THE PRESIDENT! The mournful voice of a bereaved nation rises this week in tribute. . . . And to our First Lady . . . the hearts of women, black and white throughout America, will go with her from the White House to whatever sphere of action she chooses. Such an exalted figure, possessed with the heart and the courage to crusade for the rights of the common man, regardless of race or creed, has lifted modern womanhood to new heights. . . . [She] will keep the fight alive, wherever she is, until peace, deep and lasting, becomes the UNIVERSAL WAY OF LIFE!

Ormes's embrace of progressive social ideas was apparent in Social Whirl. In the seven weeks that her column ran, she often made reference to efforts at improving interracial relations, such as the concert by soprano Dorothy Maynor that "will bring together people of all nationalities and races to hear one of the world's greatest artists" (March 3). When Paul Robeson was in town appearing in *Othello,* Ormes made

special mention of a talk he was to give on interracial relations, sponsored by the rabbi at Temple Shalom (April 21). She lauded artist Thelma Johnson Streat's appearance in Chicago, describing her commission to paint murals like *The Negro in Labor* and pointing out Streat's avowed purpose "of forming a keystone to better racial understanding" (April 7). Indeed, her political inclinations were to work toward interracial harmony, reporting, for instance, on lectures by Eleanor Roosevelt on this subject even when the First Lady spoke in other cities.

Ormes began covering some meaty news stories of the kind she later said were denied her in Pittsburgh, explaining in 1985 that as a woman she found she could charm her way into areas unavailable to "boy reporters," as she called them. In court, "I'd go right over, and the bailiff would let me read the docket. When a case had been continued, they'd tell me. I got in. Because they trusted me to do the story right."[12]

In wartime, national need and exigency push against closed doors. In June 1942, with the nation in crisis, the U.S. Navy opened its ranks for African Americans, who had long been stuck in messmen's jobs. Now sailors could seek duty in such positions as gunner's mates, machinists, mechanics, radiomen, and engineers. Chicago's Great Lakes Naval Training Center housed the navy's induction center for "Negro recruits." Great Lakes became a focal point for African Americans who considered the move a breakthrough; but the navy nevertheless clung to segregated training and housing at its all-black Camp Robert Smalls. Three years later the Bureau of Naval Personnel ordered all Recruit Training Commands to integrate. Special reporter Ormes jumped on the story, apparently scooping the mainstream press that made the announcement the next week. The byline "Zelda J. Ormes, Defender Staff Correspondent" ran under a front-page headline, "Color

*R*obert Smalls (1839–1916) was a Union hero in the Civil War. Born a slave on a South Carolina plantation, he taught himself to read and write, and in service to a seafaring master he learned how to sail a ship. One night when all were asleep, he smuggled his wife, children, and twelve other slaves onto the Planter, *a steamer transport, and hoisted a Rebel flag, which allowed him to sail undetected past Confederate gunboats. Switching the flag to a white one, he delivered the ship to a commanding officer of the Union fleet. President Lincoln received Smalls and his crew of twelve in Washington. He was given command of the* Planter *and made a captain in the U.S. Navy, a position he held throughout the war. Smalls went on to serve for twelve years in the South Carolina legislature and the United States House of Representatives.*

When Camp Robert Smalls opened for Negro recruits in 1942, its commanding officer was Lieutenant Commander Daniel W. Armstrong, whose father, Brigadier General Samuel Chapman Armstrong, led the Ninth U.S. Colored Troop in the Civil War and who founded Hampton Institute, a vocational and agricultural college established in Virginia for newly freed slaves to "go out to teach and lead their people." Hampton Institute is now Hampton University and is also notable for enrolling Native Americans as early as 1878, another of Samuel Armstrong's efforts.

The Chicago Years

Line Ended at Great Lakes," and the article began, "For the first time in the history of Great Lakes Naval Training Center, brown and white men sat down this week side by side in the same mess hall and ate together. Segregation at Camp Robert Smalls has been officially ended." Ormes scouted out the base hospital as well, noting that it was partly attended by African American servicewomen as it filled up with "wounded vets from all branches of the service [and] draws no color line."

> Harmony reigns in these spacious wards, where, in rows of white beds, men of all colors sit propped in varying positions, with pictures of wives and sweethearts besides them. Naval and civilian nurses serve these men, and of the three newly enlisted Negro WAVES at Great Lakes, two are nurses assistants, rated as Pharmacists mates, second class. They attend all patients wherever assigned to duty.[13]

During the postwar period, the climate in America was highly charged by fears about homegrown Communists and their supposed plans to overthrow the government. Director J. Edgar Hoover's Federal Bureau of Investigation (FBI) spied on a wide variety of political, cultural, and labor leaders, and it cultivated informants whose reliability was dubious at times. The FBI investigated Americans of all backgrounds, including African American leaders who were targeted primarily in New York but also in Chicago and elsewhere.[14] Indeed, in the late 1930s and early 1940s some in Chicago's black community had turned to radical politics and the Communist Party (CP), believing that it promised a fairer alternative to capitalism. Art historian Melanie Anne Herzog reminds us that

> Integral to the African American arts communities in Chicago and New York were artists for whom the socialist ideals put forth by the Communist Party offered a solution to the race and class oppression they saw in the United States. Some joined the Communist Party; many more did not join but were sympathetic to its aims. [Artist] Charles White later recalled, "It was the most natural thing in the world, or should I put it the other way around, it was most unnatural not to be involved politically."[15]

Jackie Ormes

African American veterans returned from the war to find their

seats still located at the back of the bus. After having fought for their country, they continued to face impassioned hostility—or indifference—on the part of the U.S. government to the issues of equal education, housing, and jobs and due process under the law. The CP took the opportunity to try to advance their cause within the black community. Some who had been party members before the war continued to be so after the war, and rifts often developed between them and African American anti-Communists.[16]

Spurred on by postwar patriotic fervor and cold war politics, the FBI investigated citizens whom they suspected of un-American activities. Wisconsin senator Joseph McCarthy intensified national anxiety with investigations of government workers and others whom he accused of membership in the CP or of having Communist sympathies. McCarthy's committee, the Senate Permanent Subcommittee on Investigations, was the most controversial of several congressional groups, which also included the HUAC. The misery and hardship inflicted by government interrogation during this era have had long-lasting effects, causing some people even today to be reluctant to discuss their activities or the activities of friends and loved ones in the late 1940s and 1950s; in fact, we may never learn the full story of the period. Documents obtained under the Freedom of Information Act of 1966 allow us to retrace at least parts of this history.

Apparently the government had taken note of Ormes's progressive politics and her social activism in Chicago's black community and decided that she was a suitable target for investigation. Her FBI file, titled "Subject: Zelda Jackson Ormes," is a Department of Justice report consisting of informant statements and FBI interviews with her between 1948 and 1958. Although the commentary in the report is often contradictory, the most convincing evidence supports her statement that she was never a member of the CP. (Sections of Ormes's FBI files are found in "Excerpts from the FBI File of Jackie Ormes.")

It appears that the government's interest in Ormes was prompted by her acquaintance with party members and her participation in what were considered CP front events. It is important to remember that many of the objectives of the CP, such as civil rights and economic opportunity, were goals shared by other reform movements as well. By her own account in the FBI transcript and evidenced by other

activities in her life, this was Ormes's position. She was a long-standing member of the National Association for the Advancement of Colored People (NAACP), and her cartoons in the late 1940s encouraged readers' support of the organization; throughout the 1950s she served as an officer and fund-raiser for the women's auxiliary of the Chicago Urban League, a community-based movement helping African Americans enter the economic and social mainstreams. Social conditions in the United States at the time provided more than ample motivation for her satirical comics and protest activities, regardless of any influence from left-wing or "alien" organizations.

Even though the treasonous activities that American citizens were suspected of pursuing rarely turned out to be real, J. Edgar Hoover's ongoing obsession with the CP put under the FBI's scrutiny persons who simply engaged in legitimate dissent. Like some other people involved in the arts, Ormes was sympathetic to many leftist causes and to the kinds of concerns discussed at gatherings sponsored by the CP. In 1949, for example, she acted in a few plays put on by the W. E. B. Du Bois Theater Guild, a group of amateur thespians that the FBI was secretly following. One of the plays was Clifford Odets's *Waiting for Lefty* about union strife, a subject that appears occasionally in her cartoons. People who appeared at such meetings and events sponsored by groups deemed suspicious by the FBI, as Ormes sometimes did, were targeted for questioning, casting doubt on their patriotism and often losing them friends and sometimes jobs. Hoover's list of potential subversives put Ormes in excellent company: her complete dossier stands at 287 pages, surpassing baseball star Jackie Robinson's 131-page brief, but it is considerably outstripped by Eleanor Roosevelt's 3,371-page FBI file.[17] After Hoover's death in 1972, Communist-hunting methods such as these were discredited.

Today these documents are viewed with skepticism. But the information collected in Ormes's FBI file nevertheless helps to fill in an outline of her intellectual life and suggests how progressive ideas informed her cartoons. A few examples serve to show that trajectory. Late in 1945 and only weeks into her work for the *Courier*, Ormes's first politically pointed cartoons have five-year-old Patty-Jo expounding on the dangers of fascism, nonunion scabs, and exclusive racially

Jackie Ormes

segregated clubs. By 1948, when Patty-Jo's misguided pal Benjie was "pulling Wings offa flies . . . Left Ones," Ormes was first reported as having been seen attending a lecture by a member of the CP held at a bookstore. In 1951 she concocted a substantial caption for a Patty-Jo panel about the FBI hounding Bootsie, a cartoon character created by Oliver Harrington, who was having his own troubles with the government agency. In other cartoons, Patty-Jo regales readers about their rights of free speech, by implication attacking the HUAC; and in one panel Patty-Jo denounces the HUAC more directly when she criticizes the "Hollywood witch hunts." Around this time Ormes probably became aware that the FBI was interested in her activities, and by 1952 the bureau began to approach her for interviews. Curiously, the FBI file mentions nothing about her cartoons and, in fact, never refers to her artwork.

Ormes's newspaper cartooning days wound to an end in 1956 with a few last zingers, cartoons depicting Patty-Jo supporting the bus boycott in Montgomery, Alabama. In the ensuing years, she distanced herself from CP members and activities. When all the FBI could come up with to scrutinize in Ormes's life was her assistance with hosting a troupe of the Moiseyev Dancers who were visiting from the Soviet Union, they gave up tracking her and closed her file in 1958. But her political activism remained undiminished, as she donated to legal defense funds in free speech cases and organized events for peace movements.

In spite of the possibility that the FBI might use her art against her, and at considerable risk to her privacy, Ormes continued to express her outrage at foreign and domestic policy, racism, and class bigotry. Had the FBI scrutinized the cartoons, their strongly polemical messages alone may have spurred investigation. *Patty-Jo 'n' Ginger* and the last year of *Torchy in Heartbeats* especially communicate such messages in gag and story lines that now seem forward looking, such as arguing for equal education and environmental activism. Other cartoons boldly criticize U.S. weapons programs, American military adventurism, and government encroachment on privacy and on freedom of speech.

In her community, Ormes worked for social change through the constitutional process, representing her ward on the nominating com-

mittee for the Progressive Party in 1950; according to her sister, by 1960 she voted Democrat.[18] Her many years of service in the 1960s and 1970s as precinct captain for general ward voting and Patty-Jo's entreaties in the cartoon as early as 1945 for readers to "VOTE!" further attest to her longstanding commitment to peaceful democratic change. Through the 1970s she continued to publicly commit her name and reputation to boards of art councils and to a community center named after Clarence Darrow—an attorney who defended liberal causes—as well as maintaining her friendships with persons of all persuasions.

BACK TO THE DRAWING BOARD

Before the cartooning started for real, however, in early 1945 Ormes was still stuck writing the obligatory women's column. That got her foot in the door at the *Defender*, and the occasional hard news reporting was exciting, but Ormes really longed to create cartoons. "I said, well that's fun, but I want to draw."[19] She practiced sketching funny takeoffs on everyday life, adapting to cartooning the formal art principles she learned at the Art Institute. She would no longer be responsible for social announcements in the paper; she prepared instead to present her own ideas and this time with her name, "Jackie Ormes," attached. She submitted examples of a cartoon idea to her editor. Zelda Mavin Jackson from Monongahela, Pennsylvania, declared herself a player: on March 24, 1945, *Candy* by Jackie Ormes made its debut on the editorial page of the *Defender*.

Candy was a single panel cartoon featuring an attractive house-maid cracking wise about her employer's chintzy economies and unpatriotic hoarding, all the while outwitting her by appropriating clothes from her closet. By placing the cartoon on the editorial page, the *Defender* likely intended readers to make a connection between inequities of black servitude in white households and inequities in other aspects of American society.[20] Evidently, soft-edged *Candy* was not the critical commentary that the *Defender* editorial page was looking for, or perhaps this creative venture did not satisfy her, because the cartoon ran only four months. Soon Jay Jackson's single panel reappeared in its place, with cartoons such as one titled "Who Said They Freed The South?" over a drawing of a white congressman with

Jackie Ormes

a whip in his hand and "Legislative Filibuster" written on his fat belly, looming over a black farm worker, with balls chained to his ankles labeled "poll tax," "lynching," and "low standard of living." Soon Ormes would confront race politics more directly, but with less apparent rage than was evidenced in many of the male cartoonists' efforts.

While doing occasional hard-news reporting and launching *Candy*, she simultaneously developed a pair of characters for another single panel cartoon and pitched this idea to her former employer and *Chicago Defender* rival, the *Pittsburgh Courier*. The new panel, *Patty-Jo 'n' Ginger*, began about a month after the last *Candy*. This time the wise-cracks issued from a five-year-old girl, Patty-Jo. Her big sister, Ginger, a physical reincarnation of *Candy*, never said a word; Ginger's role was to catch the reader's eye and to register astonishment at Patty-Jo's funny remarks.

Several readings are possible as to why Ormes left the *Defender*, taking *Patty-Jo 'n' Ginger* to the *Courier*. In the 1985 interview, she said, without rancor or apology, that she was not paid for her *Candy* cartoons. A possible interpretation is that she drew *Candy* on a trial basis. A payroll stub for $107.75 dated May 11, 1945, was about right for the seven-week Social Whirl column, though less than regular reporters' starting salary of about $70.00 a month for news beats. But no evidence of payment for the four-month run of *Candy* remains.

A comic strip by Elton C. Fax featuring a little girl, *Susabelle*, had run briefly in the early 1940s, but the *Defender* now preferred action and adventure, like the *Speed Jaxon* strip and a version of the *Bungleton Green* comic strips, and at the time that meant men artists. The likeliest scenario is that the *Courier* was ready to commit to a woman cartoonist who drew women and children. The *Courier* had trusted Ormes's reporting and had given free rein to her talents with *"Dixie to Harlem"* seven years before. Moving to the *Courier* might have been a risky career move for one who wished to build her reputation in Chicago. In fact, the *Courier*, in its fourteen editions around the country during these years, including a Chicago edition, enjoyed a greater overall circulation than the *Defender*. The move enhanced Ormes's national reputation and would open marketing opportunities for her Patty-Jo doll, which debuted two years later.

Of course the daily newspapers such as the *Chicago Tribune* offered

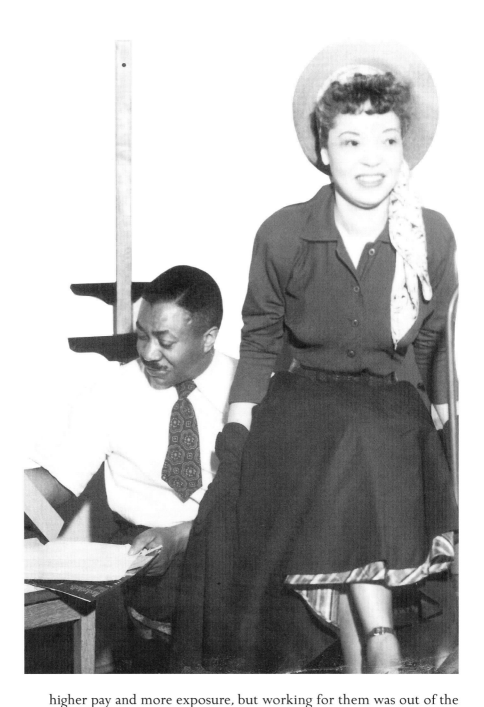

This publicity shot taken in a newspaper workroom in the 1950s includes an unidentified artist working on a piece titled "Basketball Bad Men." Fashionable Jackie Ormes wears three-quarter gloves, a jaunty hat, and ankle-strap shoes. *(Collection of Judie Miles.)*

Jackie Ormes

higher pay and more exposure, but working for them was out of the question, given the restrictive racial and sexual politics of the era. Her friend and fellow cartoonist Chester Commodore speculated that though she could have passed for white to apply for work with a mainstream paper, "Jackie wouldn't have done that. She was committed to the African American community and working for a white paper would have required her to draw white characters."[21] Even in the *New Yorker* magazine, historically a trendsetter for cartooning, black char-

acters appeared for years only in such guises as South Sea or African natives or Pullman sleeping car attendants. One especially interesting *New Yorker* cartoon bearing the signature "R. Taylor" from the early 1940s shows a pretty, partially nude and barefoot black woman seated alongside numerous fashionably dressed white women in the front office of a modeling agency, who says, "Practically all my calls come from 'National Geographic.'"

Knocking on the door of a newspaper art room, traditionally a man's domain, would have added to a woman's frustration. Furthermore, the grind of coming up with a cartoon every day for a mainstream paper, versus weekly for a black paper, was probably more than Ormes was able to handle. *Candy* had attracted the fashion world's attention, and now she needed time to take on more commercial art clients, fledgling models, style shows, and fashion design competitions. A new schedule of one cartoon a week in an independent contract fit perfectly into her life and other career interests. As described by her sister, working from her studio in her DuSable apartment, Ormes could mail the finished *Patty-Jo 'n' Ginger* cartoons to the *Courier* in plenty of time for publication and keep up with her Chicago businesses as well. Ormes's return to the *Courier* turned out to be a felicitous reunion: *Patty-Jo 'n' Ginger* lasted eleven years, Ormes's longest-lived comic creation.

Cartoon histories document the tough time that women cartoonists at mainstream newspapers had in being accepted by their male counterparts. When asked if men at the *Courier* objected to having a woman on the staff, Chester Commodore stifled a laugh, as if to say, "What's to object?" recalling Ormes's attractive appearance and personality, her talent, and her ability to meet deadlines. Commodore had been a mechanic for the railroad, cartooning in his off-hours. Thanks to a printer's strike and a friend's connection, in 1948 he began doing layout and advertising illustrations at the *Defender*. He had no formal art education and credits Ormes as a mentor. According to Commodore, Ormes advised him on how to improve his strip by adding more narrative interest. "You need to have an ongoing story," she told him, "and make it really funny." Within a few years, Commodore became a leading staff cartoonist at the *Defender*.

Women like Dale Messick, who drew *Brenda Starr, Reporter*, and

Tarpe Mills, who made the *Miss Fury* strip, changed their given names to names of ambiguous gender in order to be accepted.[22] Hilda Terry, who drew the popular *Teena* strip, was the first woman to apply for membership in the National Cartoonists Society. The male members rejected her several years running, protesting that they wouldn't be able to swear anymore at their meetings if a woman were present. In 1950 she was finally voted in.

But salary was another matter. Although she appeared to have started at parity with the men, both her sister, Delores, and Chester Commodore recalled that later she would not reach the higher salaries of the male cartoonists. Delores explained that her pay never figured in her employment decisions: "It was not about money because Earl always had good jobs." The *Courier* may have paid men more since some of them were general staff cartoonists hired to make other drawings besides their regular strip or panel, an arrangement Ormes did not have. Jay Jackson was one of these staff cartoonists and frequently drew editorial and other cartoons as well as the long-running *Bungleton Green* strips. This arrangement didn't bother Ormes; according to her sister, she was eager to draw and write gags for *Patty-Jo 'n' Ginger* and happy to have the opportunity to do so in a medium that reached a large audience. Much later, in a memoir for a 1978 doll club program, Ormes rather cryptically explained that *Torchy in Heartbeats* came to an end while other comics continued because "It was strictly a man's world!"—alluding perhaps to a rejection of her girl-inflected romantic story line or to the presence of a woman cartoonist on the funny papers pages.

Zelda J. Ormes's business card, about 1945. She was a member of the American Newspaper Guild, an American Federation of Labor (AFL)–affiliated union that represented editorial workers. *(Collection of the DuSable Museum of African American History, Chicago.)*

Jackie Ormes

About the time she started *Patty-Jo 'n' Ginger* in 1945, she set up a "Jackie Ormes Features" enterprise with a little studio niche in the Ormes apartment and printed business cards that advertised "Cartoons—Gags." Since commercial artists rarely sign their work, it is more difficult to identify her commercial art production. One signed piece has been found, a March 8, 1947, *Courier* ad for Best Yet Hair Products showing her flair for fashion while tapping into the popular imagination with a reference to the novelty tune "Open the Door, Richard" currently being played on the radio.

Days before *Patty-Jo 'n' Ginger* first appeared in the *Courier* on September 1, 1945, the United States had dropped two atomic bombs, and

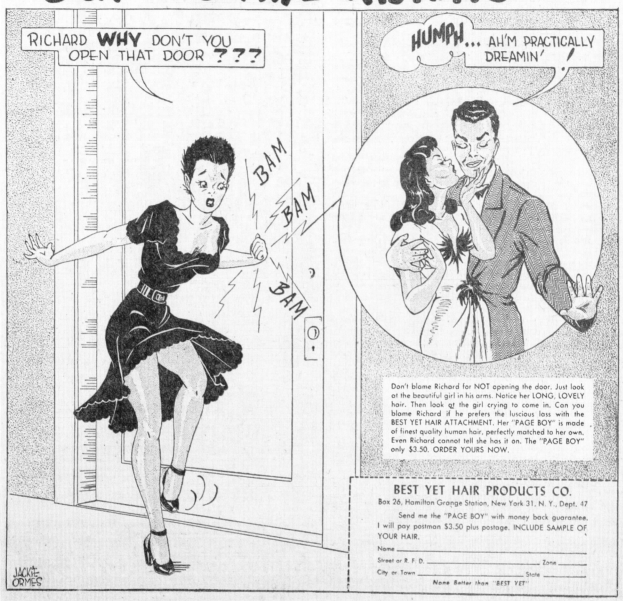

Ormes designed a few pieces of commercial art while drawing *Patty-Jo 'n' Ginger* and working on the doll idea. "Open the Door, Richard" was a catchy song made popular by Count Basie in 1947. Hair-straightening products, wigs, and hair attachments such as advertised here were essential for good grooming, according to the fashion dictates of the time. The ad appeared in the March 8, 1947, *Pittsburgh Courier*.

Japan signed its surrender the same week that the first panel appeared. As Coulton Waugh observed in his 1947 book, *The Comics*, right about this time marketing figures indicated that more than anything readers wanted to laugh.

[T]here is a much better market for gag strips these days, as is shown by a glance over the make-up of the New York comic pages since V-Day. The *Journal-American* Saturday comic sections as of May, 1946, show a roster of twenty-one comics. Of these only three are straight adventure, and three are fantastic adventure; the remaining fifteen are all based on laughs.[23]

In the inaugural cartoon, Patty-Jo provides some comic relief when she predicts the competition that Ginger's tightwad boyfriend will have now that the war is over. The first year wound up establishing Patty-Jo as an irrepressible, adorable smart aleck and Ginger as a fashion icon for women and for men the kind of pinup they had hung next to their bunks while in the military. In January Ormes confirmed her ownership by adding "Copyright Jackie Ormes Features" and the date to the bottom of each panel. She described in a 1947 interview how she did all her drawing and writing herself: "I write my own gag lines. I tried buying gags but they never seemed to fit." Situating her work in the larger media world, she told the interviewer, "Women cartoonists are not so rare as you think." Other women cartoonists of the time included Dale Messick, whose *Brenda Starr, Reporter* appeared in the *Chicago Tribune*, and Mary Petty, a cartoonist for the *New Yorker*.[24] The interview goes on to report that "As the panel continued its appearance, the audience grew; it now reaches a total of 300,000 readers through the *Courier*, which found in a recent survey that *Patty-Jo 'n' Ginger* tops all its other features in reader popularity. Syndication brings the total to one million readers."[25]

Ormes in a pose reminiscent of her cartoon characters Candy, Ginger, and Torchy Brown. Friends and relatives have attested to the fact that some of her characters closely resembled her, down to their hairstyles and clothing. *(Collection of the DuSable Museum of African American History, Chicago.)*

Jackie Ormes

Syndication may not be the accurate term at this point in her career, since Ormes produced *Patty-Jo 'n' Ginger* exclusively for the *Courier*. But because the cartoon ran in fourteen different city editions of the *Courier*, it was indeed read from coast to coast. One of the most commonly found editions in microfilm is the National Edition; other editions, like the Texas Edition, covered large regional areas. All editions ran much the same national and international news, editorials, and sports, but local news, social news, and ads differed from city to city. In 1949 the *Courier* boasted of fourteen editions, including St. Louis, Louisiana, Florida, Pacific Coast, New York "Seaboard," Washington, Philadelphia, Midwest, Ohio State, Cleveland, Cincinnati, Detroit, and Chicago as well as the City Edition (Pittsburgh).

Earl Ormes; an unidentified woman; Jackie Ormes; her sister, Delores; and Delores's husband, Murray Marvin, in an undated newspaper clipping found in Ormes's keepsakes. After Murray passed away, Delores married Henry Towles. *(Collection of the DuSable Museum of African American History, Chicago.)*

The *Courier*'s readership topped that of any other African American newspaper at the time and claimed to include a million people. Arriving in a subscriber's mailbox, delivered by a paper boy or a local *Courier* agent, or purchased at a big-city newsstand, the *Courier* would be passed from hand to hand and home to home, with people sometimes walking miles to borrow a friend's paper. Customers chose a two-year rate of $10.00 or six months for $3.50. "Ten Cents and Worth It!" crowed the masthead, and its subscribers often got more than their money's worth because the papers were so widely shared.

The mid- to late 1940s turned out to be the black press's heyday, and Ormes joined its ranks at a propitious moment. In 1947 the *Courier*'s circulation figure was 286,686 compared to 161,253 for the *Defender*; the *New York Amsterdam News* came in third at 111,427. The next year, circulation for the *Courier* climbed to its peak of 358,000. When the civil rights struggle of the 1950s brought expanded opportunities for black journalists, news coverage in the mainstream press began to better

The Chicago Years

represent African Americans' interests, and many readers turned to those dailies. At the same time, more and more roofs began to sprout television antennas, signaling a sea change in the habits of the reading public. By 1955 the *Courier*'s circulation dropped to 159,238, with the other black weeklies witnessing similar downturns in circulation.[26]

It was not unusual for women to represent their own physical likeness in their cartoons, as Tarpe Mills (*Miss Fury*) and Gladys Parker (*Mopsy*) did throughout their careers and as Ormes did in her rendering of the early and later Torchy Brown and also of Ginger in the *Patty-Jo 'n' Ginger* series. Her sister, Delores, confirmed that Ormes modeled both characters after herself, remembering with a laugh, "I think Jackie wished she was like Ginger and Torchy, Jackie and her perfect self." At five feet one inch, the diminutive artist had added inches to her characters to achieve their leggy stature, but the faces and hairstyles were recognizably Ormes's. She projected her own personality into the character of Patty-Jo as well, speaking in the language of a little girl but representing the ideas of an adult. And how she talks! Her comments, humor, and opinions are decidedly Ormes's, expounding, for instance, on taxes, labor strikes, McCarthyism, and the vagaries of abstract art, as well as fashions and relations between the sexes.

Ormes's verbal and visual depictions served as recognizable, coded messages that encouraged racial uplift. Intelligent, capable characters such as Torchy and Patty-Jo provided the same kind of models for self-improvement that were regularly communicated in other pages of the black press. The *Courier*'s news pages often featured articles about individuals who had risen from humble beginnings to success, and editorial pages regaled readers with instructive pieces on such topics as the virtues of thrift, ambition, and sacrifice. Meanwhile, the social pages ran photos of well-dressed people traveling the world or volunteering for good causes. In the same way, Ormes's characters demonstrated competence, astute insights, and, at times, extraordinary achievement, in contrast to the images of blacks in the mainstream media, where buffoonery and clueless victimization were the all-too-frequent stereotypes. Her characters' up-to-the-minute fashions, stylish home decor, and leisure lifestyles artfully extended the *Courier*'s agenda of promoting racial uplift, equating material affluence with respectability and social advancement. *Patty-Jo 'n'*

Ginger also depicted such things as music lessons, school graduation events, and leisurely summer vacations, family activities that reflected Ormes's own class status, sending the message that these aspects of the good life were attainable by everyone. *Patty-Jo 'n' Ginger* also made clear that it was imperative that one challenge inequities in the system, demand redress, and strive for better conditions.

Some readers could identify perfectly with a high standard of living, because according to her sister, Delores,

> We all had been struggling to do that because whites always had a stereotyped notion of what blacks are like, and they were wrong, because they weren't familiar with their lives. The only people they knew were servants, you know, maids, and people who were in post offices. They didn't know anything about doctors and lawyers, and professional people, that's not what we were supposed to be. Once a white person, a writer, tried to describe Jackie's life and made up a story, she had her eating watermelon and pork chops. [laughs] She never met anybody like me who was married to a lawyer. She was in awe of it, like I was some kind of a freak.

Certainly whites would have gained much understanding about African Americans had they read the *Courier*'s comic pages. In the late 1940s, Ormes's single panel was accompanied by four or five comic strips that changed from time to time and another single panel cartoon. The other cartoons and comics represented a cross-section of more or less realistic lifestyles, including wholesome family situations and adventure. All were located in the middle of the newspaper, creating a true "funny papers" page. Black cartoonists sometimes played the stereotyped Negro image for laughs. They might show, for instance, a fat cook with saggy breasts in a dowdy dress, rolling her eyes at her elegantly dressed black mistress while speaking in broken dialect. In contrast, *Patty-Jo 'n' Ginger* never used such caricature, always presenting a beautiful black woman and her upbeat little sister in sophisticated settings.

As the cartoon grew in popularity, Ormes created the Patty-Jo doll to promote her Patty-Jo character further. She explained in an interview in a toy industry trade journal that black children needed models of self-esteem in their play objects, and she described how a Patty-Jo doll

might fill this role. The writer explained that "Her concept of the doll from the very beginning laid stress upon certain criteria which at times seemed almost unattainable. Patty-Jo must first of all be a Negro doll of which Negroes could truly be proud and proud to own."²⁷ Manufacturing the doll herself was impossible. Ormes recalled: "Soon I was to learn the hard facts of the toy business, such as undercuts, permanent molds, and production cost!" She held strong to her vision for the doll and was not willing to settle for anything less than a high-quality Patty-Jo. After a few unsuitable and some ludicrous offers of shoddy production from some doll companies (including one from a man who wanted to buy the Patty-Jo name and make whatever doll he dreamed up), she finally connected with Violet Gradwohl, owner of the Terri Lee doll company in Lincoln, Nebraska.

Terri Lee was the name of the doll as well as the company. They were newcomers in the toy world and had already established a reputation for dolls of uncompromising quality, with clothing made from the finest materials and with the best dressmaking skills. Soon after they started in 1946, Terri Lee expanded their line of white dolls with the black dolls Bonnie Lou and Benjie, but sales were not going as well as hoped. Gradwohl's bold investment in a sensational new material, plastic, had put them in a positive state of mind but also in the red, according to doll historian Peggy Wiedman Casper. Ormes traveled on the train to Lincoln with the clay model in a shoebox beside her and copies of her *Patty-Jo 'n' Ginger* cartoons. Gradwohl was convinced of Patty-Jo's potential in an untapped market, and Ormes found that here was the quality—and the fashions—she sought. In late August 1947 she signed a contract with the company, agreeing to give the name Patty-Jo to Terri Lee's black girl doll and to paint some of the doll faces herself.²⁸

With her signature high-arched eyebrows and side-glancing eyes, Patty-Jo remains today the only comic character doll whose face was painted by the cartoon artist or by factory artists directly trained by her. Meanwhile, the cartoon running weekly in the *Courier*'s pages built anticipation for the new doll, with a ubiquitous piggy bank labeled "Doll Bank" and Patty-Jo dropping hints, like knitting baby clothes while saying, "Have you FORGOTTEN, Sis? I'm expecting a 'little stranger'—an' I hope it's GROSS-TUPLETS!"

This mutually beneficial arrangement between Jackie Ormes and the Terri Lee company was not to last, however. What looked like a match made in heaven ended in December 1949 when the contract's expiration date came and went, without apparent interest on either side to renew. Perhaps Ormes may have experienced problems with the doll company or Gradwohl may have been disappointed with the sales of the Patty-Jo doll. In a letter found in her memorabilia in the DuSable Museum of African American History in Chicago, *Ebony* magazine informed Ormes that they were pressing a lawsuit against the Terri Lee company, ostensibly for nonpayment of advertising bills, and historian Casper has called several of Gradwohl's business practices into question.[29] Not one to broadcast her problems, Ormes may have simply walked away from what must have been a bad business deal. But her passion for dolls lasted throughout her life. She drew paper dolls called Torchy Togs to accompany her *Torchy in Heartbeats* comic strip; made one-of-a-kind cloth dolls and paintings of dolls; collected antique and modern dolls; and kept up an active membership in Guys and Gals Funtastique, a Chicago club, as well as the United Federation of Doll Clubs, a national organization.

In 1950 the *Courier* announced plans for a "Kiddie Page." The children's page idea evolved into a magazine section supplement and an accompanying eight-page color comic section insert, like those in many mainstream papers. Full-page ads built excitement for the comic section that would include Ormes's new strip, *Torchy Brown Heartbeats*, which she would soon change to *Torchy in Heartbeats*. On August 12, 1950, a week before the strip started, a headline declared that "Torchy Brown Will Be Big Hit In Courier" over a photo of Ormes drawing the new comic strip.

> Now—in the new Courier—Jackie Ormes brings you again "Torchy Brown" with all her buoyant freshness and color. You're going to like "Torchy" with the richness of her adventures as a typical American girl, filled to the brim with the ideals that surround the best in American womanhood.

A drawing shows Torchy staring boldly, perched on platform shoes, hands on hips, in a high-fashion gown that clings revealingly to her

hourglass figure. Soon thereafter Ormes toned down the image to look more like herself, at the same time bringing her new Torchy more in line with the *Courier*'s concept of a family newspaper. While the *Courier* sometimes ran a photo of a bathing beauty on the front page of the newspaper and in the magazine section, to draw a female comic strip character in a suggestive posture was out of bounds. (Beefcake eye candy was a long time coming in the *Courier*, arriving in the splendid figure of athlete and soon-to-be movie actor Woody Strode in a 1955 photo.)

The new Torchy was a mature young career woman who would develop a social conscience, little resembling 1937's madcap teen Torchy. Like the love stories found in pulp fiction that was popular at the time, *Torchy in Heartbeats* tells of an independent woman's romances and adventures in suspenseful story lines. Continued from week to week and in a full-color strip, Torchy's dramatic adventures are quite different from the humorous black-and-white *Patty-Jo 'n' Ginger* cartoons running at the same time. Paper dolls with high-fashion clothing ensembles to cut out, titled *Torchy Togs,* often ran under the comic strip. Cartoonists had long been successful in promoting their comic strips this way, like Ethel Hays's paper dolls in her single panel cartoon *Flapper Fanny* in the 1920s; Russell Westover's long-running *Tillie the Toiler* from 1921 to 1959; Dale Messick's *Brenda Starr, Reporter,* starting in 1940; Gladys Parker's *Mopsy,* which began in 1941; and Bill Woggon's *Katy Keene* in MLJ/Archie comic books from 1945. By the fall of 1951, the *Courier* apologetically announced that the going price of fifteen cents a copy would rise to twenty. Their color comic section, including "Torchy Brown Heartbeats—a national favorite," as well as the magazine section, expanded news pages, and a decline in circulation, had apparently begun to squeeze their resources.

Torchy in Heartbeats, with story lines that dealt with issues of race, gender, and the environment, among other things, was clearly ahead of its time in 1953. This year, while other characters in the comic section confronted aliens from outer space or battled bad guys in the Wild West, Torchy exhorted her boyfriend, "Young Dr. Paul Hammond," to search for clues to a real-world disease he suspected was caused by environmental pollution. When prejudice thwarted Hammond's search, Torchy denounced the perpetrator, a bigoted white

industrialist, and then called for reconciliation between the races. This merging of political statement with melodramatic romance ran only one year, in the last of the Torchy strips, but so impressed cartoon historians with its forward-looking insights that reviews of her work give special credit to these themes of social conscience.[30] Ormes's pioneering crusade in *Torchy in Heartbeats* predated by nine years *Silent Spring*, Rachel Carson's exposé of the misuse of DDT and its effects on bird and animal life that alarmed the nation and led to the start of remedial legislation. And according to environmental sociologist Robert D. Bullard, it was not until the early 1980s that "Blacks . . . began to treat their struggle for environmental equity as a struggle against institutionalized racism and an extension of the quest for social justice."[31]

From 1950 to 1954 Ormes drew both *Patty-Jo 'n' Ginger* and *Torchy in Heartbeats,* keeping up what must have been a strenuous pace. The same injustices of prejudice and deprivation voiced by fictional Torchy were meanwhile all too present in Ormes's real world. Not one to march in protest, sit in, or personally challenge Jim Crow, she instead capitalized on her fame. Dozens of times her name appears in the *Defender*'s social pages describing her volunteer work to raise money for community improvements, civil rights causes, and peace activism.

Glimpses of her life and activities are found in documents, clippings, souvenirs, programs, and a few letters and photos in an archive of her memorabilia in the DuSable Museum, which serve as mementos of her many civic contributions and friendships. These were the memories Jackie Ormes kept always.

Many of the archival materials were fashion show programs from shows that Ormes chaired primarily during the 1950s. The Urbanaides was "a group of career women who organized for the specific task of raising funds for the Urban League . . . [which] deals with the most se-

Jackie Ormes and Duke Ellington in the mid-1950s at a party honoring Ellington. Her stature in the community brought her into contact with many luminaries as they passed through town, as did her husband's position as manager of the upscale Sutherland Hotel, one of the premier hotels for African Americans in the era of segregation. *(Courtesy of Delores Towles.)*

The Chicago Years

The singer Eartha Kitt was another celebrity friend of Ormes's, shown here at the same mid-1950s party. The man is unidentified. *(Courtesy of Delores Towles.)*

rious race based problems of housing, jobs, discrimination in health, schools, and race violence." Immersed in fashion, a favorite interest, and teamed with best friends who called themselves "The Chums," Ormes served as president and also created such programs as "A Crest of Fashion Through a Mermaid's Eye"; "Calypso Holiday"; and, playing on current news surrounding the superpowers' space race, "Beautnik—A Spinning Orbit of Fashion." She brought in entertainers such as musician Billy Eckstine, a friend of the Ormeses from their Pittsburgh days, and singer Sarah Vaughn, whom they knew as a guest at the Sutherland, making the affairs a highlight on the social set's calendar. By now Ormes was known as an arbiter of good taste; her cartoons and her Jackie Ormes Features business, which included training fashion models, had earned her the necessary credentials as a style setter.

Ormes's commitments extended equally to friends in high society as to those who were outspoken political activists. As historian E. Frances White explains, "a politically active woman was consonant with

Jackie Ormes

a respectable black woman; it was her duty to uplift the race."[32] The letters, programs, and papers among Ormes's souvenirs testify to her loyalty to many diverse groups. Along with her keepsakes of fashion show programs and gala parties are mementoes of her political activities, including a 1950 letter from the great baritone Paul Robeson asking for contributions to publish writings by John Howard Lawson, a screenwriter imprisoned for refusing to name names to the HUAC.

Torchy in Heartbeats wound to an end in 1954 when Torchy married young Dr. Hammond, leaving fans of the lovelorn on their own. The story in the 1985 interview was that "In 1955 John Sengstacke (the owner of the *Defender*) bought the *Pittsburgh Courier* and stripped away its comic section, among other things." But, in fact, Ormes misremembered these events. Many of the other comic strips continued in the *Courier*'s magazine section for several years longer; and Sengstacke actually purchased the newspaper in 1966, after which time the renamed *New Pittsburgh Courier* continued to carry other strips and panels. It's possible that Ormes gave the reporter this version of events because it was a less painful way to relate Torchy's ending; then again, in recalling a thirty-year-old history to the reporter, she may simply have gotten things mixed up. In another account in the same interview, she remembered approaching the daily newspapers for a possible new strip after *Torchy in Heartbeats* ended: "Jackie took clips of 'Torchy' and the humorous 'Patty-Jo 'n' Ginger' over to the *Tribune*. 'They sat down and just howled,' she remembers. 'We had a ball. Then I found out that the *Tribune* had a stable of seven people to turn out each cartoon. That's ridiculous. No one person did any of it. I said, oh dear, I can't handle that. I think there's no use asking for something you can't handle.'"[33]

Soon *Patty-Jo 'n' Ginger* seemed to be winding down. It showed up sporadically in the *Courier*, sometimes recycling old gags from previous Ormes cartoons, with familiar drawings that looked hastily composed. No one can remember exactly why Jackie Ormes stopped drawing, but Chester Commodore ventured the possibility that cartoonists' fatigue was a factor. "All that erasing is hard on the hands," he explained. "You erase your pencil sketches over and over. After a time, it wears you out. And coming up with the ideas . . . you just get tired." Indeed, her hands were beginning to stiffen and ache in the mornings, presag-

The Chicago Years

ing the rheumatoid arthritis that would eventually cripple her. Intellectual exhaustion was probably also a factor. The pressure of finding a new idea each week and turning it into a humorous one-line gag was constant mental exercise, like writing a comedy haiku every week. On September 22, 1956, after eleven years, *Patty-Jo 'n' Ginger* appeared for the last time.

During her cartooning heyday in the early 1950s, Ormes established herself in Chicago as an emblem of community spirit and political savvy. The many mentions and photos of her in the *Defender* attest to the newsworthiness of her social life, for instance, Ormes modeling French designer gloves at a charity event; dining at the Liberian consul's table at a consular banquet; or judging the revelers' costumes at the Beaux Arts fund-raiser ball, herself dressed as a harlequin. Appearances at charity functions, sometimes with a Patty-Jo doll that she might donate to the cause, were the highlights of school, church, and Red Cross fund-raisers, according to thank-you letters in the DuSable Museum archive. Organizers of high school "career days" would ask her to speak on panels, and she answered letters from people inquiring about how to become an artist. She worked hard for the March of Dimes, kicking off the campaign every January with a plea for contributions in *Patty-Jo 'n' Ginger,* sometimes with poignant drawings of Patty-Jo's friends on crutches or in wheelchairs. By the time she put down her cartoonist's pencil for good, she had earned prestige, admiration, and a celebrity reputation.

One acknowledgment of her stature especially stands out. A 1953 *Defender* news article reports that Jackie Ormes was one of several women featured in *Women in the News,* a newsreel movie short distributed by All-American News, a production company that served theaters nationwide in urban neighborhoods and rural localities with significant black populations. In addition, a film that includes Ormes as one of its African Americans of achievement has been found, *One Tenth of a Nation.* Although the *Defender* article does not cite the title as *One Tenth of a Nation,* it may actually be the same movie as *Women in the News.* In the film, Ormes is first seen at her drawing table, working on a *Torchy in Heartbeats* comic strip; then she appears holding her Patty-Jo doll, "the achievement Jackie Ormes is proudest of," according to the narrator. "Happiness is her trademark!"[34]

Along with the numerous Urbanaides programs in the DuSable Museum collection are materials from other benefits, like one for the Chicago Negro Chamber of Commerce, which thanked her in a letter: "the excellent fashion show you produced for our Chamboree— without expecting any compensation—we appreciate this 'labor of love' more than we can express." In the early 1960s, Ormes became a board member of the Chamber, and in the *Defender*'s business columns she was referred to as a "business woman." Ormes furnished a troupe of African American models for the Dress Design Department of the School of the Art Institute of Chicago in 1957. Though she was too petite herself to model professionally, she often modeled as a volunteer for fund-raiser fashion shows. Her small foot made for appealing ads in Chicago newspapers, a few of which she kept. As late as 1966 shoe companies were still sending her samples, and Delores said that her sister's closet was full of shoes given to her by the stores she posed for since, like Cinderella, no one else could wear her dainty size 5 shoes.

An amusingly gossipy letter dated 1957 is from her friend Serrell Hillman, an editor at *Time* magazine, who apparently knew she would enjoy some tidbits. It seems that he and their mutual friends Quentin Reynolds and Althea Gibson and Gibson's coach all went to hear Oscar Peterson play.[35] Gibson was "for once in a gay mood," he wrote, implying that the tennis star was more typically out of sorts. Apparently referring to the upcoming congressional elections, Hillman sent another letter the next year reminding Ormes that "the campaigns are heating up and we talked about you doing some freelance writing, reporting, etc. When do you think you'll come east again?" Ormes was forty-seven at the time, and there is no evidence she picked up on Hillman's proposal for an ambitious reinventing of her newspaper career. But she still enjoyed grassroots political work. "It was my pleasure to be present at a Kaffee-Klatch sponsored by you," wrote one state congressman in a 1958 thank-you letter to Ormes, and another letter in 1964 thanks her for continuing to serve as judge of elections for her precinct. Jackie and Earl were still on liberal political mailing lists as late as 1971, when this request for a donation arrived: "Dear Friend—we must take steps to guarantee the freedom of Angela Davis—her fight is our fight. Angela Davis Defense Committee."[36] During this time also she coordinated the

The Chicago Years

49

Long after her cartooning days were over, Ormes brought back the character of Patty-Jo, this time on a T-shirt she designed and sold by mail in the late 1970s. The "H'Lo!" idea came from the *Patty-Jo 'n' Ginger* cartoon and had been used in a 1948 *Ebony* magazine ad for the Patty-Jo doll, whose face, hair, and skin color were of her design. *(Collection of Gayle E. Ormes Hawthorne.)*

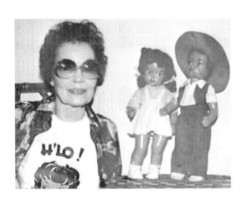

Ormes belonged to a doll collectors' club that adopted the Patty-Jo doll as a mascot. Members of the Guys and Gals Funtastique Doll Club wore T-shirts to some events, as Ormes did here. She obliged the men in the group by designing Benjie T-shirts as well, although she was not involved in the creation or sale of the Benjie doll. *(Courtesy of Delores Towles.)*

Jackie Ormes

Midwest Artists For Peace, a group of more than a hundred people who took out ads protesting the Vietnam War.

For over fifteen years Ormes served on the board of directors of the Clarence Darrow Community Center, a facility that provided recreation, education, and counseling for residents of Chicago's Leclair Courts Housing Project and the surrounding area. Helping to raise funds and to advise on policy was no small task: in 1962 alone, the center served over twenty-five thousand children, teens, and adults. Self-appointed ombudsman Studs Terkel and comedian Dick Gregory were also board members. There is a photo of Ormes drawing a portrait of Darrow to donate for a fund-raising event. Indeed, art and culture were always the major touchstone of her volunteer work. Another clipping recounts an appearance by "Jackie Ormes, panel participant," who was to give an address titled "Plight of the Negro Artist: Our Search for the Lost Image" at the 1963 Chicago conference "The Promise of a Second Black Renaissance."

Though no record survives as to which plays may have influenced her, Ormes had once credited the theater as one inspiration for her cartoon characters, and she returned that favor in 1969 when she helped initiate the Joseph Jefferson Fellowship Awards for participants in Chicago-area theater, serving on its steering committee for years. The "Jeff Awards" for excellence in Equity theater continue to this day. But her philanthropic work was not strictly limited to support of the arts. Starting with the first *Patty-Jo 'n' Ginger* cartoon for the March of Dimes in 1947, Ormes served this foundation for nearly twenty more years. March of Dimes rosters, mailing lists, and letters in the DuSable Museum archive trace her service as regional chairman in the 1960s and 1970s when she coordinated door-to-door collections in an area of South Side Chicago.

In the early 1970s Ormes lent her support to the DuSable Museum, which had started ten years earlier in the home of Margaret Burroughs, her friend and a fellow artist. When the museum moved in 1973 to its present location, a landmark Beaux-Arts building in Washington Park on the South Side, she donated a Patty-Jo doll to its collection and also worked on fund-raising, which was so important to such an institution.

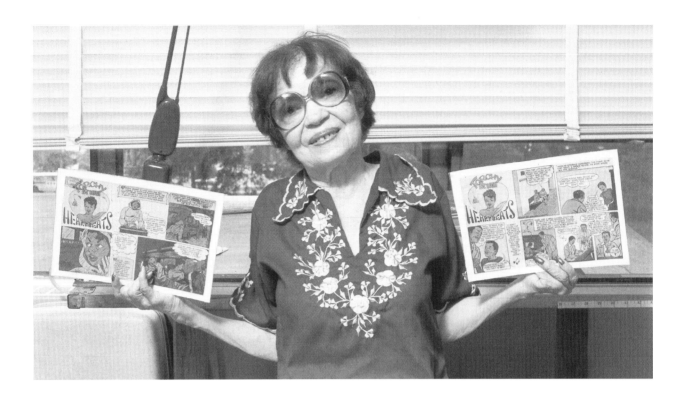

When Earl became manager for the Parkway Furniture Company in the Lake Meadows Shopping Center in 1957, the Ormeses took an apartment in the Lake Meadows complex. Here Ormes had room for her cats and parrot; plenty of wall space for her oil paintings; and a sun-filled window area for her art table, pens, and brushes. By the early 1970s, Earl returned to banking as an investigator for the Drexel National Bank. His many connections established at the Sutherland Hotel years before, as well as Jackie's own networking and community involvement, brought new opportunities for business and activism. Furniture buyers at Marshall Field's department store were always glad to hear from her when she called to broker sales from her own or friends' antique collections, according to Delores. Letters in the DuSable Museum archive attest to her occasionally painting portraits on commission, and making paintings of still lifes, African landscapes, portraits, and character studies for her own enjoyment.

After forty-five years of marriage, Earl's death in 1976 was a blow to Ormes. In 1980, Delores moved back to Chicago from Durham, North Carolina, where she had been residing since 1960, and the presence of her sister living nearby was a comfort to Ormes. By the 1960s, the crippling effects of rheumatoid arthritis that had made her joints stiff

The Chicago Years

and sore earlier could be seen in her hands. Years of maneuvering a pencil and ink pen and the pressure of rubbing with an eraser exacerbated the disease and took its toll. It became harder for Ormes to hold tools for drawing, but she could manage a brush, painting portraits for friends and for charity auctions. Delores remembers the increasing effects of arthritis: "When she visited us in the 1970s, she couldn't open the fingernail polish bottle, or reach down to paint her toenails, so I did this for her. No matter what, Jackie always kept up her appearance." Joint replacement surgery on her hands failed to achieve the hoped-for results. But she kept up her physical therapy and got through the day with the help of pills that lessened the pain.

Despite her health problems, Ormes traveled to Salem for the Cyrus-Ormes-Manzilla family reunions and never missed a doll club gathering if someone could drive her there. In 1984, she was invited as an honored guest at a doll club event in Lincoln, Nebraska. Attendees recalled her being tiny and frail but smilingly attentive and more than a little surprised that Patty-Jo had become such a sought-after acquisition by doll connoisseurs. Most who met her there recounted pleasant memories and described Ormes as "nice" or "sweet." But it's unlikely that any of those attending were familiar with her social protest cartoons, and they probably would have been surprised at the wit, sharp insights, and sometimes anger that lay beneath her cheerful surface.

Mustering her old spunk for the 1985 *Chicago Reader* interview, Ormes pulled out a scrapbook of cartoons with the photographer's help when opening the drawers where they were stored proved too difficult with her disabled hands. "I'm so surprised when people remember me," she told reporter David Jackson. Her delight at being rediscovered shows in the photographs that accompany the article. On Christmas Eve, while preparing for a party, Ormes suffered a cerebral hemorrhage. She died on December 26, 1985, and her remains were conveyed to Salem to be laid to rest with Earl's in the Ormes family plot in Hope Cemetery.

Chapter 3

NEWSPAPERS, COMIC STRIPS, CARTOONS

Newspaper comics began in America at the end of the nineteenth century, when publishers caught on to the idea that they could help sell papers. Engagingly odd characters depicted in implausible situations captured the public's affections and provided some entertainment along with the news of the day. The comics that emerged reflected the mood and events of the eras in which they were popular. Most cartoon historians agree that there were distinct thematic cycles in American comics in the decades from 1900 to 1960: turn-of-the-century domestic and kid comedy, stretching into the late 1910s; funny flappers and young independent women scenarios in the 1920s; heroes in action sagas in the 1930s; humor and adventure often mixed with a wartime theme in the 1940s; and poignant social, political, and psychological issues in the cold war era of the 1950s.

During these years, African Americans looking for news about their communities found it mainly in weekly Saturday newspapers. Today's attempts to provide inclusive newspaper coverage and well-stocked black studies sections in libraries were yet to materialize in America. "I shall be a crusader and an advocate, a herald and a spotlight, and I shall not falter," read the credo for the Negro press.[1] Black newspapers in America date to the early nineteenth century and have had a range of distinguished editor-publishers, including Marcus Garvey, Adam Clayton Powell Jr., Ida B. Wells, and Charlotta Bass. By the mid-1940s, the four largest black newspapers in the United States were the *Pittsburgh Courier;* the *Chicago Defender;* the *Afro-American,* headquartered in Baltimore and serving five eastern cities; and the *New York Amsterdam News,* serving New York from its offices in Harlem. Because it consisted mostly of weeklies, the black press did not mainly concern itself with providing up-to-date news; that job fell to daily newspapers and announcements on the radio. Shouldering the burden of "standing for something" in a world largely invested in preserving the

status quo, black newspapers often adopted a tone of advocacy and even militancy. If, for instance, the mainstream press reported gains for U.S. troops in Europe during World War II, the black press focused attention on racial discrimination in the military; when the dailies mentioned Thurgood Marshall in the general news, the black press spotlighted his achievements as NAACP leader and, later, his pioneering status as the first African American Supreme Court justice. Indeed, newspapers were one of the only weapons available at the time with which African Americans could fight racial prejudice and injustice. All was not solemn reportage, however. The black press also used the time-honored journalistic conventions of bombast, flamboyance, and puffery, which helped engage readers and increase circulation numbers.

Cartoons added wit and humor to the colorful mix of the black press in the middle of the twentieth century. But beyond their entertainment value, comics often carried messages of protest, satirizing unjust laws and social norms in ways that at times would have been risky for writers to take on in print. During times of national extremity, like the Depression, World War II, and the cold war, the black press's polemics were sometimes interpreted as seditious. Editors were threatened with prosecution and post office restrictions; and, at one time, limits were put on their ability to obtain paper for printing.[2] Although publishers and editors may have been occasionally intimidated into reining in their writers and columnists, satirical cartoonists like Jackie Ormes and Oliver Harrington carried on unbridled. One can suppose that editors saw these cartoons as a clever way to continue to criticize unjust and unfair laws and social policies, while dodging the government's oversight.

Whereas mainstream papers depended on syndicates to provide their cartoons, African American weeklies rarely used such out-of-house consortiums. One exception was the Smith-Mann Syndicate, a New York–based business that supplied the *Courier* with the color comic section that was published between 1950 and 1954.[3] Jackie Ormes had an independent contract with Smith-Mann for *Torchy in Heartbeats;* her other cartoons and comics in the regular news pages would have been made under separate agreements directly with the *Courier.*

High-circulation newspapers like the *Courier* and the *Defender* had

their own art departments responsible for general illustrations as well as comics. Cartoonists on the staff developed broad skills, drawing not only their trademark comic strips but also story illustrations, editorial cartoons, display advertisements, and other features. The effect was a spirited gazette whose content included recognizable styles, signatures, and characters.

When *Torchy Brown in "Dixie to Harlem"* was launched in 1937, Ormes was employed at the *Courier* as an assistant proofreader, not as a staff artist. She was very likely under separate contract for this strip alone, as she continued to draw the *"Dixie to Harlem"* feature for several months after she and Earl moved in with his family in Ohio. A seven-year break in her career followed, and when she resumed cartooning in 1945, her cartoons and comics were once again under independent contract. By this time Jackie and Earl had moved to Chicago, far from Pittsburgh and the *Courier*'s art departments, and this situation, if not the widespread gender discrimination of the postwar period, seems an obvious factor in her not being offered a full position with the *Courier*. "She was independent," as her friend and colleague Chester Commodore described her working relationship with the *Courier*, and her contracts were apparently on a year-to-year basis as evidenced by the starting and ending dates of her comics and cartoons. Nevertheless, Ormes's characters caught the imagination of the *Courier* editors and the public, and the paper continued to renew her contracts off and on for over a decade.

By all accounts, the premier African American newspaper cartoonist of the day was Oliver Wendell Harrington (1912–95). First appearing in May 1935 in the *Amsterdam News Magazine*, his *Dark Laughter* cartoon moved in later years to the *People's Voice* and finally in 1943 to the *Courier*. Educated at Yale, Harrington was assigned by the *Courier* to travel throughout America and Europe as a military correspondent during World War II. This opportunity to view widespread inequalities suffered by African American soldiers inspired him to "battle racism through his art, his writings, and an alter ego named Bootsie, his best-known character."[4] Bootsie was the main character in *Dark Laughter*, "a stout, bald and mustachioed man" who had a knack of walking into situations where "as often as not, he himself is the butt of the humor. Racism and conflict with the white community frequently serve

*Newspapers,
Comic Strips, Cartoons*

as the main topic, but much of the ridicule is directed at blacks them-
selves and the way they treat each other."[5] Because both Harrington's
working-class *Dark Laughter* and Ormes's upscale *Patty-Jo 'n' Ginger*
were single panel cartoons, they were usually made the same size and
placed together on the funnies page, providing interesting visual and
contextual contrasts. Bootsie might, for example, dodge a bill collec-
tor, while Ginger and Patty-Jo emerge from a movie palace, properly
dressed in the latest styles complete with fancy shoes and hats.

Bootsie never spoke, but other men and women in *Dark Laughter*
had plenty to say. On his front porch stoop or at his favorite watering
hole, they peppered him with advice or observations, his face humor-
ously registering the often complex psychological and political mean-
ing in their words. In a 1973 essay Harrington described the motiva-
tion for his comics' messages: "I personally feel that my art must be
involved, and the most profound involvement must be with the Black
liberation struggle."[6] His expressive faces, fully modeled bodies, de-
tailed settings, and virtuoso brushwork prompted one critic—only
half in jest—to compare Harrington's technique to those of Michelan-
gelo and Tintoretto.[7] Harrington is also known for his wartime action
strip in the *Courier, Jive Gray,* and for other independent cartoons that
ran in various newspapers until the mid-1960s. His political activity
drew criticism from the U.S. government during the cold war years,
and he relocated in Europe for a period of time to avoid harassment.

Although Ormes's cartoons were substantial in number, relatively
fewer of hers than Harrington's directly confronted racism; her politi-
cally oriented pieces more often targeted topics such as foreign and
domestic policy and the arms race. To be sure, Harrington touched on
those issues, but his emphasis was the effects of these situations and
policies on the black population. In one *Dark Laughter* cartoon deal-
ing with the Korean War, for instance, he criticized what he felt was
a disproportionate number of African American draftees by showing
black GIs wondering why so many in their foxhole looked like them.
But sociopolitical satire made up only a part of each cartoonist's total
output. Ormes's work more often focused on topics relating to domes-
tic situations, boyfriends, clothing styles, and human foibles than it
did on political topics; Harrington produced many nonpartisan com-
ics as well. Usually both cartoonists' panels were located in the middle

of the newspaper, on a true "funny papers" and features page, along with horoscopes, tips on winning at bridge, and letters from the paper's readers. Sometimes the necessities of page composition required their panels to be used to fill in vacant spots on other pages, as can be seen in the different makeup of various editions in different cities.

Derogatory images in the mainstream press—including the character Mushmouth in the *Moon Mullins* strip; the bumbling pair Amos and Andy, who appeared on radio and briefly in a comic strip; the white hero and black sidekick duo, such as Mandrake and Lothar in the *Mandrake the Magician* comic strip—have been exhaustively discussed elsewhere. One cartoon historian posits that some cartoonists may have taken their cues from a 1944 instruction manual, *How To Draw Funny Pictures:* "The colored people are good subjects for action pictures; they are natural born humorists and will often assume ridiculous attitudes or say side-splitting things with no apparent intention of being funny. The cartoonist usually plays on the colored man's love of loud clothes, watermelon, chicken, crap-shooting, fear of ghosts, etc."[8]

Perhaps the most significant cultural contribution of Ormes's various cartoons was her characters' unequivocal pride. At one time even some black cartoonists drew racial stereotypes for laughs, much the same way cartoonists of Irish and German stock had earlier used caricatures of their ethnic backgrounds. Sometimes readers took offense. Even Oliver Harrington's much-loved Bootsie, probably the best-known black comic character, occasionally came under fire, as this 1953 letter from a reader to the *Courier* indicates:

> To the Editor,
>
> I work in a Los Angeles County office and every week buy the Courier because you have splendid editorialists. My co-workers also read the paper, and not having any associations with colored people previously, they have developed a keen interest in our race generally, and followed a few cases particularly.
>
> They have put their feet in our shoes, figuratively speaking. They know we are trying to keep our standard high, resent belittling caricatures of our people, hence they were horrified when they saw this cartoon which is supposed to be funny.

They reasoned that we would be furious, and rightly so, if we saw it in a white paper.

We all believe the standard of the paper is too high to allow the blot of "Dark Laughter" to besmear it.

— Mrs. Hazel B. Prince, Pasadena, Calif.[9]

M. Thomas Inge's biography of Harrington quotes him brushing off such interpretations and suggesting that critics should lighten up and see the humor in everyday life.[10]

A 1945 Associated Negro Press wire service story headlined "Negro Villain In Comic Book Killed By Youngsters" suggests that some young people in New York understood the power of stereotype in a medium that catered to their age group.

Oldsters in their fight against racial prejudice might gain something from representatives of Youthbuilders, Inc., who last week persuaded Fawcett publications to drop the character, "Steamboat," from one of their favorite comic books, "Captain Marvel."

Pictured as an ape-like creature with all the coarse Negroid features, including a southern drawl, "Steamboat" usurped a great portion of the comic book as villain of the story. The strip was fine, the youngsters all agreed, but such a character will go far to break down all that anti-bias groups are trying to establish. The crusade began at Junior High School 120, Manhattan.

Taking up the matter at a meeting of the local chapter of Youthbuilders, Inc., a committee was appointed to call on William Lieberson, executive editor of comic books, Fawcett publications, who characterized the group as "born diplomats."

The kids had a snappy comeback for everything, he said. They pointed out that "Steamboat" was a Negro stereotype tending to magnify race prejudice, and when Lieberson told them that white characters too were depicted in all sorts of ways for the sake of humor, the Youthbuilders retorted that white characters were both heroes and villains while "Steamboat," a buffoon, was the only Negro in the strip.

Lieberson was completely won over when one boy produced an enlarged portrait of "Steamboat" and said, "This is not the Negro race, but your one-and-a-half million readers will think it so."[11]

Jackie Ormes

Just as offensive as the use of ethnic stereotypes in cartoons was

the near absence of realistic black people as characters. Novelist John Updike noted that for decades even the *New Yorker* magazine failed to include black characters in its usually hip and socially aware cartoons. Of the *New Yorker* era from 1955 to 1964, he commented, "The foremost domestic issue of the time was the struggle of the black minority for civil rights, yet people of color are almost totally absent from these cartoons, except for a joke showing an anxious drugstore clerk facing a diverse mob of customers and calling out, 'Joe, these people say they want flesh-colored Band-Aids!'"[12]

Fortunately, newspapers seemed to be more responsive than sophisticated magazines were to issues of inclusion. As the civil rights struggles of the 1950s raised the consciousness—and changed the laws—of the nation, newspaper comics, both in the mainstream and in the black press, changed as well. A few black artists began cartooning for the dailies by the mid-1960s and brought their realistic black characters along with them, like Morrie Turner in *Wee Pals* and Brumsic Brandon Jr. in *Luther*.[13] Established comic artists including Charles Schulz introduced brown-skinned characters, such as Franklin, who began to appear in Schulz's *Peanuts* strip. As ads for hair straighteners and skin lighteners began to disappear from black newspapers in the middle of the 1950s, more characters in their comics were increasingly depicted as attractive, intelligent, sophisticated, and capable, just as all of Ormes's characters had been two decades earlier.

The pioneering professional woman who became the first female cartoonist in the male-dominated African American newspaper industry would largely situate her heroines in conventional career roles. Candy is employed as a maid; Ginger's occupation seems to be looking after Patty-Jo; and the later Torchy, who took training as a nurse's aide, is not so much professionally committed to nursing as she is devoted to a cause and to her doctor boyfriend. (The 1937–38 Torchy is an exception; first presented as a madcap teenager determined to find fun and fame, she ultimately rises to celebrity status in the competitive world of nightclub entertainment.) These depictions reflect an era when relatively few career paths were available to women, especially to African American women. In the context of the realities and attitudes of the day, giving a starring role to a maid such as Candy would serve to pay tribute to the dignity, intel-

ligence, and strength of these working women. And within their specific work situations, whatever they were, Ormes's characters were eye-catching figures imaginatively bestowed with sartorial riches. The attractively dressed and coifed women in her cartoons helped build Ormes's career outside of her work for the *Courier*, expanding her activities in the fashion show, commercial art, and model training businesses. Among the items in her archive are many clippings and photos of herself used for promotional purposes. When asked about her aesthetic and thematic choices, her friend and colleague Chester Commodore admired her shrewd business sense: "Jackie knew where her bread was buttered."

Newspaper comics were immensely popular, good for business, and very likely read with greater regularity than the editorial pages.[14] By the end of World War II, artists in mainstream papers worked primarily for distribution syndicates, and this wide national circulation provided them with good salaries and a production workshop. Large syndicates like those of the Hearst or Pulitzer newspapers marketed features to hundreds of subscribing papers for them to publish under their own banner. These syndicates' control of comic strips sometimes became a disadvantage for artists when the syndicates decided to exercise rights of ownership over an artist's creation. In another arrangement, a syndicate might itself dream up an idea and hire an artist to draw it but then later replace a burned-out artist on a popular strip or find someone else to do the strip when an artist died. *Bringing Up Father*, one of the longest-running comic strips to date, was created by George McManus in 1913, but from the mid-1950s to its demise in 2000 it was subsequently drawn by several other artists. The demands made on syndicated cartoonists required at least one assistant to help produce six black-and-white daily strips and one color strip fifty-two weeks a year. Many strips therefore became team efforts, written by one person, drawn by another, and someone else perhaps doing the lettering, balloons, faces, bodies, backgrounds, or coloring. Editors double-checked finished drawings for consistency, making sure, for instance, that every chair had four legs or checking for anything that might give offense, such as a baby popping up less than nine months after a wedding. The process typically required a six-week lead time for a daily strip and eight weeks for Sunday's full-color funnies.

Jackie Ormes

Cartoonists in the black press, however, were pretty much on their own. Like Ormes, most wrote and drew all parts of their strips and panels. Not surprisingly, artists might choose the same current topic for humorous treatment, such as the new medium of television or the Korean War. Black cartoonists from that time have stated that newspaper editors did not hold meetings of art department staff to decide content or to otherwise assign topics for the funnies. Lacking such editorial directives, artists themselves determined artistic values, propriety, timeliness, and the cultural trends depicted in their work. Jackie Ormes had artistic license, without worry that mainstream syndicates would object to her often provocatively dressed characters or to her occasional edgy themes, such as the mention of prostitution briefly slipped into *Torchy Brown in "Dixie to Harlem."* Comics in the black newspapers were remarkable in their energy, skill, timeliness, and original points of view that were conveyed by every character in the series—whether cowboy, detective, space invader, hero, villain, funny kid, or glamour girl.

The black newspaper industry was starting to reach its full strength and vigor about the time Ormes reentered cartooning in 1945. Both papers she worked for—the *Defender* and the *Courier*—had circulation figures that continued to climb throughout the late 1940s and early years of the 1950s. The *Courier* was especially friendly to cartoonists and ran four to five comic strips each week, along with Harrington's and Ormes's single panel cartoons. Some of the comic strip artists who appeared off and on during this time included Elton C. Fax (*Susabelle*), Oliver Harrington (*Jive Gray*), Wilbert Holloway (*Sunnyboy Sam*), Jay Jackson (*Bungleton Green*), Samuel Milai (*Bucky*), Clovis Parker (*Krazy Jess*), and Jerry Stewart (*Scoopie*). As Tim Jackson oberves in his invaluable Web site, Salute to Pioneering Cartoonists of Color, these artists also drew the hard-hitting editorial cartoons, created the inspirational illustrations for opinion columns, and provided art for some display advertising. Elton C. Fax is notable not only for *Susabelle*, which started in 1942, but also for his decades-long career as an author, fine art painter, and illustrator.[15]

Male cartoonists in the *Courier*'s black-and-white funny pages drew women characters, but most of them seem stiffly outlined and static when set beside Ormes's carefully detailed and gracefully drawn

women. Of course the smaller comic strip format to which they were confined in the 1940s limited their art, compared to the larger single panel that gave Jackie Ormes sufficient space to feature details of Ginger's fashions, hairstyles, and bodily contours. With the advent of the *Courier* comic section in 1950, which provided more space and a full color palette, male cartoonists such as Edd Ashe in *Guy Fortune* and Samuel Milai in *Don Powers* unleashed carefully articulated femme fatales, wholesome girl-next-door beauties, and sleek atomic-age space women. However, their female characters remained supporting actors to the leading men, while Ormes's Torchy Brown was the lead character in both her own strip and in an accompanying feature, *Torchy Togs*, pinup paper dolls with fashionable outfits.

Recent scholarship has suggested that George Herriman, creator of *Krazy Kat*, was African American. His surrealist comic strip depicted an innocent, affectionate cat whose head was often the target of Ignatz Mouse's brick projectiles. Herriman apparently disguised his African American heritage partly in order to gain entree into King Features Syndicate, a Hearst newspapers subsidiary, describing himself as having Greek roots and always wearing a hat to cover his hair, assumedly to disguise his ethnic origins. It is reported that in later life Herriman confided to a friend about his Creole background, a fact later confirmed by birth records.[16]

Most cartoonists in print today use computer technology to prepare (e.g., to draw or add shading and lettering) and send finished work electronically to the publisher. Some also use pen tablets, writing surfaces that employ sensors to transmit art to a computer monitor. Cartoonists of the mid-twentieth century often left a paper trail of original art for art historians to study or for the public to enjoy in libraries and exhibits, but "originals" from the contemporary computer era may in the future be inaccessible, stored as computer files by the artists who made them. Though modern technology can render a beautiful product, hand-drawn cartoon art on paper possesses a richness of meaning missing in the computer-generated versions. Lines taper from thick to thin or curve with a spontaneous, sensuous quality that reveals a movement of the wrist and stroking motion of the fingers. Erasures and white-outs are visible on originals, providing interesting clues to the artist's creative process.

Jackie Ormes

From drawing table to newspaper, cartoons and comic strips in midcentury America moved in prescribed steps. Ormes's *Torchy* comic strips spun a single yarn over one year, the length of her contract with the newspaper or syndicate. Stories were broken into weekly episodes with suspenseful endings that made readers come back for more. At the outset of both her *Torchy* series, she would have planned a general idea for a single-year story, with an introduction, climax, and conclusion. The single panel cartoons, *Candy* and *Patty-Jo 'n' Ginger* were based on one gag, the joke decided from week to week.

After composing the words for one strip or cartoon, Ormes began making preliminary pencil sketches on Bristol board, a type of paper that uniformly absorbs ink. Her original drawings were drawn to twice or more the scale of the finished cartoon. Once the pencil sketching was complete and after much deliberation and erasing with a nonsmearing white eraser, she used pen and india ink to draw over the pencil lines, sometimes filling in areas with a brush. Authoritative crisp black lines became Ormes's signature style; often balanced with ample white space, the clean, flat effect is reminiscent of previous decades' art deco styles or even of their predecessors, Japanese prints. To finish a *Patty-Jo 'n' Ginger* panel, she often added Zip-A-Tone shading sheets to add texture to items in the cartoon and skin tones to characters' legs and arms. This adhesive screen of thousands of tiny dots came in different densities to create shading and was much used in the paper-based cartooning days.

The final inking for her comic strips was completed when she hand-lettered the words. In her comic strips, the text appears below the drawings, is blended into the picture, or is placed in balloons above the speaker's head.[17] Her single panel cartoons were handled differently. In *Patty-Jo 'n' Ginger* Ormes penciled her words on the originals, which the newspaper's compositors would replace with typeset captions. Tight production deadlines probably did not allow a chance to proofread these typeset lines, and spelling mistakes sometimes crept in. Single panels have only one speaker, and since only Patty-Jo was allowed to talk, it was clear who was speaking in the caption. As time went on, Ormes sometimes recycled the art or the humor, adding a new caption to a previously used image (such as the sight gag of Patty-Jo speaking from the inside of a sidewalk mailbox) or repeating a

Arriving at the newspaper, the cartoon or strip was photographed and its negative was used to engrave an image onto a metal plate two columns or more wide, depending on the panel or strip. Then the plate was set in a metal frame dummy, along with columns of news, photos, and ads, according to how an editor indicated the page should appear. A worker pressed a sheet of heavy cardboard, called a matte, onto the entire dummy page, creating a mold, and poured molten metal into it to make a curved printing plate. Cylinders held the curved printing plates on a rotary press, a huge, noisy machine. Fans of old movies remember illusions of the process, as a newspaper rolled off the press, became airborne, and spun toward viewers like a pinwheel. In the real world, however, the curved plates inked the paper and rollers pulled it out of the press to be cut into sheets and folded into pages.

Jackie Ormes

favorite joke in a fresh scene—for instance, her many variations of gags on fashions or taxes.

After the inking was finished, Ormes packed up the drawing and mailed it to the newspaper in Pittsburgh. Her lead time for *Patty-Jo 'n' Ginger* appeared to have been about a week, as indicated by the topical nature of some cartoons, as when Patty-Jo riffs on a Supreme Court decision days after the event or refers to week-old news of an atomic bomb test. Such commentary on current events gave the cartoons a freshness and pertinence not often seen in mainstream funny papers. It is likely that with *Patty-Jo 'n' Ginger* Ormes had generalized drawings already prepared and could insert topical verbal text to make a timely, relevant statement. In contrast, large syndicate lead times could be two months, as indicated by Milton Caniff's *Terry and the Pirates,* an international adventure strip that took about that amount of time in reacting to the Japanese attack on Pearl Harbor.

Not every *Patty-Jo 'n' Ginger* panel appeared in all editions of the *Courier.* The City Edition (Pittsburgh) especially lacked *Patty-Jo 'n' Ginger* which appeared in a more complete series in the National Edition or other regional editions. Since more advertising could be sold in the home base city, it's likely that cartoon space had to yield to make room for revenue-producing ads.

There was probably a longer lead time to meet deadlines for *Torchy in Heartbeats,* since these full strips clearly involved extra work, including color. The *Torchy Brown Heartbeats* (its title for the first eight months of its existence) comic strip began in 1950 with the advent of the *Courier*'s color comic section. For this strip, Ormes would first have composed a story and then prepared the pencil sketch, ink drawing, and lettering. Color schemes were then worked out and included in written directions she sent to the Smith-Mann Syndicate

in New York along with the black-and-white original strips. In the era before offset printing, separate engraved plates of the original drawings would be made to carry yellow, red, blue, and black ink. Then they were printed one over the other, combining those four colors to make all the correct shades indicated in her original artwork.

Chapter 4

TORCHY BROWN IN "DIXIE TO HARLEM"

Torchy Brown in "Dixie to Harlem" ran in the *Pittsburgh Courier* from May 1, 1937, through April 30, 1938, and depicted the escapades of a country girl, starry eyed and slightly wacky, abounding in pluck, optimism, and determination. Stuck in Mississippi tending cows and chickens on Aunt Clemmie and Uncle Jeff's farm, Torchy is restless. Her ambition to move away is kindled by a visit from her friend's cousin Dinah Dazzle from New York City. A portrait of Torchy's glamorous mother, who had left the family under mysterious circumstances after first passing along her skill at singing and dancing, inspired many of Torchy's fanciful daydreams. The identity of this "Gay divorcee," is revealed in a surrpise ending with a character whose profile resembles Josephine Baker's. Displaying more gumption than talent, Torchy leaves the farm and heads straight for the Cotton Club in Harlem in a setup ripe for week after week of humorous scenes.

While presenting a funny, entertaining story, this strip reflected the real struggles of people migrating from the South to the big northern cities, as reported in the *Courier*'s news pages. A running theme of the strip concerns families' North-South bonds, as when Dinah Dazzle's visit prompts Torchy's flight from Mississippi and when Torchy writes from New York to Aunt Clemmie and Uncle Jeff, remembering her loving family and her southern roots. Years later, Alice Walker would describe in *The Color Purple* the same urge to flee the South, the struggle to find one's way in the North, and the persistence of remembering those roots. In contrast, comics such as *Sunnyboy Sam* and *Society Sue and Family* running alongside *Torchy Brown in "Dixie to Harlem"* were mostly light domestic comedy, dealing with everyday situations. Torchy's homespun wisdom spiked with youthful slang freshened the storytelling in a way not seen in other *Courier* comic strips at the time.

Readers probably recognized some of their own day-to-day problems in *"Dixie to Harlem"* but could view them a little differently

through the comic, perhaps with some amusement. One strip mocked the predicament of passing for white, as youthful Torchy puzzles in the southern train station over whether to go in the direction of the "Colored" arrow or to the more comfortable "White" section, a situation that the light-skinned Ormes could have faced in her own life. In the strip, an Italian American man spies the newspaper Torchy carries and asks, "You got da Joe Louis news? Dot's great. You like fruit?" "You betcha," Torchy replies, as she slides past the conductor's stern eye and sits next to the man whose skin is slightly shaded. "O-ya!" he assures the train official. "Dees leetle lady iss my very good fran'. I insist you mus' run along now, meester conductor, I got lots of readink to do!" Neither Torchy nor the Italian American man would directly confront legalized racial injustice in late 1930s Mississippi. But together they bluff the even darker conductor with their nearly matching skin tones and stay put as the train proceeds northward to safety and to social practices that gave some degree of protection to people of color.

Though her days in New York are fraught with danger, Torchy masters the city in episodes reminiscent of screwball comedy. Three strips in the series deal with prostitution, a subject unheard of in the comics of mainstream papers. Upon Torchy's arrival at Grand Central Station, a stranger, Miss Mayme, scoops up her bags and persuades Torchy to come home with her. Before she can settle in at Miss Mayme's, the maid signals a warning, prompting Torchy to eavesdrop on Miss Mayme's phone conversation: "Yeah doc, just your type—five feet of tender Mississippi pig meat. . . . Green? Sure. . . . But cute as Christmas. . . . you know the play ol' man." Wide-eyed Torchy yips, "Whassis? . . . Looka heah now—if she's talkin' bout me it don't sound so good! Lawdy—lemme get outa here." She frantically packs her bags and runs off with sweat drops flying.

Ormes's Torchy character and this story line resemble fantasies popularized in 1930s pulp fiction, theater, movies, and true-life stories. Lena Horne, whom Ormes knew from her days in Pittsburgh, had been discovered by talent scouts at the age of sixteen while dancing in the Cotton Club. Though the club's glory days had faded with the passing of the Harlem Renaissance cultural scene, Horne's rise to celebrity loosely corresponds with the fictional Torchy's. (Later, in the 1941 movie *Boogie-Woogie Dream*, Horne would play the role of a club

Torchy Brown in "Dixie to Harlem"

dishwasher who jams after hours with pianists Pete Johnson and Albert Ammons; in the movie the musicians are discovered and go on to a career in show business.)

The name Torchy Brown recalls Torchy Blane, a fast-talking self-confident newspaper reporter played by Glenda Farrell in Warner Brothers' 1936 *Smart Blonde* and eight sequels. The name of the strip also relates to the Federal Theatre Project of the Works Progress Administration (WPA), which in 1937 sponsored a touring revival of *Dixie to Broadway* that was billed as "America's Greatest Colored Musical Revue." The original 1924 entertainment featured Florence Mills and was one of the popular black revues that made it to Broadway for a long run. *Dixie to Broadway* probably was a model for *Torchy Brown in "Dixie to Harlem,"* with Ormes tapping into reader recognition of a real legendary star. Whether or not Bill Ward borrowed from Ormes's strip for his 1944 cartoon *Torchy Todd*, whose leading character was another young beauty, is unknown. He started the comic strip for a newspaper at a U.S. Army base in Brooklyn, where, he quipped, making a comic strip was better than getting shot at. In the late 1940s Ward revived *Torchy Todd* and put her in a comic book for Quality Comics.

Like most artists, cartoonists analyze their contemporaries' work and adapt ideas to come up with original scenarios. It stands to reason that the inventive Ormes, a new and self-trained cartoonist, was influenced by the work of others. Ormes's professional interests would have prompted her to look not only at the comics in the weekly black press but also at the daily *Pittsburgh Press* and *Post-Gazette* and later the daily *Salem News. Bringing Up Father,* by George McManus, which appeared in the mainstream papers in Pittsburgh and Salem, where Ormes lived, may have influenced her. In clean, thin black lines, McManus drew the story of Jiggs, the paterfamilias, who is pulled away from his buddies at an Irish pub by the questionable good luck of winning a lottery and by his wife, Maggie, a social-climbing harridan. Similarly, Torchy strives for fame and wealth as she moves from a simple rural life to success in the bright lights of a big city. Such rags-to-riches plots were popular in the have-not days of the Depression.

Running under the *Torchy Brown in "Dixie to Harlem"* strip in the *Courier* was Samuel Milai's *Society Sue and Family,* a humorous strip that featured female as well as male characters and placed them in refined

settings, sometimes in fashionable clothes. Like Ormes, Milai occasionally offered views of ladies in their dressing rooms, striking pinup poses. In comparison, Ormes's inventive compositions, her fashion sense, and her characters' supple bodies command a viewer's first interest, which may explain why the editors put her "on top." And there was another striking difference between the two strips: in Milai's world, shades of blackness seem to reflect one's class and station in life. His lady of the house has lighter skin than her dark maidservant, an indication of color-based hierarchies of class that Ormes avoided using in her artwork.

Ormes drew most of "*Dixie to Harlem*" with a pen and ink, creating fine, crisply etched figures in sharp focus. Using a brush to create her strip, as some cartoonists did, would have produced a more shaded, painterly chiaroscuro appearance, as in Harrington's lushly inked *Dark Laughter*. The fine, light drawing of her early *Torchy Brown in "Dixie to Harlem"* has a unique artistry; it is easy and pleasurable to look at. Sight gags of characters who take pratfalls, hog the spotlight, or strut fashions in the foreground of these comics compete for attention with Ormes's intricately detailed backgrounds. Her ability to observe and communicate the world around her is seen in an array of everyday objects like the accurately drawn living room bric-a-brac or the meticulous city skylines that fill the frames. Characters' faces are dramatized with a medley of apt expressions in which eyes squint, lips pout, and brows furrow, as compared to some other cartoonists whose characters' range of expression consists of either opening or shutting their mouths. Within the array of sophisticated black women featured in the strip is Torchy's friend Bumps, who is quite overweight. Bumps is depicted in lacy lingerie and gorgeous gowns with the same artistic care and detail given svelte Torchy and Dinah, and Bumps speaks with similar intelligence and wit. As Torchy moves from country to city, her athletic, farm girl body evolves by magical degrees over the course of time into supple curves and postures. About this time some comics, such as Harrington's *Jive Gray*, began to use cinematic angles such as overhead views, fade-outs, and depth perspective that dramatized the action, as in a suspenseful movie. In contrast, Ormes composed scenes in a static frame with a stationary viewpoint. She invites the reader's eye to play across the pictorial details at leisure, in the style of George

Torchy Brown in "Dixie to Harlem"

McManus, Wilbert Holloway, and Samuel Milai. By the mid-1940s, her lines became stronger and thicker, with edges deeply carving the shapes of people, clothing, and details.

Unlike her later work, *Torchy Brown in "Dixie to Harlem"* was straight humor. Never would this Torchy mouth righteous speeches or moral lessons, even when dealing with serious social issues. Here Ormes was on a joyous narrative ride propelled by the spirit of Torchy Brown, the hippest young woman in Harlem, who believed that anything is possible if you want it badly enough.

Twelve comic strips from the one-year run of *Torchy Brown in "Dixie to Harlem"* appear here, reproduced from microfilm copies of the newspaper pages on which they originally appeared. In the process of cleaning and restoring the images from microfilm, some of the original shading was lost. No original art remains, nor have I been able to locate *Courier* newspapers from these years in their original paper format. Though less than perfect, these examples from digitally scanned microfilm strips were chosen to give a sense of the story line and to show a variety of drawing and writing.

The first installment of *Torchy Brown in "Dixie to Harlem,"* May 1, 1937.

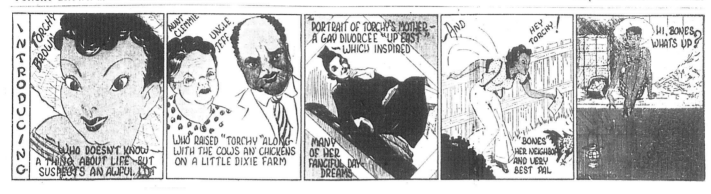

City cousin Dinah Dazzle visits, bringing big ideas to the two country girls, Torchy and Bones. May 15, 1937.

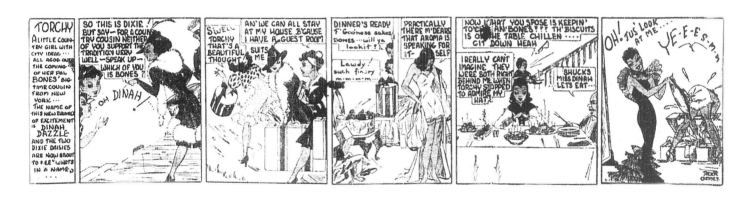

In this eye-catching strip, Torchy proves her country smarts by bargaining with a farmer. June 12, 1937.

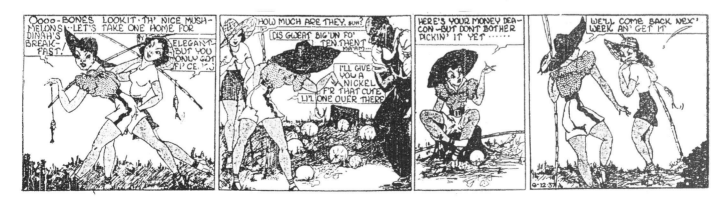

Seasonal motifs appear in many of Ormes's backgrounds. Here Torchy rides a Fourth of July rocket into a fanciful dream. July 10, 1937.

 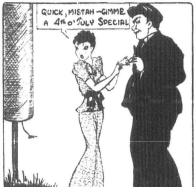

Torchy's dream takes her power shopping. Both Ormes and her characters dressed in the latest styles. Thirteen years later she would add paper doll cutouts to her comic strips, all with fashionable wardrobes. July 24, 1937.

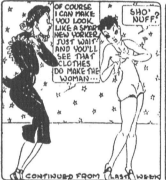 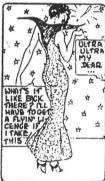 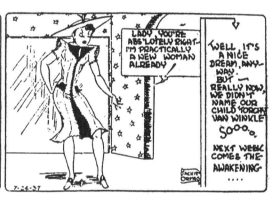

Torchy sells her farm animals to buy a train ticket to New York and for money to live on once she gets there. August 14, 1937.

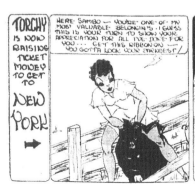 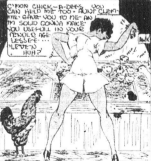 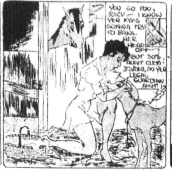 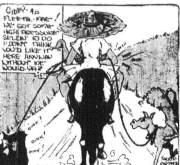

With bittersweet humor, Ormes takes on segregation in the United States. September 4, 1937.

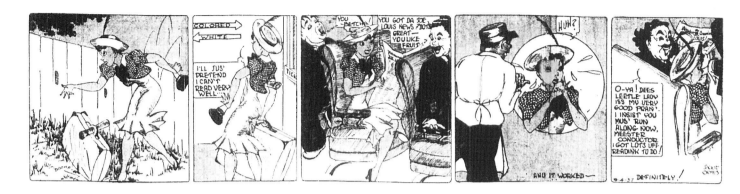

For the first time a child shows up in the strip, and she looks a lot like Patty-Jo, who would materialize in her own cartoon series eight years later. During this period the strips began to carry titles, this one reading "Wanted: One Friend!" October 16, 1937.

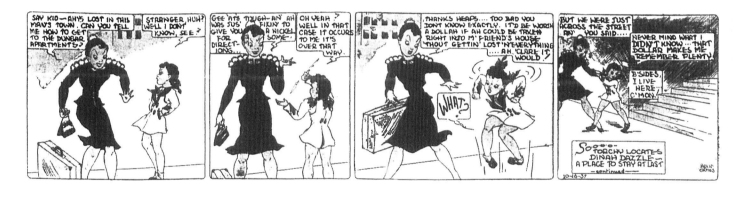

"Orders Is Orders!" Ormes refers to herself as a "dizzy dame." Nudity was unheard of in comic sections of mainstream newspapers. December 25, 1937.

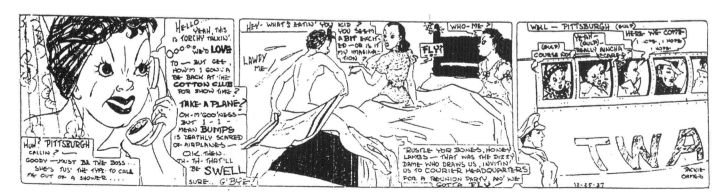

"Business of Star Hitching!" Torchy's dancing friend is Bill "Bojangles" Robinson, a vaudeville, cabaret, and motion picture star. January 22, 1938.

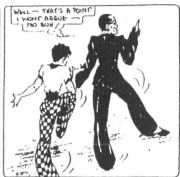

"Excited! Who's Excited?" Ormes was a fan of the fights. In this strip, which takes place in a boxing arena, an arrow in the first panel indicates where Torchy will find her seat. She cheers on heavyweight champ Joe Louis, shouting, "ATTA JOE!" February 26, 1938.

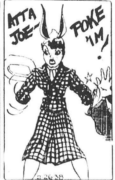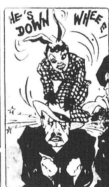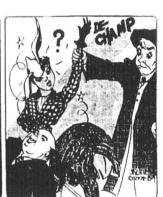

"What's This???" The final installment of *Torchy Brown in "Dixie to Harlem"* solves a mystery introduced in the strip a year earlier about the identity of her mother. Torchy's exotic costume dramatizes a familial connection to the woman shown in the last panel, who strongly resembles dancer Josephine Baker. April 30, 1938.

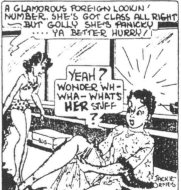

Chapter 5

CANDY

Wartime labor shortages had opened doors for some black women to find work in factories and other industry. The *Chicago Defender* seized the opportunity in articles and editorials to campaign for improved wages and conditions for black women in domestic service.[1] For weeks other artists, Jay Jackson and Wilbert Holloway in particular, had featured quick-witted, attractive housemaids in their cartoons on the editorial pages to reinforce the *Defender*'s political statements with entertaining illustrations. According to Ormes in a later interview, the editors decided to give her a chance to try her hand at a cartoon, without monetary compensation.[2]

In her first professional artistic venture in seven years, Ormes made an especially powerful (if brief) debut with *Candy* on the *Defender*'s editorial page for four months in 1945. Now living in Chicago, she had returned to journalism as an occasional special assignment reporter and social columnist for the *Defender*. Within two years, she began a single panel cartoon about Candy, a buxom and outspoken housemaid. The wisecracking Candy, who appeared regularly alongside the verbal broadsides and exhortations of regular *Defender* columnists such as Walter White, S. I. Hayakawa, Langston Hughes, and W. E. B. Du Bois, added some levity while commenting on more serious issues. When Earl Ormes saw his wife's preliminary drawings for the cartoon, he christened the character "Candy," a reference to the character's appealing body and to his sister-in-law, Emma "Candy" Ormes, who was delighted with the in-joke.

Candy was a subversive housemaid who took amusing verbal jabs at wartime black marketeers, hoarders, and hypocrites, as personified by the detested lady of the house. Candy establishes her moral superiority over madame in panels that invite readers to reflect on the upside-down order of things. She talks about comforting children in the household when their self-interested mother ignores them, and, off-

stage of course, she compares madame's gatherings of pompous snobs to her own fun times with good friends. Candy's forte is taking clothes from madame's closet. In these scenes the ever-fashion-conscious Ormes had the opportunity to draw fancy gowns, elegant shoes, and slinky underwear for Candy to model.

Although Ormes never showed Candy's employer in person or commented on her color, the paper's ongoing editorials attacking low wages of black domestics in white households and establishments suggest that she was white. Reminders of black servitude in white households permeated American culture, as exemplified in this poem by Countee Cullen that was well known at the time:

> *For a Lady I Know*
> She even thinks that up in heaven
> Her class lies late and snores,
> While poor black cherubs rise at seven
> To do celestial chores.

Ormes added Zip-A-Tone shading material on her originals to give a smooth, even effect on characters' bodies and long legs. No other character but Candy is shown in the cartoon, but in future cartoons and comics that had several characters, Ormes made all characters the same shade, pointedly ignoring the "pigmentocracy" of African American class structure that some other cartoonists chose to illustrate. Throughout the eleven-year run of *Patty-Jo 'n' Ginger*, for instance, all the characters—boyfriends, soda jerks, teachers, and department store salespeople—have the same skin tone, as do masters, servants, and both the doctor and the poverty-stricken tenants in *Torchy in Heartbeats*.

Candy ran only four months, but the beautiful and articulate black woman that Ormes modeled for the first time in it would be transformed soon enough into Ginger, a beauty whose cartoon run lasted eleven years.

Original art or newspaper copies of *Candy* are not available, and so reproductions made from microfilm must suffice. It's safe to assume that published *Candy* cartoons had crisp, clear edges and fine detail, as was typical for Ormes's drawings.

March 31, 1945.

*"Gee, I hope Mrs. Goldrocks doesn' t gain any more weight.
I can' t possibly wear a size larger."*

"Gee, I hope Mrs. Goldrocks doesn't gain any more weight.
I can't possibly wear a size larger."

"I'm getting fed up with rolling her cigarettes. It's enough
to make me break down and share my tailor-mades!"

June 2, 1945.

*"I' m getting fed up with rolling her cigarettes. It' s enough
to make me break down and share my tailor-mades!"*

"Mrs. Goldrocks admits her biggest thrill is black-market
'bargains.'—That's because she's convinced they're
really exclusive!"

June 16, 1945.

*"Mrs. Goldrocks admits her biggest thrill is black-market
'bargains.' — That's because she's convinced they're
really exclusive!"*

June 30, 1945.

*"Mrs. G. is telling all her friends about my Victory garden.
Wait till she sees the meat balls I planted last week."*

"Mrs. G. is telling all her friends about my Victory garden.
Wait till she sees the meat balls I planted last week."

Chapter 6

PATTY-JO 'N' GINGER

Most books that discuss Jackie Ormes's work in the *Pittsburgh Courier* have focused on the 1953–54 Torchy character, but it is Patty-Jo that the readers of the *Courier* whom I talked to seem to remember most vividly. One person described an acquaintance born in the 1950s who was named after Patty-Jo. A twenty-something star of the 1972 musical comedy *Purlie* by Ossie Davis called herself simply Patti Jo and dressed her hair and clothing much like Ormes's character. Two textual references citing Patty-Jo, one from Langston Hughes mentioned in the introduction, and another from sociologist St. Clair Drake in chapter 8, further suggest the influence of the Patty-Jo character. That a girl child expressed wisdom, exposed folly, and could say what was on many people's minds and get away with it must have struck a chord with readers. According to a magazine article published a year and a half after the cartoon's first appearance, the *Courier* "found in a recent survey that 'Patty-Jo 'n' Ginger' tops all its other features in reader popularity."[1]

Histories of newspaper cartoons have often ignored the long run of *Patty-Jo 'n' Ginger*. The most obvious explanation is that African American newspapers have escaped the attention of researchers who have confined themselves to comics found in the mainstream papers. In addition, gender bias may have led some researchers to assume that Ormes's cartoons treated only "frivolous" feminine topics, like clothes and boyfriends, and were therefore unworthy of close scrutiny. Other writers may have been put off by Ginger's provocative poses, which could be viewed as exploitative of women. The single panel format of *Patty-Jo 'n' Ginger* has also contributed to certain omissions: Trina Robbins's books on women cartoonists have restricted their scope to comic strips and comic books, purposely leaving out single panel cartoons. Other historians have focused on the later *Torchy in Heartbeats* strip to

spotlight Ormes's prescient critiques of environmental pollution and racial prejudice, overlooking the biting satire in *Patty-Jo 'n' Ginger*.[2] By contrast, the politically pointed humor in Oliver Harrington's *Dark Laughter* was openly admired by readers and is regularly documented by historians today. In truth, the very things that made *Patty-Jo 'n' Ginger* compelling—the depiction of a precocious and witty little girl and her attractive big sister—may have disguised the cartoon's polemical commentary, misleading readers into thinking that this was children's fare or somehow frivolous in content. An adorable child's amazing cleverness was part of the feature's charm, to be sure, and "cute" would be an apt description of many of the cartoon's installments. Readers would not always find hard-hitting political satire in the cartoon; many gags focused on Patty-Jo ribbing Ginger about her appearance and clothing. On one level, jokes such as these could be read as light humor, but at the same time they gave Ormes the opportunity to make observations about significant topics like class, consumerism, and racial uplift. And even while delivering humorous social satire, Ormes avoided the easy shots that some others used in their cartoons for laughs, as these might have proved insulting or demeaning. Though Ginger would pose in elaborate clothes, she never was scolded for spending money, as women were in some other cartoons of the day. In the relatively few instances where Patty-Jo and Ginger's father appears in the cartoon we never see him throwing papers in the air, yelling, "Bills! Bills! Bills!" as other cartoon fathers or husbands might.

The 1940s and 1950s made up the era of the pinup girl, who could be found in mainstream media and in places such as magazine covers, advertisements, matchbooks, playing cards, and calendars. Many consider Rolf Armstrong to be the founder of the genre, when in the 1920s he airbrushed paintings of fantasy goddesses in soft pastels for magazine and book illustrations. A long list of artists followed in the ensuing decades. They varied the idea, some specializing in the girl next door and others in sultry sirens or ladies in distress. *Esquire: The Magazine for Men* had in the 1930s elevated erotic art from its vulgar status to "good taste" and made it acceptable for readers of higher social status. Combined in the same issues with serious fiction from such writers as Ernest Hemingway, F. Scott Fitzgerald, and Langston Hughes, *Esquire*'s

glamour girls attained respectability and objectified modern attitudes toward sex and nudity. George Petty ("Petty Girls") and Alberto Vargas ("Varga Girls") airbrushed sensuous colors on a series of sleek legs, bodacious breasts, and flowing manes of hair.

World War II created a new use for pinup art and photographs: the artwork boosted the troops' morale by reminding them of home and of "What you're over there fighting for," to paraphrase comedian Bob Hope's famous quip. Popular magazines such as *Life* and government-issued magazines such as *Yank* obliged GIs with full-page images of the likes of Betty Grable, Rita Hayworth, and Lana Turner that could be torn out and hung in soldiers' Quonset huts. Gil Elvgren had especially excelled at calendar art, and his erotic images on Brown and Bigelow calendars that hung in gas stations, barbershops, and pool halls helped give rise to the term *calendar girl*. During the war, Elvgren was one of several artists who produced girlie art in self-mailer packets called "Military Pin-up Kits," which consisted of posters that friends could buy and send to GIs to hang in their lockers, above their bunks, or on the ship's bulkhead.

Naturally, no black soldier would dare pin up a white woman's picture. As Maureen Honey explains, the U.S. government's "dissemination of the white pin-up reinforced segregation and white supremacy, something the black press was quick to recognize."[3] *Ebony* and *Negro Digest*, magazines that started in the mid-1940s, responded with wartime pinup photos of such beauties as Lena Horne and Dorothy Dandridge. Photos of beautiful women in bathing suits sometimes appeared on the front page of the *Courier*, and other times the paper ran more demure portraits of women with lovely faces and stylish coiffures. The *Courier* also enlisted African American artists like Jay Jackson, who placed attractive women in his various cartoons, while the *Defender* provided space in *Candy* for Ormes to draw shapely girl-next-door images. Shortly after *Candy* ended, Ormes received a letter from a GI thanking her for this view of "wholesome American womanhood." Jay Jackson, a versatile cartoonist for several African American newspapers, ran ads during the war for packets of "Pin Up Girls—These solid senders sketched from beautiful brown models are strictly whistle bait! 6 For $1."[4]

Soon readers of the magazines began to write letters to the editors

Patty-Jo 'n' Ginger

to debate the propriety of these photographs. Negative letters complained that the photos were "in very bad taste" and "disgusting"; supporters called the photos "beautiful" and noted that most of the leading magazines of the day carried them. "The defenders of cheesecake saw it as respectable beauty, so respectable, in fact, that the inclusion of African-American women counted as racial advancement," historian Joanne Meyerowitz has written.[5] The shapely torsos and supple limbs of Ormes's adult characters, sometimes scantily clad, offer the kind of beauty many readers said they wished to see, and with these images she claimed her place in the artistic lineage of notable pinup artists and photographers such as those found in the pages of *Esquire* and *Life*.

Oliver Harrington and E. Simms Campbell, cartoonists in the black press, excelled at drawing women. Campbell honed his craft in the 1930s drawing sexy females in his *Harlem Sketches* single panel cartoon, reflecting the *Courier's* penchant for front-page photographs showing plenty of skin. Later, he drew for *Esquire* and other magazines and was the only African American cartoonist to work for a major publisher. He was especially known for *Cuties*, a single panel cartoon in *Esquire* with white pinup beauties to which saucy gag lines would be added. Campbell's presence in the bastions of whites-only publishing was a courageous stance. The days of persecution of black men for simply looking at white women were far from over, yet he prospered using live, nearly nude white women as models for his drawings in a national publication. When asked about risks he might be taking, Campbell shrugged them off, saying about people who might object, "Who gives a damn? I guess they get over it."[6] African American pinups were not found in large circulation magazines until they appeared years later in photographic format in such magazines as *Playboy*.

Women might not have admitted it, but many enjoyed looking at soft porn glamour girls, and they also drew erotic art. Ormes herself had painted a nude self-portrait that hung on the Ormeses' bedroom wall. Women excelled at drawing pinups in natural poses with loose realistic postures that seemed to invite intimacy, in contrast to the depictions of coy, out-of-reach goddesses that men often drew and that eventually became cliché. Zoe Mozert drew illustrations for the covers of *True Confessions* magazine for such stories as "A Slave to His

Caresses." Working in pastel, Mozert personalized the standard image with recognizable facial features and once made a notoriously revealing publicity poster of Jane Russell for Howard Hughes's movie *The Outlaw.* Joyce Ballantyne brought a sense of fun to pinup art; her classic Coppertone Suntan Lotion ad of 1959, of the puppy tugging at the little girl's bathing shorts, captures a sense of Ballantyne's playfulness with the female body of various ages. Both Mozert and Ballantyne were beauties who used themselves as models for the images they drew. Pearl Frush could draw either the unattainable goddess image or the girl next door. She perfected a technique of fine detail and near photographic realism in the style of Vargas but added more clothing to her figures, whose relative modesty may have enabled Dad to hang the picture in the family's garage, if not in the kitchen.

Ormes herself was strikingly attractive, well coifed, and well attired, and she, too, used her own body as a model for the curvaceous women who appeared in her work, including Ginger. The family newspaper was a relatively safe place for her to show a body like her own, and it was safe as well for readers in their own homes to gaze sometimes upon a barely dressed black woman. Writer bell hooks points out that in American culture "we mostly see images that reinforce . . . the subjugation of black bodies by white bodies. . . . Our eyes grow accustomed to images that reflect nothing of ourselves worth seeing close-up. . . . Given this cultural context, we are often startled, stunned even, by representations of black images that engage and enchant."[7]

Ginger's acceptability in a family newspaper in spite of her attention-getting poses was partly due to her chaste persona. She remains safely within the erotic boundaries of the time: desirable but never provocative, a charmer but not a seductress, viewed partly unclothed, yes, but only in private spaces like her dressing room or when accidentally slipping on Patty-Jo's misplaced roller skate, with her skirt flying above her shapely legs. When she gazes directly at the viewer, her look is one of surprise at Patty-Jo's words, never the sexy come-hither glances of other pinups. Indeed, Ginger is strictly hands-off, conforming to the *Courier*'s standards of decency, standards that were at times admittedly more relaxed than those of many mainstream papers. It was reported that thirty-seven mainstream papers removed a *Miss Fury* strip in 1942, when a character showed up in a bikini. Some other strips occasion-

Patty-Jo 'n' Ginger

83

ally got away with running a particularly revealing scene, such as *Oh, Diana* was known to do in the mid-1940s. The artistic freedom Ormes enjoyed in drawing these figures enlivened the funnies page, and Ginger's attractive figure clothed in the latest fashions helped sell newspapers, making her invaluable to the *Courier*.

No one can remember Ormes employing a model, even for the child characters or for the occasional male characters. Ormes studied her own body, face, and hair in order to draw Ginger, according to her sister. She decided early in her career to "draw a cartoon strip where a little girl is the star," Ormes recalled.[8] Once she found the imaginary child body and face that suited her, she stuck with it. The little girl throwing a fit on the street corner in *Torchy Brown in "Dixie to Harlem"* in the 1930s is a dead ringer for five-year-old Patty-Jo years later, down to her pigtails and facial features. Like most child cartoon characters, Patty-Jo remains forever young, blissfully frozen in time even as the world changes around her, in interesting ways to which she can respond. Mother is referred to once, though we never see her, and Father makes two appearances, reassuring readers that this is an intact family. But it's Ginger who does the cooking, shopping, and escorting of Patty-Jo from school or to dancing lessons, wordlessly impressing on her sister her own tastes and attitudes that hint at what the little girl will become.

Big sister–little sister setups like *Patty-Jo 'n' Ginger* had been popular in other comic strips and cartoons and in movies like *The Philadelphia Story* (1940). The convention is for the kid to get the best lines, while the authority figure provides opportunities for jokes about things like catching men and sweetly tolerates wisecracks and pranks better than a mother would. Adding interest and conflict to this sibling banter is the fact of Patty-Jo's family's relative affluence, which permits characters to dress up and go places while little alpha females like Patty-Jo lord their status over their chums.[9]

The archetype of the adorable little girl, often with a smart mouth like Patty-Jo's, has long been found in leading roles in literature and popular culture. Topsy's words and actions in the novel *Uncle Tom's Cabin* pricked the conscience of a nation; Baby Snooks (played by Fanny Brice) on vaudeville stage and radio inspired laughter with her mishaps and truth telling; Little Orphan Annie led the hunt for the

bad guys in the comic strip of that name by Harold Gray; and Shirley Temple sassed bigwigs in some of her films as well as talking back to her formidable grandfather in *The Little Colonel*. Patty-Jo follows this tradition with stage-center appearances and often with caustic remarks. Her impertinence is softened by Ginger's languid, wide-eyed, silent pantomime. At times Patty-Jo's remarks defy logic: as a young child, she can't possibly understand the words she is saying, but this, in itself, is funny. Ormes is obviously inventing her own idiom for Patty-Jo's character, mixing elevated language with low, slangy vernacular and confusions of meanings that often result in sly puns. Her speech is not quite the way people talk, regardless of age, but is constructed in a way that defines her personality as childlike yet shrewd.

Comic strips can build tension over time for an eventual climactic payoff, but a single panel cartoon must deliver the goods in one moment of time. *Patty-Jo 'n' Ginger* demonstrates Ormes's mastery of the form. The reader's attention is first drawn to the elegant settings, provocative postures, and up-to-the-minute fashions and then to the verbal one-liner that by turns may be funny, insightful, or even somber. Again, the relatively short lead time to deadline gave *Courier* cartoonists the opportunity to exploit topical news, a timeliness that the slow-moving mainstream syndicate workshops did not enjoy. Patty-Jo's observations, her riffs on life's problems and current events, provided a way to think about things differently. "First you look at the cartoon and laugh, and then you look at it again and get angry," two Pulitzer Prize–winning editorial cartoonists agreed in describing their work.[10] Indeed, today some of Patty-Jo's ongoing complaints and attacks on the status quo would likely be found on a newspaper's editorial pages. She railed against racism, against restrictions on free speech, and against the confining nature of popular ads, fashions, or styles.

Though it was mostly meant for grown-ups, *Patty-Jo 'n' Ginger*, like many of its predecessors, naturally also had kid appeal. Patty-Jo's antics could be visually understood by children who were unable to read or unaware of news events. In well-defined action easily grasped in a few seconds, she put tadpoles in the lemonade, exasperated perfume-counter saleswomen, rode a friend on her bike, and acted up in school, to name a few gambits. Her face might be laughing, puzzled, smug, or surprised, but it was never mean. Patty-Jo concocted mis-

Patty-Jo 'n' Ginger

chief and mouthed off, to be sure, but she did so with a lovable geniality. And Patty-Jo cost children nothing. They would have to pay a precious dime to buy a comic book, but the funny pages were included in the price of the newspaper that Mom and Dad already provided. Here was some free entertainment for children, and, better yet, the characters had brown skin, a combination that made Patty-Jo dear to the hearts of African American kids, who now as baby boomers remember her fondly.

No other child in cartoon history had a wardrobe comparable to Patty-Jo's. Her closet was chock-full of shoes, hats, dresses, pinafores, nightgowns, robes, and skating and cowgirl costumes, as well as all manner of sunsuits and winter and spring coat sets. Every week for eleven years she showed up in something imaginative and new. Of course, ingenues such as Brenda Starr (drawn by Dale Messick), Miss Fury (by Tarpe Mills), and Mopsy (by Gladys Parker) and teenage girls like Emmy Lou (in *Bobby Sox* by Marty Links), Susie Q. Smith (Linda Walter), and Teena (Hilda Terry) paraded across newspaper panels in a wide variety of clothes. But children usually appeared in one single trademark outfit, like Little Orphan Annie's and Little Lulu's white-collared red dresses or Nancy's black sweater and plaid skirt. Several of the artists just mentioned (all women) had once worked in the fashion industry, just as Ormes herself trained fashion models and promoted style shows. During the late 1940s, when her Patty-Jo doll was being produced by the Terri Lee doll company, Ormes dressed her pen and ink cartoon characters in real garments from the Terri Lee catalog.

Eighty-eight *Patty-Jo 'n' Ginger* cartoons appear here, culled from the more than five hundred that were produced over the cartoon's eleven-year run. Twenty-five are reproduced from original art, measuring approximately nine inches by eleven and a quarter inches. The others have been digitally photographed from the original newspaper pages, with most single panels measuring approximately four inches by six inches; a few were digitally scanned from microfilm of the newspaper pages. Interpretive captions accompany each of the cartoons, with commentary that I hope will illuminate such things as the topical events referred to in the cartoons and the cartoons' relevance to Ormes's life and also provide some analysis of her artistic methods.

PATTY-JO 'n' GINGER

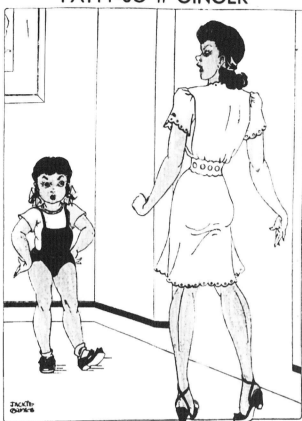

September 1, 1945: Usually the *Pittsburgh Courier* introduced a new comic with some fanfare, but the first *Patty-Jo 'n' Ginger* appeared on this date with no prior notice. Her *Candy* cartoon, frequently featuring wartime themes, had recently ended its short run, and Ormes had returned to the *Courier* after leaving the *Chicago Defender*. Here she introduces Patty-Jo as a precocious, outspoken child and Ginger as her attractive but silent older sister. Germany had surrendered the previous May, and Japan had capitulated just two weeks before this cartoon appeared. The nation was war weary and had lost its appetite for adventure comics in favor of humor, according to Coulton Waugh's 1947 book *The Comics*.

"Now that the war is over, I guess I'll see what the man shortage had to do with that no-nickel Jody we've been puttin' up with!"

"Now that the war is over, I guess I'll see what the man shortage had to do with that no-nickel Jody we've been puttin' up with!"

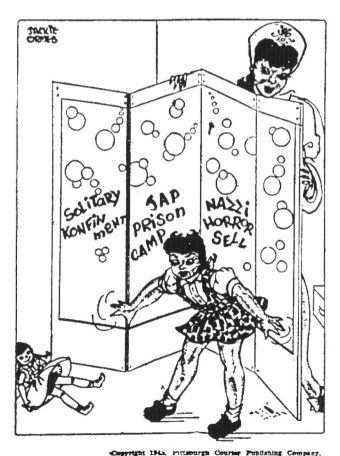

"Gnats on ol' Mrs. Blowhard . . . All I said was maybe the neighbors won't LET her Sammy grow up to be a drummer in Basie's band!"

October 6, 1945: Patty-Jo seems to be saying that hatred and oppression prevent kids from growing up to do what they want to do. Nazi wartime atrocities were much in the headlines. Every day the Nuremberg trials uncovered new evidence about these perpetrators of genocide, and photos revealed horrifying cruelty, filling the pages of popular photo magazines like *Life*. Ormes's commentary in this panel is a popular sentiment of the era, upholding the rights of children of different backgrounds to realize their hopes and dreams.

"Gnats on ol' Mrs. Blowhard . . . All I said was maybe the neighbors won't LET her Sammy grow up to be a drummer in Basie's band!"

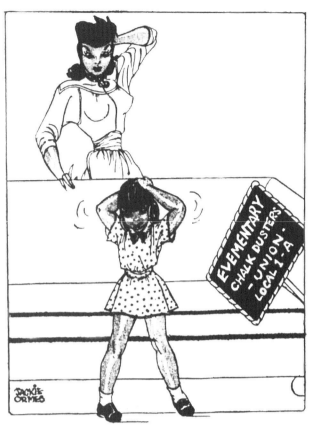

"We BLACKBOARD workers are callin' a strike, an' if the 'apple polishers' break our picket-line, there's gonna be trouble!"

October 20, 1945: The war was over and a wave of strikes and work stoppages swept across the country, as union leaders were now freed from their wartime pledges not to strike. Here Patty-Jo dons a football helmet in case there is any rough stuff on the picket line. Ormes witnessed events from her home in Chicago, historically a major site for labor union activity. The topic of labor struggles shows up in at least six of Ormes's cartoons, with Patty-Jo imitating strikers' calls to action in ways a child might understand. For example, here she responds to her teacher's request to take on the unpleasant job of cleaning dusty blackboard erasers.

"We BLACKBOARD workers are callin' a strike, an' if the 'apple polishers' break our picket-line, there's gonna be trouble!"

December 29, 1945: Cartoonists would often maintain a file of ideas to trot out for appropriate seasons and holidays. Depictions of dolls and toys and reminders of Santa Claus attracted young readers. Here Ormes carefully details various types of dolls, including a black girl doll with natural hair, a white doll with pigtails, a white boy doll, a bent-leg baby, a peg wooden doll, and a stuffed animal. The group also includes an Asian doll in a straight-line haircut and Asian pajamas, an interesting gesture considering the Allies' defeat of an Asian power earlier that year.

"And NOW, my little lamb chops (to pass this jive on and on), what do YOU want Santa to bring YOU for Christmas?"

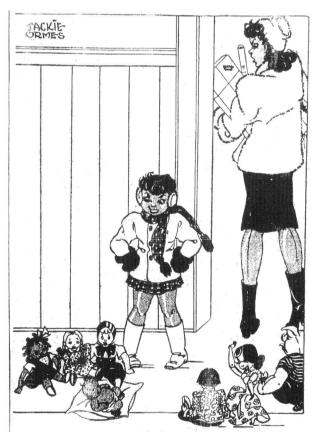

"And NOW, my little lamb chops (to pass this jive on and on), what do YOU want Santa to bring YOU for Christmas?"

March 16, 1946: Much of Ormes's humor revolved around Patty-Jo arguing that she is smarter than her big sister. The joke here is the old chestnut about people who are too dumb to come in out of the rain. This panel is included for its artistic novelty and rhythmic qualities: the dome of the umbrella interrupts a multitude of small, diagonal lines, and the supple curves of the characters' bodies offset and balance each other in space. Ginger's and Patty-Jo's eyes communicate intimacy, and Ginger surprises the observer as she steps out of the frame and nearly into the reader's lap. It was unusual for Ormes to fill a panel as completely as she did this one, and yet it retains her characteristic open and airy style.

*"I insist on carryin' my OWN umbrella, Ginger . . .
but for GOO'ness sakes, don' t let people think you
haven't sense enough to get out of the rain!"*

Copyright 1946, by Jackie Ormes Features.
"I insist on carryin' my OWN umbrella, Ginger . . . but for GOO'ness sakes, don't let people think you haven't sense enough to get out of the rain!"

Psst! . . . Don't get MAD, Sis . . . I jus' couldn't put this off any longer. Another month's growth and it would have become one of the 'terrible frustrations' of my youth!"

May 4, 1946: Ormes must have liked this gag a lot because the visual component showed up at least four times with new captions over the years. Seeing a kid in a mailbox creates tension for the viewer, and it must be resolved by the joke, in this case an explanation that Patty-Jo's little psyche would be damaged if her strange desire to climb inside a mailbox went unfulfilled. Child psychology was much discussed in 1946, the year that Dr. Benjamin Spock published *The Common Sense Book of Baby and Child Care,* a child-rearing guide that became the bible for millions of young parents in the postwar baby boom.

"Psst! . . . Don' t get MAD Sis . . . I jus' couldn' t put this off any longer. Another month' s growth and it would have become one of the ' terrible frustrations' of my youth!"

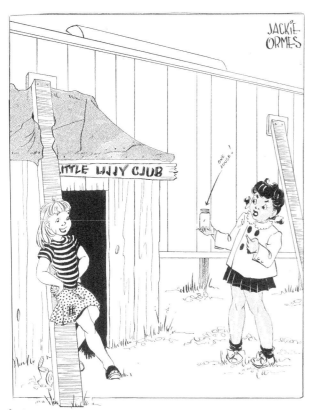

August 31, 1946: Restrictive property covenants in Chicago enforced the segregation of neighborhoods, and many organizations excluded members of specific ethnic groups from membership, even cultured, well-educated, well-dressed citizens like Ormes. The name over the clubhouse is meant to read "Little Lilly Club," as in lily white, and here she debunks the notion of white superiority. This allegory of the "trashy" white girl, who apparently has body lice, being showed up by the smart, neat-as-a-pin black girl is especially caustic for Ormes, whose method is usually gentler. *(This reproduction was made from original art.)*

"I told sis about visiting your exclusive neighborhood club-house yesterday so she figured I better return this little member that followed me home."

October 5, 1946: The image of Patty-Jo's piggy bank seems to pop up in cartoons whose subject matter concerns her strongest desires and commitments. In this panel she introduces the idea of "Daddy," whose progressive opinions she repeats from time to time. Earlier in 1946 the National Association for the Advancement of Colored People had successfully backed *Morgan v. Commonwealth of Virginia,* in which the Supreme Court struck down segregation in interstate bus travel and in railway dining cars. NAACP leader Walter White (who expressed moderate views) as well as W. E. B. Du Bois (who took more liberal positions) were both editorial columnists for the *Pittsburgh Courier. (This reproduction was made from original art.)*

"I'm joining the NAACP tonight . . . Maybe if we all get 'On the ball' now, we won't find ourselves behind that ol' '8 ball' Daddy talks about!"

November 2, 1946: Patty-Jo was not above delivering a harangue on an important subject, and voting was one issue her creator took very seriously. This cartoon appeared a week before congressional elections. While millions of black and some poor white citizens in the South could not register because of restrictive literacy tests, poll taxes, and intimidation, many northerners of all races failed to vote because of apathy or, as Ginger's placard suggests, the inconvenience of bad weather.

"This oughta bring em out to do something even if it's wrong!"

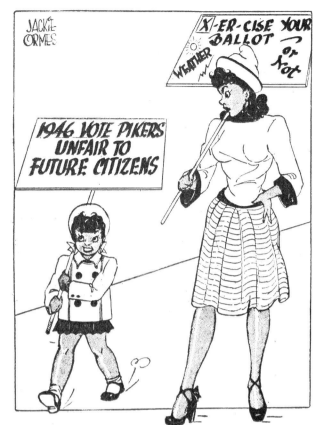

Copyright 1946, by Jackie Ormes Features.
"This oughta bring em out to do something even if it's wrong!"

January 18, 1947: In the postwar years more than twenty thousand polio cases a year were reported in the United States, an epidemic that mostly struck children between four and fifteen years of age, paralyzing their muscles. This is Ormes's first plug for the March of Dimes, a collection drive benefiting the National Infantile Paralysis Foundation. She campaigned for the foundation's polio research and treatment efforts in her cartoons every January for nine years, often adding the organization's logo to the face of those panels.

"Oh, Davie, your 'V-P Day' is getting CLOSER and CLOSER ! . . . I just sent another shiny new dime marching to battle polio."

Copyright 1946, by Jackie Ormes Features.
"Oh, Davie, your 'V-P Day' is getting CLOSER and CLOSER ! . . . I just sent another shiny new dime marching to battle polio."

It's a letter to my Congressman . . . I wanta get it straight from Washington . . . Just which is the "American way" of life, New York or Georgia???

February 8, 1947: Five-year-old Patty-Jo writes her congressman in letters scattered on the floor that say, "Why?" "How come?" and "By the people for the people." Promises made in the Constitution have not been kept for African Americans, she implies, and she reminds people of their duty to speak out against the lingering presence of segregation in the United States.

Around this time, interiors in Ormes's cartoons begin to reflect her taste for the sleek, clean lines of moderne furnishings and artworks on the wall.

"It's a letter to my Congressman . . . I wanta get it straight from Washington . . . Just which is the "American way" of life, New York or Georgia???"

April 5, 1947: Daddy apparently takes issue with the Truman Doctrine approved by Congress three weeks before. This policy of financial aid for the crumbling economies of Greece and Turkey established the United States' position of subduing global Communism, a system that was taking hold in those countries. Ormes's criticism of the doctrine reflects her concerns about America's empire building.

In this drawing, one of Ormes's most delightful, several favorite motifs appear. While intrepid Patty-Jo explores stuff in the attic, a baby carriage in the background reminds us of her young age, the globe reinforces her verbal message, and the mannequin suggests the shape she will inherit. *(This reproduction was made from original art.)*

"I always figured this thing was a world map from the DARK AGES, but the way Daddy talks about Truman's new foreign policy it must be shapin' up this way again!"

I ALWAYS FIGURED THIS THING WAS A WORLD MAP FROM THE DARK AGES, BUT THE WAY DADDY TALKS ABOUT TRUMAN'S NEW FOREIGN POLICY IT MUST BE SHAPIN' UP THIS WAY AGAIN!

July 5, 1947: Fireworks had been banned because of blackout regulations during World War II, but now Americans looked forward to celebrating the Fourth of July with backyard roman candles and cherry bombs. In a disappointing turn of events, several states continued to restrict the sale of fireworks due to safety concerns. Patty-Jo protests curtailment of her liberties in an ironic jibe at a country that develops big, destructive bombs while outlawing her fun with relatively harmless ones. *(This reproduction was made from original art.)*

"Shucks—Let's go price Atom Bombs—They haven't outlawed them yet!!!"

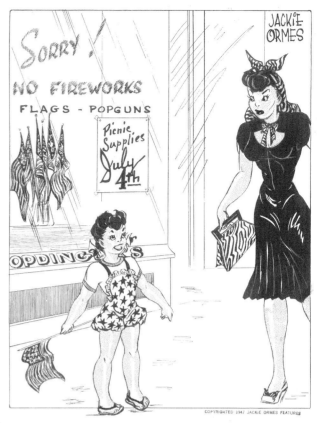

July 12, 1947: Fearful of the gathering threat to freedoms in the cold war era, Patty-Jo compares the vendor's American Beauty rose, a deep red color, to the Soviet Union's—and Bolshevik—red-colored flag. By the time of this cartoon, arguments were flaring in the pages of the *Pittsburgh Courier* as anti-Communists spoke out against and former fellow travelers distanced themselves from the party. On January 17, 1948, a few months after Patty-Jo cautioned the flower vendor, the *Courier* reported on "The first Negro appointed as an investigator . . . working for the House Un-American Activities Committee (HUAC) since last April," whose job was to subpoena "Negro leaders in the area of business, education and religion" as "friendly witnesses" to reveal "Communist recruiting and propaganda among Negroes."

"You're stocked pretty heavy, Leo . . . Ain'cha scared they'll be viewed with alarm by that new committee an' tagged un-American beauties?"

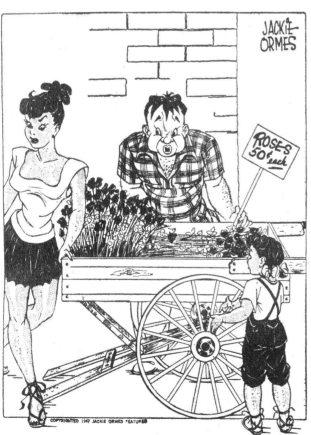

"You're stocked pretty heavy, Leo . . . Ain'cha scared they'll be viewed with alarm by that new committee an' tagged un-American beauties?"

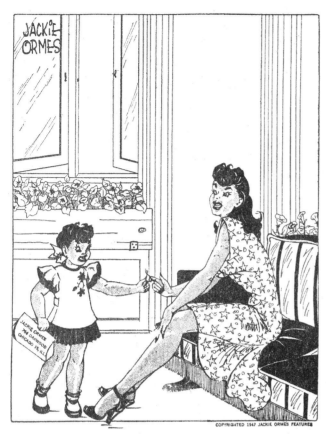

"All I ask for my birthday is a DOLL that won't out-talk ME!"

August 9, 1947: Capitalizing on readers' affection for her little character, Ormes responded to requests by marketing a Patty-Jo doll. She builds anticipation for the doll in this first announcement of its impending production. The contract signed this month with the Terri Lee company permitted her to sell dolls directly from her own home, as well as to earn a percentage of the company's sales. Patty-Jo carries in her hand a coupon with Ormes's address; the actual coupon with her or the company's address also ran from time to time in a *Pittsburgh Courier* ad. Though the Patty-Jo doll was not a talking doll, the reference here is to dolls with talking mechanisms.

"All I ask for my birthday is a DOLL that won' t out-talk ME!"

September 6, 1947: The Terri Lee doll company's huge variety of doll costumes appealed to the fashion-conscious Ormes. Dressing cartoon Patty-Jo in Terri Lee clothing was a subtle yet clever reference to her doll and was intended to promote sales. Ormes was also committed to enriching play for African American children, as the high quality of materials and workmanship in the dolls and their costumes attests. A parade of dolls (from left to right) includes a Patty-Jo cowgirl; five Patty-Jo dolls in dresses; and a boy doll, Benjie, in a shorts set—all authentic Terri Lee costumes found in the company's catalog. *(This reproduction was made from original art.)*

"But they' re so much like me, Sis . . . Just s'pose an idea hits 'em . . . kinda frightnin', isn' t it????"

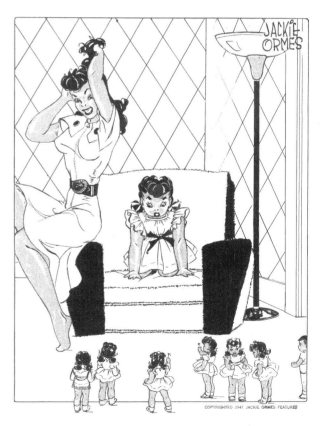

September 13, 1947: The little people keeping Patty-Jo awake are, of course, dolls from the Terri Lee line, all dressed in Terri Lee clothing. Patty-Jo herself wears a Terri Lee pajama set, further promoting sales of the dolls and clothing. Ormes apparently owned a few toy props that she used for models: the roly-poly pig and spring-legged dog are regulars in her cartoons. She expands the boundaries of the panel by pushing elements beyond the edges for readers to imagine a larger room and all the wonderful dolls and toys it must contain. *(This reproduction was made from original art.)*

"Hello . . . Connect me with the Sand Man, please! there are CERTAIN LITTLE PEOPLE in this house who seem DETERMINED to stay awake after MY bedtime!"

"Hello . . . Connect me with the Sand Man, please! There are **certain little people** in this house who seem **determined** to stay awake after **my** bedtime!"

October 4, 1947: The character of Benjie, already a doll in the Terri Lee line, was taken up by Ormes and first appeared in this *Patty-Jo ' n' Ginger* panel. The cowboy and cowgirl costumes come straight from the Terri Lee catalog. Benjie stayed on for years after Ormes ended her association with the company.

In this panel also is an example of language that Ormes used to define Patty-Jo as young and unsophisticated but insightful. Unlike some of her contemporaries, Ormes never imitated black dialect in her captions; constructions like "s'posed" added believability to the little girl's pronouncements. Ormes used the Chicago Park District in many cartoon backgrounds. *(This reproduction was made from original art.)*

"He wasn' t impressed! . . . I TOLD you Benjie! It's COWS that's s'posed to appreciate our finery. We'd be a SENSATION at the STOCKYARDS."

COPYRIGHTED 1947 JACKIE ORMES FEATURES

"OK — OK, YOU'RE MAKIN' IT BUT 1 JUST
KNOW THIS 'NEW LOOK' IS BOUND TO CATCH UP WITH
ME TOO, SOONER OR LATER !"

October 11, 1947: Christian Dior's spring line of couture clothing, called the "New Look," departed from wartime austerities such as knee-length straight skirts. Among Dior's innovations were long, luxuriously billowing skirts no more than twelve inches above the ground. Patty-Jo observes that Ginger is cutting too much off the hemline to be in the very latest style. Ginger has even piled Patty-Jo's hair up *à la française*. Ormes would still be following Dior in August 1954 when Patty-Jo complains about the dictatorial nature of fashion gurus: "Gee . . . it must be awful to have that Dior fella switch rules on you in the middle of the game!" Here a Patty-Jo doll with the Terri Lee trademark daisy on her wrist stands just out of the frame. *(This reproduction was made from original art.)*

"OK — OK — You're makin' it . . . But I just know this 'new look' is bound to catch up with me too, sooner or later!"

October 18, 1947: Ormes invites readers into a darkened movie theater in this virtuoso drafting effort. Its perspectival depth and the use of light and dark demonstrate her artistic maturation from the flat, delicate *Torchy Brown in "Dixie to Harlem"* comic strip ten years earlier. Theaters in South Side Chicago sometimes featured the work of small-budget, self-financed, independent black filmmakers who were responding to stereotypes promoted by the big studios with "black audience" films that promoted positive characters and stories. Characters in these "race movies" had fully formed lives in roles that included middle-class businesspeople, detectives, cowboys, lawyers, and adventurers, to name a few.

"Oh! — But she can't sit here! We're holding this seat for a man . . . Any cute one!"

COPYRIGHTED 1947 JACKIE OR...S FEAT... #1...

"Oh!—But she can't sit here! We're holding this seat for a man . . . Any cute one!"

October 25, 1947: When people dropped money into Community Chest collection cans during the yearly campaign, they received a Red Feather pin to wear showing their support. Since the term *red* was becoming a slur indicating a suspected Communist affiliation, Patty-Jo demurs from a phone solicitor's request. Ormes seems to suggest that people were distancing themselves from affiliation with the Communist Party. Patty-Jo is frequently on the phone, which would have been unusual for a five-year-old at the time. Ginger's leggy silhouette creates interest on the other side of the panel. *(This reproduction was made from original art.)*

"Gee, Sis—Sounds like a VERY worthy cause to support—But who's game enough to wear that Red Feather they're passing out?"

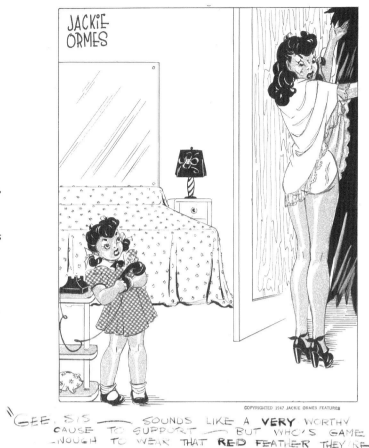

November 1, 1947: The House Un-American Activities Committee marked Hollywood as a hotbed of subversion activities and for two months now had been subpoenaing people in the motion picture industry to testify about purported Communist Party affiliations and influence in the movies. Witnesses were pressured to "name names" of CP members or confess to Communist leanings. This unethical practice was popularly called a "witch hunt" because of its similarity to the seventeenth-century Puritan witch trials. Ormes often spoke out in her cartoon against infringement of free speech or individual liberties, sometimes metaphorically expressing her outrage as she does here.

"You'll be GLAD we came as witches—wait an' see! I understand some Hollywood scouts are simply HUNTING them these days!"

"You'll be GLAD we came as witches—wait an' see! I understand some Hollywood scouts are simply HUNTING them these days!"

"Did you VOTE Tuesday . . . or are YOU a solid
citizen in spite of yourself?"

November 8, 1947: In this yearly reminder for readers
to do their civic duty and vote, Ormes assigns Patty-Jo
the job of scolding people who are too lazy to go
to the polls. The panel also features interesting
period decor, as well as a plug for Ormes's doll
enterprise, with both Patty-Jo and the Benjie doll she
carries wearing Terri Lee clothing. Throughout the
run of *Patty-Jo 'n' Ginger*, men are mentioned and
occasionally seen, but this man gets to sit closer to
Ginger than do most others. Ginger is impatient for
Patty-Jo to go to bed and is tapping her toe.

*"Did you VOTE Tuesday . . . or are YOU a solid citizen
in spite of yourself?"*

January 10, 1948: Ginger strikes an especially
dramatic pose in a setting that could have come
straight out of a stage or film musical extravaganza.
Apparently she had attracted the admiration of a
cartoon fanciers' organization, who named her the
best dumb dame pinup of the year—though no trace
of this organization can be found. Ginger may have
been yummy, but she was no dummy; other cartoons
show her graduating from school; reading books;
and attending the theater, concerts, movies, and art
exhibits.

*"Hey, Sis, Lookit! For saying NOTHING but NOTHING
all last year, 'Cartoon Nuts, Inc.,' have voted you
MISS YUMMY DUMMY of 1947!"*

"Hey, Sis, Lookit! For saying NOTHING but **NOTHING**
all last year, 'Cartoon Nuts, Inc.,' have voted
you MISS YUMMY DUMMY of 1947!"

April 17, 1948: *Patty-Jo 'n' Ginger* and Oliver Harrington's *Dark Laughter* had been appearing in various places in the *Pittsburgh Courier*'s pages, but by now both panels found a home on the same page as the comic strips. The elegant interior Ormes depicts here, in which Patty-Jo's biggest worry is her sister's choice of escort for the evening, contrasts starkly with the *Dark Laughter* panel next to it, in which Bootsie's landlady locks him out of his tenement digs for not paying his rent.

"Gee, that was silly to let yourself in for an evening with that pipsqueak . . . Why don' t I make like I have the measles and he' ll be scared to stick around!"

"Gee, that was silly to let yourself in for an evening with **that** pipsqueak . . . Why don't I make like I have the **measles** and he'll be scared to stick around!"

April 29, 1948: The federal income tax deadline had just passed, and some citizens were still smarting from it or making familiar jokes about its inevitability. Patty-Jo purposely confused the word *tax* with *tacks* and left one on the seat of the chair Ginger just used. This highly stylized composition provides a glimpse of unabashed cheesecake pinup art.

"Gee, Sis . . . Didn' t I tell ya? Benjie an' I were playin' government officials today so we levied lotsa TAX . . . on chairs an' LOW places."

"Gee, Sis . . . Didn't I tell ya? Benjie an' I were playin' government officials today, so we levied lotsa TAX . . . on chairs an' LOW places."

June 19, 1948: When asked if Ormes was a good cook and why she made so many cooking jokes in her cartoons, her sister, Delores, replied, "Oh, yes, she was a wonderful cook. We both thought it was really funny when a woman couldn't cook!" Taxidermy shops were another source of humor for Ormes, as were pet stores and perfume counters. Patty-Jo wears a Terri Lee summer suit in order to remind readers of the character's identification with the doll.

"G' won . . . Ask him somethin' . . . You know what a mess you made of that chicken you stuffed Sunday!"

"G'won . . . Ask him somethin' . . . You know what a mess you made of that **chicken you stuffed Sunday!"**

June 26, 1948: A serious message appears here in *Patty-Jo 'n' Ginger*. In Ginger's right hand is a fund-raising instruction booklet titled "Negro College Fund," and falling to the floor are cards that say "Pledge." The United Negro College Fund started four years earlier to help finance private schools such as Tuskegee and Howard Universities. Patty-Jo points out the injustice of substandard public schools found in poorer black neighborhoods and argues for federal aid to education.

"Gosh—Thanks if you're beggin' for me—But, how's about gettin' our rich Uncle Sam to put good public schools all over, so we can be trained fit for any college?"

"**Gosh—Thanks** if you're beggin' for **me**—But, how's about gettin' our **rich Uncle Sam** to put good public schools all over, so we can be trained fit for **any** college?"

July 24, 1948: Benjie's sometimes right-wing father, always offstage in the cartoon, serves as a convenient foil for Ormes's liberal positions. Disputes between right- and left-wingers at this time included conflicts around labor issues, including a split within the Congress of Industrial Organizations (CIO) union leadership along ideological lines. To complicate matters, a few CIO officials had Communist affiliations. When they and others refused to sign non-Communist affidavits required in the newly enacted Taft-Hartley Act, leftist unions were unable to negotiate contracts and were eventually forced out of the CIO. One of the primary union complaints at this time was minimum wage, which stood at forty cents an hour.

"Naw . . . I don't see much of Benjie anymore. His dad gave him an important political job pulling Wings offa flies . . . Left Ones!"

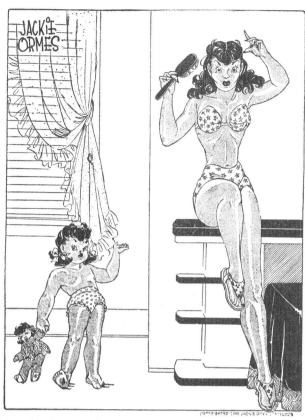

"Naw . . . I don't see much of Benjie anymore. His dad gave him an important political job pulling **Wings** offa flies . . . **Left Ones!**"

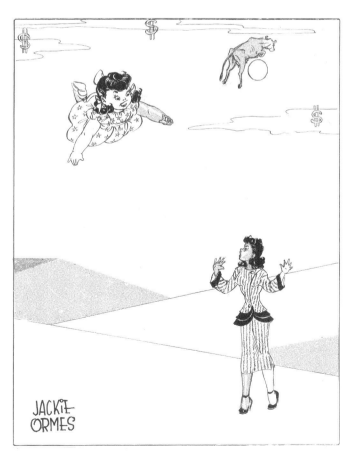

August 14, 1948: Prices were rising rapidly due to the abandonment of wartime price controls and the greatest economic expansion in America's history. The consumer price index rose more than 20 percent in two years; an electric washing machine that cost forty-five dollars in 1943 now cost eighty dollars. Ormes wonders just how crazy the nation's economy will get in this scene reminiscent of surrealist art of the early twentieth century. Patty-Jo's dreamlike fantasy refers to a passage from a nonsensical Mother Goose nursery rhyme: "Hey, diddle, diddle, the cat and the fiddle, the cow jumped over the moon." *(This reproduction was made from original art.)*

"Why not? Everything else is!!"

"Why not? Everything else is!!"

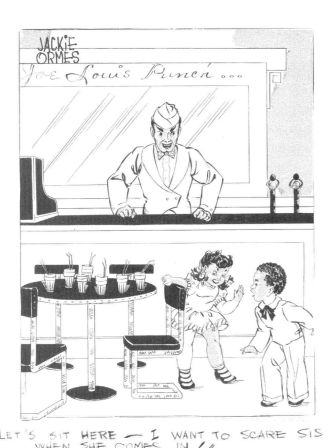

September 11, 1948: Joe Louis's "punch" was responsible for twenty-one career knockouts. The "Brown Bomber" reigned as world heavyweight boxing champion for eleven years and eight months, a record for heavyweights. He became a hero for all Americans when he defeated Max Schmeling, Hitler's symbol of Aryan superiority, in 1938. Louis served in the army during the war, mostly fighting in exhibition matches to raise funds for the armed services and to boost morale. He made personal donations to military relief funds as well. Ormes was acquainted with his ex-wife, Marva, through their work on fashion shows. *(This reproduction was made from original art.)*

"Let's sit here — I want to scare Sis when she comes in!"

October 23, 1948: The subject of racial inequality dominated the year's political campaigns, now in full swing. Democrats lauded President Truman's civil rights performance; Republicans ran ads in the *Pittsburgh Courier* for Thomas Dewey, who promised "citizenship for all"; and Senator Strom Thurmond from South Carolina led a group of "Dixiecrats" in the States Rights Party, whose platform stated, "We stand for the segregation of the races and the integrity of each race."

Here Ginger sports another Dior New Look: softly padded sloping shoulders, cinched-in waist, and a barrel skirt that nearly hobbles the wearer. In a previous panel Patty-Jo had trimmed Ginger's hair; now it looks more like Ormes's own coiffure.

"Guess what, Sis. Miss Loyalouse says our school is 'WAY behind the times . . . Mostly on account of we're still using OLD picture lessons showin' ALL races are EQUAL!"

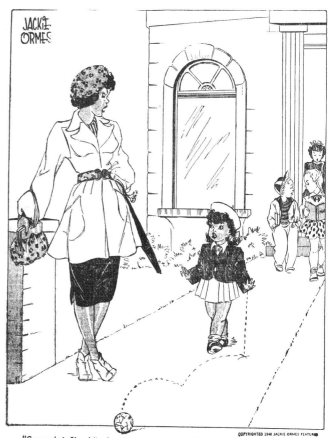

November 20, 1948: Three monkeys on the ledge behind Patty-Jo are sworn to secrecy by their Tendai Buddhist principles to "see no evil, speak no evil, hear no evil." Ormes placed various knickknacks on shelves, bookcases, and end tables in her drawings, engaging viewers' attention and signifying the tastes of her cartoon characters. Patty-Jo rarely caused real mischief; in this somewhat rare example she wears the Terri Lee dotted swiss pinafore. *(This reproduction was made from original art.)*

"O-o-o-o, s'a good thing YOU li'l fellas and I have an understanding about such things!"

"O-0-o-o, s'a good thing **YOU** li'l fellas and I have an understanding about such things!"

"C'mon, Benjie . . . Let's hear THIS one's story. I guess it's like Election: The Santa who promises the merriest platform comes out on top Christmas morning!"

December 11, 1948: Perhaps Ormes is referring to the recent election, in which the Democratic Party made promises to integrate the military, considered by many an essential first step to breaking down barriers in employment and housing. But President Truman moved slowly, and civil rights leaders repeatedly met with him, urging progress. Their persistence paid off, though compliance by some branches of the military was slower than others. In 1951, the demands of the Korean War forced the holdout army to finally order full integration in all units.

"C'mon, Benjie . . . Let's hear THIS one's story. I guess it's like Election: The Santa who promises the merriest platform comes out on top Christmas morning!"

"Hold it, Sis—Le'mme go hide MY 'schmoo' now, before certain committees start investigating—THEN I can risk laughing at this wunnerful story."

February 5, 1949: In 1948, Al Capp introduced into his *Li' l Abner* comic strip armless, pear-shaped critters he called schmoos, whose purpose in life was to have fun, free of social constraints or governance. America went schmoo crazy, and more than one hundred schmoo-themed products came on the market. Capp's anarchic creature was interpreted by some to convey subversive sympathies, and Patty-Jo carries a schmoo toy in several panels, partly in solidarity with her fellow cartoonist. This was another inventive way Ormes found to attack the House Un-American Activities Committee. In Ginger's hands is a copy of *The Life and Times of the Schmoo,* a cartoon book that sold seven hundred thousand copies in its first year.

"Hold it, Sis—Le'mme go hide My 'schmoo' now, before certain committees start investigating—THEN I can risk laughing at this wunnerful story."

March 12, 1949: Patty-Jo offers more advice about proper manners, pointing out how people who talk out loud in theaters distract from the show. This cartoon is interesting for its design and fashion elements and the glimpse it provides of Ginger and Patty-Jo's lifestyle. Patty-Jo wears a Terri Lee coat set, with a little purse, and Ginger's hourglass silhouette is enhanced with a Dior New Look–inspired outfit featuring a leopard jacket, hat, and gloves. Ormes's sister-in-law Vivian recalled that Ormes owned a real leopard jacket. The box-office sign says ninety cents for adults and forty cents for children, and the actor in the poster looks a lot like Gilbert Roland, the Mexican American heartthrob who starred in *The Cisco Kid* movies, which appealed to both children and adults. *(This reproduction was made from original art.)*

"I 'specially liked the part where the lady in front told you an' Jeannie to shut your mouth!"

"I 'SPECIALLY LIKED THE PART WHERE THE LADY IN FRONT TOLD YOU AN' JEANNIE TO SHUT YOUR MOUTH!"

March 19, 1949: Patty-Jo and Ginger have foregone their beauty shop appointment to save money for the circus. They are shown here using a jar of grease, an electric hair iron, rag curlers, and a net to press the natural tight curls out of their hair, according to the beauty dictates of an earlier, less enlightened era. This would be Ormes's only cartoon reference to any distinctly African physical feature. Unlike some of her cartoonist colleagues, she never depicted or commented on differences in African American skin color as representing elements of the "pigmentocracy."

"Gee . . . maybe if I keep remembering we saved CIRCUS money it'll look BETTER!"

"Gee . . . maybe if I keep remembering we saved CIRCUS money it'll look BETTER!"

"HMMM! IT'LL BE INTERESTIN' TO SEE JUST WHAT TYPE OF MAN THIS ATTRACTS . . .!"

April 2, 1949: Patty-Jo teasing Ginger about needing to catch a man was a common humorous subject in the *Patty-Jo 'n' Ginger* series. Ginger was a product of her times, and in this era marriage was high on the list of role expectations for women. Her depiction in the cartoon as an avid consumer of clothing, automobiles, home furnishings, and art reflected Ormes's own taste and was a rich source for humor. Torchy, Ormes's other adult female character, appeared in a strip the next year as an independent adventurer, defying the gender expectations of the era.

Patty-Jo's coat and hat are from the Terri Lee line, and the back is faithfully detailed in the mirror's reflection. *(This reproduction was made from original art.)*

"Hmmm! It'll be interestin' to see just what type of man THIS attracts . . .!"

April 23, 1949: Undercover spies for the Soviet Union were said to have infiltrated the U.S. government, universities, and other organizations, and the House Un-American Activities Committee was determined to ferret them out. In another attack on the HUAC, Ormes ridicules the hysteria generated over the supposed hundreds of Communists alleged to be hiding and planning to undermine the United States. *(This reproduction was made from original art.)*

"What'd I tell you?... underground workers... jus' wait till the un-American Committee hears about this!"

March 30, 1949: Get-rich-quick pyramid schemes were sweeping the nation, and they worked like this: a new member joins a "club" where she hands over $2 and becomes one of the hundreds at the bottom of a pyramid-shaped chart. On subsequent nights she brings in new members and moves up in the chart until the twelfth night, when she becomes number one at the top of the pyramid and receives $4,096. These fraudulent schemes never paid most investors. In the black community, policy (lottery) rackets were familiar types of gambling indulged in by rich and poor alike and winked at by police and politicians. Cartoonist Wilbert Holloway put made-up lottery numbers in his comic strip, *Sunnyboy Sam,* and people wrote to thank him when they won. *(This reproduction was made from original art.)*

"Come quick, Doc ... It must be serious ... Ginger says her PYRAMID'S collapsed!"

May 14, 1949: Kissing games can be chancy, and Patty-Jo disqualifies her first spin when it points to a dandified kid who looks a bit like Scoopie, another comic character in the *Pittsburgh Courier*'s funny pages. Once in a while Ormes would make reference in the panel to another cartoon character on the page, including the times Patty-Jo speaks fondly of Uncle Bootsie of the *Dark Laughter* single panel cartoon. This panel's large white open area is a startling expanse, especially compared to other comics on the page that are filled with detail and shading. Leaving out certain details focuses the viewer's attention on more important aspects, like the children's individualized faces, bodies, and clothing. *(This reproduction was made from original art.)*

"THAT WAS JUS' A PRACTICE SPIN . . . OK?"

"THAT WAS JUS' A PRACTICE SPIN O.K?

May 21, 1949: Patty-Jo works at matchmaking again in one of Ormes's favorite settings, an ice cream shop. Billie Holiday's voice floats up from the jukebox singing "Girls Were Made to Take Care of Boys," a song from a forgettable 1948 movie *One Sunday Afternoon*. Ormes loved music but rarely mentions popular musicians in her cartoons. The *Pittsburgh Courier* enthusiastically reported news of black entertainers and music industry celebrities and ran a yearly write-in contest for fans to choose their favorites. In 1949 the paper had been following a lawsuit that singer Nat King Cole and his wife had brought against a Pittsburgh hotel for refusing them a room because of race. *(This reproduction was made from original art.)*

"Don't look now, Sis . . . But there's a brand new new job for you coming up—but KEEN!"

"Don't look now, Sis . . . But there's a brand new new job for you coming up — but **KEEN!**"

"W-e-e-el, I'M IMPRESSED, BUT LARRY DOBY DOES II BETTER

June 4, 1949: Ormes sometimes singled out news makers and their special achievements. Larry Doby was the first African American to join the American League, only a half year after Jackie Robinson broke the Major League Baseball color barrier in the National League in 1947. Cleveland Indians owner Bill Veeck, who signed Doby, cautioned him to not even glance at an umpire over a disputed call. "My reaction [to racist insults] was to hit the ball as far as I could," Doby said. He hit the longest home run ever in Yankee Stadium nine days before this cartoon appeared. Doby played in the all-star game for six consecutive years starting in 1949; his batting average was .280 in 1949 and .326 in 1950. Ormes used this graphic several more times, with new captions. *(This reproduction was made from original art.)*

"W-e-e-el, I'm Impressed, but Larry Doby does it better."

August 27, 1949: Ormes reminds readers of the problem of hunger in the community. The unemployment rate in the United States was 5.9 percent (up from 3.8 percent the previous year) and even higher in the black community, due to exclusionary hiring policies. The allusion here is to the quarantine cards that county boards of health would place on people's front doors to warn of epidemic disease. For polio victims, often children, the large red cards on their homes were nearly as frightful as the disease, since no one wanted to go near them. Layoffs and deprivation produced their own kind of isolation.

"No foolin' ... It's for Joey's door 'cross the alley ... his daddy said ALL of them got it since he's been laid off, an' it's CATCHIN'!"

"No foolin' . . . it's for Joey's door 'cross the alley . . . his daddy said ALL of them
got it since he's been laid off, an' it's CATCHIN'!"

September 3, 1949: Patty-Jo's adventures often serve as a model for self-improvement, suggesting benefits for those who would take bold actions, like this one, to claim a share of life's pleasures. Patty-Jo's knowledge of amenities like air conditioning, her skill in negotiating the big city, and her self-confident assertiveness all reflect a modern sensibility. Patty-Jo wears a Terri Lee pinafore.

"We dropped in on account of the wonderful things we heard you had here . . . 'specially your AIR-CONDITIONING!"

"We dropped in on account of the wonderful things we heard you had here . . . 'specially your AIR-CONDITIONING!"

"Hold it, Sis . . . don't 'splan nothin' to him! . . . sir, we left that color line blank, and refuse to answer on accounta in THIS school, it might be INCRIMINATIN'."

September 17, 1949: Some of Patty-Jo's antics were visual gags, while others, like this one, were sly verbal musings intended to tap into a collective understanding. Ormes's own school records required a "nationality" identification, and hers was "Am–Negro." The word *incriminating* was much in the air with the House Un-American Activities Committee hearings, with some witnesses pleading the Fifth Amendment with words to the effect, "I refuse to answer on the grounds that I might incriminate myself." Patty-Jo seems to be saying that she might be treated as a criminal if her race were identified on her school application.

Ginger is wearing an angora wool skirt, a cuddly material that was in vogue during the pampered, indulgent postwar years.

"Hold it, Sis . . . don't 'splan nothin' to him! . . . sir, we left that color line blank, and refuse to answer on accounta in THIS school, it might be INCRIMINATIN'."

September 24, 1949: Poking fun at abstract art and its elite status was a frequent gambit in newspaper cartoons designed for popular reading. Jean Dubuffet was an abstract painter inspired by what he called *art brut,* or raw art, from sources he considered uncontaminated by culture, like art made by children or the insane. Though Ormes experimented at times with open space in cartoons, her work never strayed from the representational realm. She attended art exhibits of all kinds, as well as avant-garde theater that dealt with serious themes and more popular attractions like movies and musicals.

"A Frenchman named Dubuffet did it . . . but if you ask ME, he never even TRIED!"

"A Frenchman named Dubuffet did it . . . but if you ask ME, he never even TRIED!"

October 15, 1949: Girls could participate in sports like track and tennis but were barred from contact sports like football. Patty-Jo has challenged this status quo, ruining her Terri Lee jumper and skirt set in the process. In a further challenge to male hegemony, this is one of the first times Ormes's panel appeared in the newspaper above Harrington's *Dark Laughter.*

"What'cha mean it's no game for girls? We got feet too, ain't we?"

"What'cha mean it's no game for girls? We got feet too, ain't we?"

October 22, 1949: Benjie's family serves as a foil to Patty-Jo's: we would not see bugs in Ginger's pantry, nor would her household suffer gladly the sometimes right-wing political remarks of his father. On the other hand, Benjie puts up with a lot while tagging around after Patty-Jo. Though he is mistreated at times, he remains her constant pal.

"Guess what? Over at Benjie's house today his mom gave us lunch, an' gosh!—a raisin got up and walked right outa' the bread pudding!"

"Guess what? Over at Benjie's house to day his mom gave us lunch, an' gosh!—a raisin got up and walked right outa' the bread pudding!"

HOW MERRY CAN YOUR CHRISTMAS BE WITH US TO DECORATE YOUR TREE

December 24, 1949: An unabashed plug for the Patty-Jo and Benjie dolls has them in a Christmas ornament, pitching the dolls "to decorate your tree." Jackie Ormes as Ginger poses in front, along with a gift tag on which is written her name and address, inviting people to write directly to her to order a Patty-Jo doll. By now relations between Ormes and the Terri Lee company had unraveled. Evidence shows that her contract lapsed this month, and this cartoon was an effort to sell the last Patty-Jo dolls in her inventory. The dolls and a few fashions from the Terri Lee catalog, however, continued to appear in her cartoon.

". . . For ONE and ALL, from ALL of ME!"

" . . . For ONE and ALL, from ALL of ME!"

"A Touch for a Crutch"

January 14, 1950: Patty-Jo's words were written not only to entertain but also to remind readers of their social responsibilities. Ormes began each new year with a kickoff cartoon for the March of Dimes polio campaign (the first was on January 18, 1947). When her cartooning days ended, Ormes continued to help as chairperson for the door-to-door campaign in her area.

"A Touch for a Crutch"

February 11,1950: Late in January President Truman instructed the Atomic Energy Commission (AEC) to develop the hydrogen bomb. Originally established to devise peaceful uses for the atom, the AEC, with plentiful resources, now was dedicated to developing weapons in an attempt to stay ahead of the Soviet Union in the arms race. At the same time, slum housing and privation were all too evident in Ormes's backyard. Scenes depicting poverty were unusual for Ormes, whose signature style featured representations of glamour and elegance. When asked in the mid-1980s to contribute a cartoon to represent her work in a doll history book, this is the one she sent.

"Now you folks can REALLY stop worryin' . . . Uncle Sam's blowing our national wad on an H-bomb for your PROTECTION . . . course that don't spell HOUSING, but you gotta admit, it ain't HAY, either!"

''Now you folks can REALLY stop worryin' . . . Uncle Sam's blowing our national wad on an H-bomb for your PROTECTION . . . course, that don't spell HOUSING, but you gotta admit it ain't HAY, either!''

March 18, 1950: Ormes suggests the ambiguity of mixed racial heritage and the need to fight for rights of all kinds, including the right to simply share the fun of St. Patrick's Day festivities. In South Side Chicago, where Ormes lived, people of all backgrounds turned out for the St. Patrick's Day parade. Today the parade is held downtown, and the Chicago River is dyed green, its waters remaining that color for about a week. *(This reproduction was made from original art.)*

"You betcha I'm mad . . . that smart alec Micky O'Shannan starts snickerin' at li'l ol' brown me wearin' St. Patrick trimmin's an' I hadda use my African an' Indian warfare to defend my Irish!"

June 17, 1950: Patty-Jo teases Ginger that a toy cowboy is taking a peek at her. Ormes's cartoons occasionally featured near nudity and even innocent voyeurism. In another cartoon, Patty-Jo spies a peeper's eye looking at Ginger through a hotel room keyhole. The *Pittsburgh Courier* was an independent paper that could set its own code for propriety. By contrast, thirty-seven mainstream syndicated newspapers canceled one day's *Miss Fury* in 1942 because they thought the bikini she was wearing was too revealing. Undoubtedly it was important for this family paper that Ginger was a wholesome girl next door who never gave a come-hither look or noticed people were watching her.

"Oooops! . . . Howdy, Ma' am!"

"Oooops! . . . Howdy, Ma'am!"

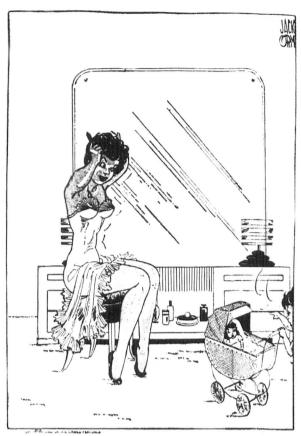

" . . . an' the man I marry has got to love dolls, too!"

September 2, 1950: Patty-Jo might as well have said, "an' the man I marry has got to love *children* too!" Patty-Jo is already thinking about the future, marriage, and babies, topics well beyond a five-year-old's ken—which makes the cartoon funny. Ormes's cartoons often included home furnishings; the influence of designers Ray and Charles Eames, also of Chicago, can be detected here.

The Patty-Jo doll still showed up in panels, though Ormes's contract with the Terri Lee company had ended nearly a year earlier. Patty-Jo is simply a truth teller here: Ormes surrounded herself with dolls and talked about her hobby with other doll artists and collectors.

". . . an' the man I marry has got to love dolls, too!"

December 30, 1950: If salt is sprinkled on a bird's tail, the story goes, it cannot fly and can be caught. Around this time Ormes began a leitmotif bearing a serious message of peace. The Korean War, which started in June, went on for years, with many lives lost and resources dissipated on all sides. Perhaps worse, it was seen as a metaphoric battleground for cold war supremacy in a world with nuclear weapons. In December, the U.S. delegate to the United Nations, Ralph Bunche, an African American, was awarded the Nobel Peace Prize for his work.

"Gee—PEACE DOVES—an' me with no salt!"

"Gee — PEACE DOVES — an' me with no salt."

January 6, 1951: Comedian and bandleader Phil Harris had recorded a song titled "The Thing," which had a punch line of three loud beats on a bass drum instead of words. The song tells of a beachcomber who finds an unnameable "thing" (read "boom-boom-boom" in drum beats) he can't get rid of and is forever shunned, even at St. Peter's pearly gates. The song was catchy and fun, but at the same time it drove people crazy with its repetitive percussion booming over and over on the radio. The caption on this cartoon is a refrain from the lyrics.

"Get outa HERE with that boom-boom-boom . . . an' don' t come back no more!"

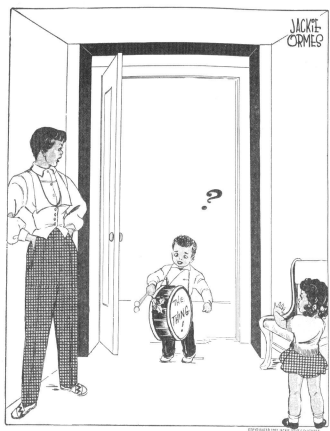

"Get outa HERE with that boom-boom-boom . . . an' don't come back no more!"

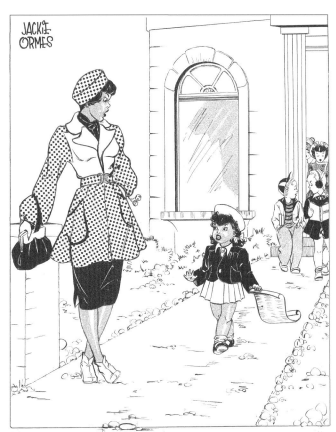

"We kids got up a petition for the Congress . . . protesting guaranteed SOCIAL INSECURITY. We claim it's heading us for a DESPAIR STATE an' robs us of our ambition to be adults!"

January 13, 1951: One possible interpretation of this caption is that Ormes supports expanding social welfare programs. It probably means that if Congress defeats a proposed expansion of the Social Security Act, designed to increase benefits for retirement, the nation's children will inherit "social insecurity." They will live in a "despair state" and have anxieties about growing up to be adults who are forced to retire in poverty. Interestingly, at this time in history the term *welfare state* had a positive connotation as a place where no one suffers privation. Because of their long history of economic struggle, African Americans were reported to place great confidence in Social Security.

The art appeared once before, on October 23, 1948; now the characters are freshened up in a change of clothing. *(This reproduction was made from original art.)*

"We kids got up a petition for the Congress . . . protesting guaranteed SOCIAL INSECURITY. We claim it's heading us for a DESPAIR STATE an' robs us of our ambition to be adults!"

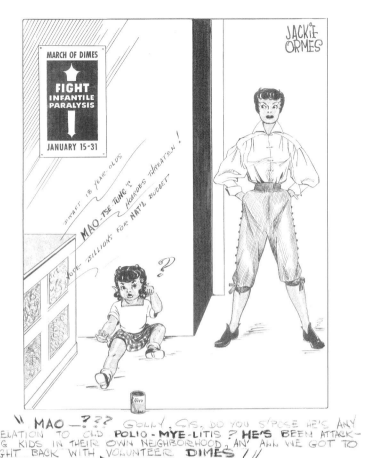

January 27, 1951: Ormes allows Patty-Jo to confuse the words *Mao Tse-tung* and *polio myelitis* in order to make a political point and to make her pitch for the March of Dimes at the same time. Mao Tse-tung had consolidated power in what was now the People's Republic of China, a Communist ally of the expansionist Soviet Union. Ormes lampoons what she feels is an overreaction by the United States to the threat of foreign powers and focuses instead on threats at home, like infantile paralysis. In his State of the Union speech this month, the president identified ten urgent legislative matters, starting with "First, appropriations for our military buildup, and second, extension and revision of the Selective Service Act."

Ginger is on the cusp of fashion in her toreador pants; now that it is acceptable for women to wear pants, they are getting shorter. (*This reproduction was made from original art.*)

"MAO—??? Golly, Sis, do you s'pose he's any relation to old POLIO-MYE-LITIS? HE'S been attacking kids in their own neighborhood, an' all we got to fight back with is volunteer DIMES!"

February 10, 1951: Ormes's criticism of Truman may seem curious because he championed civil rights legislation during the time of a reactionary southern-controlled Congress. "Civil rights is a 'dead duck' for the duration of the Eighty-second Congress!" began a lead story on the *Pittsburgh Courier*'s front page a month earlier. Some modest progress was being made, however: another headline read "LSU Must Accept First Race Student." Ormes's protest against Truman here refers to his efforts to thwart the Sino-Soviet alliance.

Rarely do we get a view of Patty-Jo and Ginger from the back or a streetscape receding in one-point perspective. Ginger's stylish see-through boots were made of plastic, a sensational postwar material that was finding new uses.

"Hm-m-m . . . I guess Mr. Truman hasn't told the Lord about our sanctions against Red China yet . . . he's still sending us this daily hunk of sun from the ORIENT!"

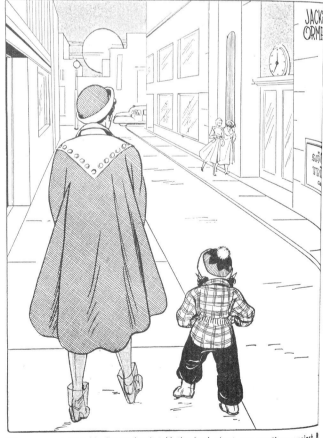

"Hm-m-m . . . I guess Mr. Truman hasn't told the Lord about our sanctions against Red China yet . . . he's still sending us this daily hunk of sun from the ORIENT!"

March 10, 1951: Workers like "Benjie's daddy" complain that while government raises taxes employers don't raise wages. The *Pittsburgh Courier* put this cartoon on the opinion page, along with Wilbert Holloway's editorial cartoon of a "taxpayer" struggling under weights labeled "taxes" that two "politicians" are piling on his back. Holloway's cartoon illustrates an article that names the new phenomena of luxury and sales taxes, along with the usual federal, state, and city taxes, and "hundreds of others cleverly hidden from view . . . [like] exorbitant prices for FOOD largely because of Government crop subsidies designed to hold the farm vote."

"Look . . . a parade with no music! Benjie's daddy is out there, and HE said the JOBS are okay, but they wanta EAT after taxes!"

"Look . . . a parade with no music! Benjie's daddy is out there, and HE said the JOBS are okay, but they wanta EAT after taxes!"

"So, like I said, the Rev. Mr. Holy was leading the congregation in prayer and got us into a wonderful chorus of PEACE MONGERING when Uncle Bootsie yelled 'LAWD an' MR. TRU-MAN, TOO!' . . . then a mother jumped straight up an' shouted AMEN . . . that's when the preacher stopped cold an' said: 'This is Easter, Brother Bootsie, let's keep it CLEAN. We don't want no FBI in here!'"

March 24, 1951: Patty-Jo often sticks up for Uncle Bootsie, the alter ego for Oliver Harrington, a *Pittsburgh Courier* cartoonist who frequently drew cartoon diatribes about racial injustice. Harrington's work was sometimes found in the *People's Voice,* a newspaper that became aligned with the Communist Party after Congressman Adam Clayton Powell, Jr., resigned as editor in 1946. Naturally Harrington's political connections got the attention of the FBI and House Un-American Activities Committee, and late in 1951 he moved to Paris to escape their harassment. Black-owned newspapers provided one of the few venues for African Americans to speak out, and in this era Ormes and Harrington spoke critically about the government in the *Courier*'s funny pages.

"So, like I said, the Rev. Mr. Holy was leading the congregation in prayer and got us into a wonderful chorus of PEACE MONGERING when Uncle Bootsie yelled 'LAWD an' MR. TRUMAN, TOO!' . . . then a mother jumped straight up an' shouted AMEN . . . that's when the preacher stopped cold an' said: 'This is Easter, Brother Bootsie, let's keep it CLEAN. We don't want no FBI in here!'"

April 7, 1951: The House Un-American Activities Committee investigated leading "colored" people, in a practice of red-baiting designed to discredit the civil rights movement. The movie posters in the background for *Southern Fury* and *Dixie Belle* and the "Rear Door" sign suggest a reference to the humiliating rules of segregation in the South. Most mixed-race theaters in southern states restricted African Americans to separate entrances and separate seating, which usually was inferior.

"It would be interestin' to discover WHICH committee decided it was un-American to be COLORED!"

"It would be interestin' to discover WHICH committee decided it was un-American to be COLORED!"

June 9, 1951: Patty-Jo has brought home a disappointing report card, and she explains the bad grades by suggesting that she and the teacher hold conflicting worldviews. Patty-Jo may be asserting that her "attitude" is her love for all the world's people, whereas her teacher insists that the people of some foreign nations are hateful enemies.

The world globe is frequently in the background when Ormes satirizes such things as weapons buildups, nationalism, and war. Other items used as stage props are the Mexican figurine and the cactus planter. Ginger's string sandals are trendy, and readers get a peek at the garter fastener and top edge of her nylon stocking.

"Yeah . . . it's my ATTITUDE teacher keeps gripin' about, but I tell her I'm not equipped to HATE people in big chunks, seein' as how my HEART'S just for lovin', I got no place to put it . . . HAVE I?"

"Yeah . . . It's my ATTITUDE teacher keeps gripin' about, but I tell her I'm not equipped to HATE people in big chunks, seein' as how my HEART'S just for lovin', I got no place to put it . . . HAVE I?"

June 16, 1951: Ormes attacks the national hysteria about Communism with a clever play on words. The boy runs away in such haste that it looks like he's gone mad or, as the expression goes, lost his marbles. A "commie" was the name for a child's common clay marble, but to an adult it meant "commie rat" as in a person of the Communist persuasion.

"O . . . him? He hasn't got any MARBLES! SOMEBODY told him they outlawed 'commies', so he gave 'em all to me an' RAN like crazy!"

"O . . . him? He hasn't got any MARBLES! SOMEBODY told him they outlawed 'commies', so he gave 'em all to me an' RAN like crazy!"

" . . . so IT seems our A-bombs can make Americans outa ANYBODY, no matter WHERE!"

June 23, 1951: Perhaps Ormes was referring to the irony of an impending alliance to further restore relations between two former combatants. The Japan–U.S. Security Treaty, signed on September 8, ended occupation but allowed Americans to use the island of Okinawa as a military base. Indeed, it seemed for Japan there was no choice but to seek the protection of America's nuclear and military might, and for the United States it was better to provide a nuclear shield than to give Japan nuclear secrets. The Korean War raged nearby, and "Japan did not have one single man under arms and we took the obligation of assuring the defense of Japan," recalled a U.S. ambassador when the treaty was renegotiated years later.

". . . so IT seems our A-bombs can make Americans outa ANYBODY, no matter WHERE!"

"Guaranteed SPEAKIN' birds, huh? That's interesting . . . what are they IN for . . . conspirin' to teach or advocate something' against HUMANS?"

July 28, 1951: Encroachments on free speech seemed to make Ormes's blood boil. In May a Supreme Court ruling in *Dennis v. the United States* affirmed the convictions of eleven Communist Party members under the Smith Act and was one of the landmark rulings of the century. In his dissent Justice Hugo Black wrote, "These petitioners were not charged with an attempt to overthrow the Government. . . . The charge was that they agreed to assemble to talk and to publish ideas at a later date. . . . this is a virulent form of prior censorship of speech and press which I believe the First Amendment forbids." Pet stores were a favorite setting for Ormes's cartoons dealing with freedom of speech controversies. Because she owned an African Grey parrot herself, she was well aware that parrots are unbridled talkers.

"Guaranteed SPEAKIN' birds, huh? That's interesting . . . what are they IN for . . . conspirin' to teach or advocate something against HUMANS?"

August 18, 1951: This dizzying version of a soda shop stood out in the funny pages for its bold distortion of forms, inclined floor, spare geometric windows, and industrial-style soda counter. Ormes was attentive to the styles of various schools of art, as in this drawing that echoes the clean profile of the International Style found in some of Chicago's modernist architecture. Panels sometimes feature Ginger taking Patty-Jo to an art gallery. In one such panel the little girl admonishes her big sister about abstract paintings: "Don't 'ADMIRE' any more of his paintings. . . . he'll give us another one!" Those looking for double meaning here might conclude that Patty-Jo is ridiculing the ways people mismanage their money. *(This reproduction was made from original art.)*

"What can I get with a dime that keeps fallin' through the hole that quarter burned in my pocket this afternoon?"

WHAT CAN I GET WITH A DIME THAT KEEPS FALLIN' THROUGH THE **HOLE** THAT QUARTER BURNED IN MY POCKET THIS AFTERNOON?

October 6, 1951: Ormes comments on the rise of militarism in America and the irony of using the word *peace* for meetings that further the cold war. Four weeks earlier Western allies and the Soviet Union met at the San Francisco Peace Conference to work out a treaty granting Japan increased sovereignty. One of the U.S. goals for this meeting, in addition to that of reconciling Japan with its Asian neighbors, was to diplomatically outflank the Soviet Union, making its Communist expansion efforts in the Pacific untenable. *(This reproduction was made from original art.)*

"Could I go to the PEACE conference with Benjie's folks, huh, Sis? . . . I want to live dangerously!"

November 24, 1951: Operation Cleaver was the name of an offensive assault upon the Iron Triangle area in Korea by the IX Corps of the United Nations forces, which included Turkey and fifteen other countries. Ormes opposed U.S. involvement in Korea, as evidenced in a report from her FBI file, based on a 1953 interview: "The subject [Ormes] spoke of Korea, stating that we (United States and/or United Nations) were the aggressors in that conflict and should withdraw and permit 'Asians to fight Asians.'" *(This reproduction was made from original art.)*

"No foolin' . . . so this smart turkey looks up at Mr. Shultz holdin' the axe, an' sez, 'But I'm SURE you're MISTAKEN, sir . . . I was just reading an old newspaper this morning that said we TURKEYS were such VALUABLE allies in your Korean OPERATION CLEAVER!"

December 1, 1951: In the 1950s, African Americans were nearly invisible in history textbooks that contained such chapter titles as "The American Way" and "Land of Promise." Some history teachers (but apparently not Patty-Jo's) taught "against the textbook," challenging the material and presenting additional facts in order to better represent truth and to open an exchange of ideas. Negro History Week was organized by Harvard scholar Carter G. Woodson in 1926 for people to reflect on black achievement, making, in his words, "the world see the Negro as a participant rather than as a lay figure in history." In 1976 Black History Month was implemented, a time when events and programs across America bear witness to black accomplishment.

"But I'm proud to flunk my history course. I can't help it if the school hasn't got the right text book on Negro Americans . . . I jus' feel good contradictin' the teacher when she's wrong!"

December 22, 1951: Most *Pittsburgh Courier* cartoonists, including Ormes, extended Christmas and New Year's wishes in their comics. Putting aside the merrier themes of dolls and presents of her late 1940s panels, Ormes carried a sober wish for peace in her newspaper greeting this year. The drawing of Ginger here is a dead ringer for Ormes, thus underscoring her own identity with that of Patty-Jo's big sister and personalizing her cause for peace. By now she was drawing and writing both *Patty-Jo 'n' Ginger* and *Torchy in Heartbeats*.

"An' please, God . . . if we can't have PEACE all over, let's at least limit the fightin' to the few folks who are MAD at EACH OTHER!"

December 29, 1951: The aesthetics of the world of science fiction influenced this futuristic scene of Patty-Jo and Ginger walking melodramatically through a beam of light that ends on Earth. Or is it Earth? Some characters in the sci-fi films of the era were carried off to a more peaceful planet. Movies such as *The Day the Earth Stood Still* (1951) were arty antinuclear allegories where aliens from outer space sometimes bring messages of peace and understanding but are misunderstood and come to a bad end; most often, however, the aliens are menacing, such as those in *The Thing from Another World* (1951).

"And, let's insist for ourselves—and little folks EVERYWHERE, that all our steps be FORWARD in 1952!"

"And, let's insist for ourselves — and little folks EVERYWHERE, that all our steps be FOR-WARD in 1952!"

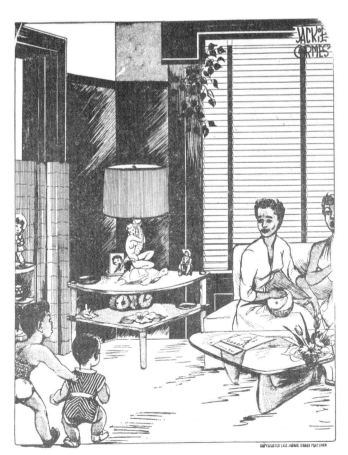

"Mrs. Simpson, your little boy has just come up with a brilliant idea—he wants to go home!"

June 21, 1952: Most *Patty-Jo 'n' Ginger* cartoons featured domestic scenes with Patty-Jo delivering a wisecrack. This cartoon is interesting for its many decorative elements, all of which could be found in the Ormes home. Centered in the panel is a lamp with a nude female figure riding a turtle and embracing a fish-tailed sea creature, a possible reference to Aphrodite, the Greek goddess of love, beauty, and desire, who in one legend was born from the foam of the sea and who held sea tortoises as sacred. The lamp appears a few more times in cartoons, as does the glass-top coffee table designed by Isamu Noguchi and first manufactured by Herman Miller in 1944.

"Mrs. Simpson, your little boy has just come up with a brilliant idea—he wants to go home!"

"Say, uh . . . Mr. Delegate . . . folks are sayin' you might have an' old civil rights plank to throw out . . . an' we're waitin' around to grab it if you do, 'cause we figure it oughta make a dandy SEE-SAW!"

July 12, 1952: The 1952 Democratic and Republican national conventions were held in Chicago, and Jackie Ormes attended with press credentials. In this cartoon she expresses the fears of many African Americans in this play on words that suggests the ambivalent support politicians gave to civil rights initiatives. The Democratic Party had nearly lost the 1948 election when southerners split over Truman's strong civil rights plank. In 1952, to qualm southern jitters, they nominated Alabama senator John Sparkman as the vice presidential running mate for Illinois senator Adlai Stevenson. Republicans nominated General Dwight D. Eisenhower, with Richard M. Nixon as his running mate.

"Say, uh . . . Mr. Delegate . . . folks are sayin' you might have an' old civil rights plank to throw out . . . an' we're waitin' around to grab it if you do, 'cause we figure it oughta make a dandy SEE-SAW!"

August 9, 1952: Ormes seemed struck by the carnival atmosphere of national conventions where delegates wore goofy hats, cheered wildly when their candidate's name was mentioned, and interrupted proceedings to dance in snake lines across the convention floor. Ormes's depiction of the "We-kidlican Nashnal Convenshun" looks orderly in comparison to real conventions. Some of the millions of Americans who saw the proceedings for the first time on television complained that the silly demonstrations degraded the seriousness of the process. By 1956 the nominating process had been streamlined, and both parties made efforts to select a candidate early so the televised conventions could be used to stage party support in front of a TV audience.

"Mr. Chairman, I rise to state for the record that the PEEP-UL of the convention got gripes, fears and ambitions the REST'A the POLITICIANS never HEARD about!"

"Mr. Chairman, I rise to state for the record that the PEEP-UL of the convention got gripes, fears and ambitions the REST'A the POLITICIANS never HEARD about!"

October 25, 1952: Heavy fighting had been raging for two months when North Korea broke off peace talks over the issue of repatriation, insisting that their soldiers who wanted to stay in South Korea be returned. U.S. secretary of state Dean Acheson delivered a speech to the UN General Assembly on that issue, saying a vote of support would test the UN's staying power; he was persuasive, and the UN supported the measure to let the soldiers remain. As an opponent of the Korean War, Ormes ridicules the UN's affirmation of Acheson's entreaties. Many people regarded American involvement as an effort to defend South Korea from aggressors from North Korea, but to Ormes it seemed like America meddling in a civil dispute.

"It's important . . . I'm submitting a nice Christian name for the U. N. Assembly this season . . . we should call it Mr. Acheson's AMEN CORNER!"

important . . . I'm submitting a nice Christian name for the U. N. Assembly this season . . . we should call it Mr. Acheson's AMEN CORNER!"

"I'm being GOOD this morning, so I c'n go over to Bernnie's house today and play . . . AIR RAID . . . with pillows for bombs, I think! Feathers'll fly like crazy an' we'll duck for shelter and then WOW . . . we tear back HERE before his Dad gets home!!!

October 24, 1953: In the cold war era, when both the United States and the Soviet Union possessed the atom bomb, schoolchildren were often made to participate in school bomb drills.

In this period, African art begins to show up in the cartoon, including carved masks on the walls and figures on tables and bookshelves. The painting of an African woman depicted here was an actual painting by Jackie Ormes that hung on the wall of her home. A *Vogue* magazine on the ubiquitous glass table suggests Ginger's—and Ormes's—unseen presence.

By 1953, with Ormes now drawing both *Torchy in Heartbeats* (a full-color comic strip) and *Patty-Jo 'n' Ginger,* she began to recycle topics and visuals from previous years in *Patty-Jo 'n' Ginger.* For that reason, only two cartoons from 1953 are presented here.

"I'm being GOOD this morning, so I c'n go over to Bernnie's house today and play . . . AIR RAID . . . with pillows for bombs, I think! Feathers'll fly like crazy an' we'll duck for shelter and then WOW . . . we tear back HERE before his Dad gets home!!!"

"So HERE we are ON TELEVISION . . . wonder who's tuned in?"

October 31, 1953: This funny kid joke also makes reference to the inequities inherent in the new and very popular medium of television. Patty-Jo intimates that the only way an African American could get on television is by sitting on it.

This composition packs in many of Ormes's favorite props, which by now would be familiar to *Pittsburgh Courier* readers. She had used the world globe since 1946, and the Patty-Jo doll is still around even though her connection with the Terri Lee company ended in 1949. The Aphrodite and tortoise lamp appears again, along with bamboo matchstick window shades, which lend an exotic feel to the room. The 1950s "butterfly" canvas-and-steel chair pushing out of the right side of the frame is a new addition. The television, placed front and center, dominates this panel—as well as American culture in general.

"So HERE we are ON TELEVISION . . . wonder who's tuned in?"

May 8, 1954: Ormes ridicules congressional hearings led by Wisconsin senator Joseph McCarthy that had been running on television since January. Millions of Americans watched the senator and his aides fanning the flames of the Red Scare as they hunted for Communists in the army and government. Public support began to evaporate before the spectacle of McCarthy bullying, harassing, and browbeating witnesses with no hard evidence to support his accusations. When McCarthy obliquely attacked President Eisenhower and Secretary of the Army Robert T. Stevens, the Senate finally censured McCarthy. Ormes had a soul mate in cartoonist Walt Kelly, who was at the time caricaturing McCarthy as a wily bobcat in his comic strip *Pogo* in the mainstream papers, calling him "Senator Malarkey."

"It's a movie starring CINAMACARTHY again . . . continued from last week!"

"It's a movie starring CINAMACARTHY again . . . continued from last week!"

May 15, 1954: The Ormeses now lived in the Sutherland Hotel, which Earl managed and which featured a jazz club and a dinner-dance ballroom, where the music-loving Jackie Ormes undoubtedly took in performances.

The chest that's featured here is by Heywood-Wakefield, furniture that in the era typified style and class. Other Heywood-Wakefield pieces show up in the cartoon from time to time; this piece belonged to Ormes and can be seen in the background of a 1985 photograph of her.

"Don' t be infantile, Benjie! We' re on a strictly classical kick in our house these days . . . Nothing but Stan Kenton 'n' George Shearing stuff is spinning . . . but nothing!"

"Don't be infantile, Benjie! We're on a strictly classical kick in our house these days . . . Nothing but Stan Kenton 'n' George Shearing stuff is spinning . . . but nothing!"

August 14, 1954: Ormes pokes fun at the dictators of fashion and the fans who follow them in this self-aware parody. Christian Dior pronounced the wasp waist and bouffant skirt outré in 1954 and replaced it with his slender H-line silhouette.

Ginger's presence in *Patty-Jo 'n' Ginger* began to wane between 1950 and 1954 when Ormes was busy drawing *Patty-Jo 'n' Ginger*, *Torchy in Heartbeats*, and *Torchy Togs* paper doll cutouts, which appeared in full color next to the *Torchy* comic strip. Ormes was hard-pressed to come up with more of the detailed fashions readers expected to see on Ginger, so she cleverly hid most of her or omitted her entirely. In September, *Torchy in Heartbeats* came to an end, leaving *Patty-Jo 'n' Ginger* as Ormes's only cartoon.

"Gee . . . it must be awful to have to have that Dior fella switch rules on you in the middle of the game!"

"Gee . . . it must be awful to have to have that Dior fella switch rules on you in the middle of the game!"

October 16, 1954: Patty-Jo stands up to protest states' reaction to desegregation of schools following the Supreme Court's *Brown v. Board of Education* decision on May 17, 1954. States such as Delaware and Maryland that had segregation laws were slow to respond. Chief Justice Earl Warren spoke for the Court a year later in a rearguing of what is called the *Brown II* case. Warren delivered the unanimous decision that states should enforce desegregation "with all deliberate speed." Patty-Jo's malapropism is a little spicy for her audience, who look surprised. The double meaning of her words and the words on the blackboard concerns more serious business.

". . . One ' Naked Individual,' with Liberty and Justice for all!!!"

October 8, 1955: Patty-Jo ridicules the absurdity of a whistle provoking the murder of a child. Emmett Till was a fourteen-year-old African American from Chicago who was visiting his Mississippi family when he was accused of flirting with a white woman, reportedly whistling at her. The woman's husband and another man kidnapped and murdered Till, were acquitted in a sham trial, and later admitted the crime. Americans both black and white were outraged at the realization that not even children were immune from racist violence. Most accounts credit school desegregation and the Montgomery bus boycott with starting the large-scale civil rights movement, but many believe the Emmett Till case did just as much to energize the country for legal and social reform.

"I don' t want to seem touchy on the subject . . . but, that new little white tea-kettle just whistled at me!"

December 17, 1955: Ormes's style changed about the time the *Pittsburgh Courier* went to a smaller tabloid format. Gone are the delicate lines and supple curves; the characters now seem static, flat, and less believable. Production changes may have been limiting or dispiriting, or the rheumatoid arthritis that would eventually cripple her hands may have started to affect her drawing. Weeks went by with no *Patty-Jo 'n' Ginger* in the *Courier*'s pages. When it did appear it was the only cartoon in the regular pages; the magazine section carried all the other comics, such as the adventure strip *The Chisholm Kid; Kandy,* about a beautiful, independent woman; and the detective-glamour feature, *Mark Hunt.*

"LET'S GET OUT OF HERE . . . I DON'T THINK HE APPROVES OF US!"

"LET'S GET OUT OF HERE . . . I DON'T THINK HE APPROVES OF US!"

"Right inisde, ladies . . . You're expected, I'm sure!"

January 21, 1956: Ormes kept up her yearly cartoon for the March of Dimes until this last appearance. An injectable vaccine for polio was announced by Dr. Jonas Salk nine months before, and now the March of Dimes funded a search for an oral vaccine—licensed in 1962—as well as research into other childhood diseases. Polio knew no racial barrier; the March of Dimes often included young African Americans in their poster children ads.

"Right inisde, ladies . . . You're expected, I'm sure!"

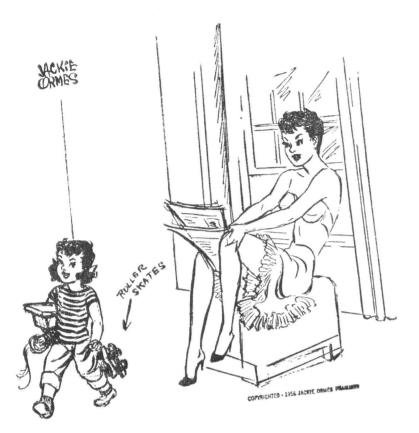

March 31, 1956: For a period of several weeks, *Patty-Jo 'n' Ginger* appeared only rarely, except when Ormes was inspired to rally behind an extraordinary cause such as the Montgomery bus boycott. In support of Rosa Parks's refusal to relinquish her seat to a white man, the African Americans of Montgomery would not board city buses. The boycott was led by a young Martin Luther King Jr., and it continued for 381 days until the U.S. Supreme Court found segregated seating unconstitutional. Patty-Jo is packing up her roller skates to send to the black citizens of Montgomery to help them get around, and Ginger, though a shadow of her former self, perches in a trademark pose.

"You guessed it! Bundle for the South . . .
Montgomery, Ala., that is!"

"You guessed it! Bundle for the South . . . Montgomery, Ala., that is!"

September 22, 1956: In this, her last, *Patty-Jo 'n' Ginger,* Ormes aims a parting shot at racism. Patty-Jo has just read the newspaper headlines of the ongoing bus boycott in Montgomery, and she suggests that Ginger could help change things by "running" and getting into politics to change unfair laws. The U.S. Supreme Court would declare segregation unconstitutional two months later, and on December 21 African Americans began riding buses again.

This cartoon doesn't disappoint the fashion conscious. Ginger wears a stylish side-slit sheath, sling-back shoes, and seamed stockings. Once her cartooning days ended, Ormes trained models, produced fashion shows, and lent her name and know-how to fund-raisers for the Urban League. She continued making oil paintings; worked on boards of directors for housing, theater, and arts enterprises; and with her husband enjoyed entertaining his business guests.

"So, that's politics. Why don't you RUN for a BUS?"

"So, that's politics! Why don't you RUN for a BUS?"

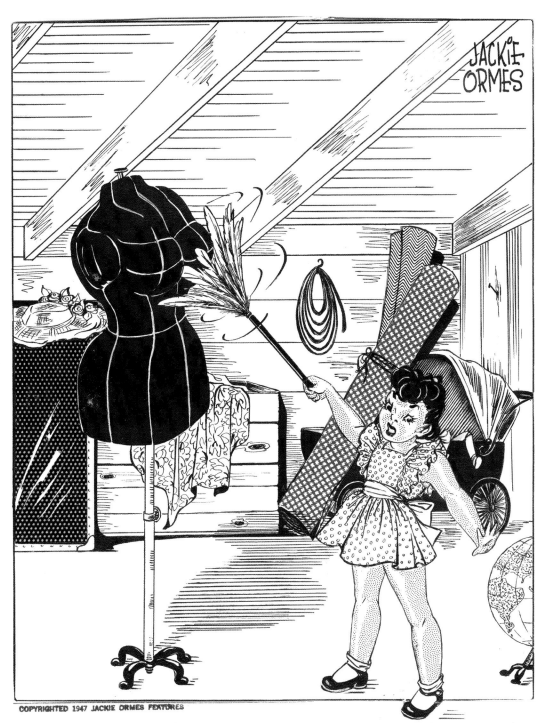

An original drawing appears here on a full page to better reveal Ormes's artistic techniques. It is fully annotated on page 92. Approximately nine inches by eleven and a quarter inches, india ink on Bristol board, with red Zip-A-Tone.

Chapter 7

TORCHY IN HEARTBEATS

When readers opened their *Pittsburgh Courier* on August 19, 1950, they found for the first time two extra attractions folded into its pages. A bright red and blue banner shouted "COMIC SECTION" from the cover of what looked like a large comic book. Inside the comic section, on high-quality white newsprint, were eight color pages of comic strip adventures, kid capers, intrigue, science fiction, nature lessons, advertisements, and paper dolls. Unlike today's soft pastel-shaded Sunday funnies, this insert's screeching yellows, siren reds, and deep blues were blended into other intense hues that jumped off the page or, conversely, drew the reader's gaze into cool, mysterious scenes. Though other strips in the comic section, such as *Don Powers*, which depicted the exploits of an athlete turned crime fighter, and *Guy Fortune*, which featured an adventurer, sometimes had beautiful women in glamorous clothes and sexy poses, *Torchy Brown Heartbeats* (later, and for most of its run, titled *Torchy in Heartbeats*) stands out as the only one with a woman as the star character and romance as the main event.[1]

Another tabloid-size insert, the black-and-white magazine section, accompanied the comic section. It carried such features as pictorials on personalities and their achievements, homemaking tips, stories about hobbies, health and romance advice, crossword puzzles, a section for canasta and bridge players, and an occasional hard-boiled detective story by Dashiell Hammett.[2]

Original copies of the *Courier*'s comic section are nearly impossible to find today. In spite of the good intentions of our nation's libraries, they must take the blame for many comics that were destroyed, including hard copies of *Torchy in Heartbeats* missing from the more than two hundred strips that Ormes drew during its four-year lifetime. Burdened with tons of historical newspapers, libraries in the 1970s turned their archives over to be microfilmed and then sold or trashed the newspapers, a practice documented in Nicholson Baker's book *Double*

Fold: Libraries and the Assault on Paper.[3] Apparently only some comic sections were deemed important enough to microfilm, and the many issues that went unrecorded are now lost. In fairness to the librarians who made these decisions, it's possible to conclude that gathering all the comic sections would have been a difficult task at the time of microfilming; the magazine-size supplements may have wandered away from their original newspapers long before. Fortunately, during this time *Patty-Jo 'n' Ginger* appeared in the *Courier*'s regular news pages, and since these pages were microfilmed, they all survive today. Ormes herself retained very few original drawings or copies of her art in the *Courier*, saying, "I haven't saved a lot because it just looked like—oh it looked like it would never stop. That's how you think when you're busy. You think it'll never stop."[4]

In the 160-some extant *Torchy in Heartbeats* comics, the character Torchy pursues adventure and romance and occasionally strikes pinup poses that capture readers' attention. From August 19, 1950, to the end of December 1950, Torchy appeared as a lovelorn heroine whose boyfriend, Dan, was killed while pursuing a life of crime (this four-and-a-half-month episode has not yet been found but is referred to in a subsequent episode); between January 1, 1951, and October 27, 1951, Torchy's role was love-struck rescuer of a young man in distress who was a musical genius; during the November 3, 1951, to early January 1953 series, she is trapped in and then escapes from a jungle with a new love; finally, from late January 1953 to September 18, 1954, she appears in her most celebrated role as a campaigner for environmental justice and racial equality—and, thrillingly and just as important in the story line, Torchy is at last victorious in love.

Splashed in color across the comic section, *Torchy in Heartbeats* was part of the *Courier*'s effort to reclaim a reading public that in the early 1950s was increasingly being lured away by television. Women's interests were now a larger part of 1950s newspaper economics, and clearly the strip was intended to exploit a growing market of women consumers who were beginning to expect more than the items that appeared in newspapers' grocery and kitchen appliance ads. Long-running comics in mainstream papers proved the popularity of colorful stories of fantasy women navigating a career while remaining beautiful, sensitive, loving, and dressed in ever new fashions. Ormes's name

Torchy In Heartbeats

recognition from the *Patty-Jo 'n' Ginger* cartoon made her a natural to attract readers to the *Courier*'s new comic section. Attuned as always to popular national trends, she took cues for her stories from soap operas on the radio and now on television, as well as from romance pulp fiction, adapting the genre of love story melodrama to her own narrative voice.

The *Courier* added a bonus feature with Ormes's fashion paper dolls called *Torchy Togs,* which accompanied many of the weekly *Torchy in Heartbeats.* In *Torchy Togs,* the character Torchy speaks directly to readers, advising women on such matters as which season to wear certain colors or fabrics and the necessity of proper foundations—"a must for perfect grooming." Sometimes readers are invited to send in fashion designs to be selected and published in the *Courier* along with the contributor's name, an interactive gambit that further bound together artist and reader, newspaper and community. Demonstrating her keen fashion knowledge, Ormes describes fabric, cut, and texture and sometimes credits designers like Christian Dior or Chicago hat designer Artie Wiggins (a friend and the wife of Maurice Wiggins, who played in Negro League baseball). One panel gives an address where fashions can be purchased by mail order, suggesting a business connection with one of her fashion show colleagues. The paper doll cutouts are intended for grown-ups as well as for children; in one panel, Torchy invites "gals! [to] . . . get your scissors and see how these dresses look on me. Or—if you're a guy, a pin is all you need!" to hang the pinup figure of Torchy in a convenient spot.

Although Ormes's drawing style in this strip is different from that of her other work, her unique flair is unmistakable. The strong black-and-white outlines in *Patty-Jo 'n' Ginger* are now filled in with color. She packs the small panels of the strip with interesting detail, inviting the eye to play over interiors and landscapes that add dramatic context to characters' plights, reminiscent of her *Torchy Brown in "Dixie to Harlem"* strip twelve years earlier. By now Ormes had developed a more realistic style in the manner of Oliver Harrington, who in *Jive Gray* had adapted ideas from Milton Caniff's *Terry and the Pirates.*[5] Intensifying the drama of Torchy's adventures, she adds authentically rendered backgrounds such as tramp steamers and Latin American jungles, and she often shows faces in emotionally expressive close-ups. Composi-

tions are more sophisticated than those in the earlier *"Dixie to Harlem"* strip as well, sometimes with such cinematic effects as overhead or low viewpoints, voice-overs, long shots, close-ups, and cutaways that heighten dramatic effect. Like Candy and Ginger, her cartoon predecessors, Torchy has a figure that is prominently eye catching. Ormes finds opportunities to promote Torchy as a pinup figure, as, for instance, when she removes and shreds her blouse to make bandages at the scene of an accident or when she swims in a jungle pool. Over the four years of the strip's run, the character's face, eyes, lips, and hairstyle mirror changes in Ormes's own appearance, as did Candy and Ginger and the 1930s Torchy.

The word *heartbeats* in the title prepares readers for tales about a tender heroine whose caring nature leads her to intimate relations that sometimes end up hurting her. Ormes tells her stories in accessible yet florid, over-the-top language that taps emotions in the same way that the Victorian romance novels that she read as a teen did or in the way that she might have found in 1950s romance pulp fiction or have heard on radio soap operas. Sometimes readers are not quite sure exactly what kind of work Torchy is meant to be doing in her different careers, but we are never in doubt that she is capable, independent, adventurous, noble, and sweetly vulnerable to the vagaries of the heart. Plots follow conventional formulas aimed at a more popular readership, until the last year of the series, when it climbs to a higher level to address the serious issues of public health and racism.

Depictions of heroic performance in *Torchy in Heartbeats* may have been shaped somewhat by the influence of Chicago's black radio theater. Ormes participated in some social and educational activities and did a little acting with the W. E. B. Du Bois Theater Guild, a group of socially conscious actors whose work included stage performance and *Destination Freedom*, one of the only black radio dramas of the era. Broadcast over WMAQ from June 1948 to October 1950, *Destination Freedom* dramatized heroic stories of real people, like Crispus Attucks, Frederick Douglass, and Ida B. Wells. Author and journalist Richard Durham wrote the scripts. "In most instances, the heroes and heroines in Durham's historical dramas were achievers and activists who found themselves constantly at odds with the discriminatory practices endemic to American society."[6] Stories of struggles and adversity

afforded listeners fresh, uplifting views of achievement and of a hopeful future, much like *Torchy in Heartbeats*.

A single reference in a later strip provides a clue to the story line from the strip's now lost first four months of *Torchy Brown Heartbeats*, its original title when it began in 1950. At the start of the fifth month's new episode, Torchy reflects on her doomed love relationship with Dan: "unable to stop his march down the path of crime, [she] sees him slain in a raid on a gambling casino, and now, with a heavy heart, Torchy packs her bags" and flees in an ill-fated bus trip.

Although no overt attempts at humor appeared in this strip, an inside joke occasionally crept in, as when in 1951 Torchy rescues from a bus wreck and then falls in love with a handsome "talented musical genius" named Earl, after Ormes's husband. In this story line that has resonances with the popular 1950 movie *Young Man with a Horn*, with black actor Juano Hernandez in a prominent supporting role, there is a doomed romance. Just as the movie's heroine relinquishes the trumpet player, so too the comic character Torchy gives up Earl in yet another heartrending speech, freeing him for his one true love, music.

At the time, South Side movie houses showed independent black films, and there were also some mixed-race theaters. Certainly the "race films" by filmmakers like Oscar Micheaux and George and Noble Johnson provided examples of a more ample life than did the big studio movies where blacks were relegated to limited, stereotyped roles.[7] Like the stories spun out by Ormes in her comic strip, race films showed black people solving problems on their own terms. In race films, the black characters who were portrayed ran the gamut from handymen to middle-class businessmen, ranch owners, airplane pilots, and explorers, to name a few. Ormes clearly understood the power of these images for black audiences and readers.

In the next episode, Torchy packs up her broken heart and hops a tramp freighter to Brazil. In several scenes Ormes deals with Torchy's involvement with violence and rape, subjects of compelling interest because of their relevance to contemporary headlines and to the collective memory of her readers. The freighter's captain (who is black, as all of her characters are) is a sympathetic figure, but he cannot always be on hand to shield Torchy from danger. And danger comes in the form of the burly first mate who has been stalking her.

> *Torchy:* "I can't get away from him in here. I'll have to go on deck—storm
> or no storm!"
>
> But then she saw Fred Fromer's massive figure and, unmindful
> of the giant waves that lashed in fury, she ran, terror clutching
> at her heartstrings....[The panel shows Torchy limp in Fromer's
> grasp.]
>
> *Fromer:* "Tired running? This is where we stop playing tag, honey! This is
> where you learn not to slap Fred Fromer!"
>
> *Torchy:* "N-no—please—(sob)—OH!"
>
> *Cont'd next week!*

Torchy's courage and moral determination save her from defilement
as she hangs onto the ship's ropes in the battering storm and Fromer is
swept overboard.

Violence against women was an unusual scenario for the funny
papers and a topic rarely taken up by male cartoonists. Gulled by the
promise of office work on a banana plantation, Torchy learns that the
job offer is a ruse to trap pretty young women. The lecherous overseer,
Le Gran—whose name suggests Simon Legree, the cruel slave master
in *Uncle Tom's Cabin*, and whose actions echo southern antebellum op-
pression—grimaces, lurks, skulks, and rides roughshod over his "na-
tive workers." He puts Torchy on notice that she will be his eventual
conquest. In a scene that would probably never have made it into a
mainstream newspaper of the time, Le Gran pins Torchy flat on her
back with his body lying on top of hers. She escapes his clutches be-
fore he can compromise her virtue, and in the harrowing jungle scenes
that follow, Torchy flees with another captive, handsome high-minded
"Young Dr. Paul Hammond."

Ormes's 1953–54 series introduces something entirely new to
American comic strips, when Torchy tackles environmental racism.
As mentioned earlier, it is this activist story line with which Ormes
is most frequently identified in anthologies and encyclopedias to-
day. Ormes blends plenty of sentiment with her more concrete
message. While Hammond sets up a clinic in a rural area of the
U.S. South, Torchy takes nurse's aide training and then follows him
to work at his side. Though she is usually confined to a nurse's uni-

Torchy In Heartbeats

form in the context of the story, Torchy's fashions and pinup figure are displayed in the *Torchy Togs* side panel, which revives our heroine's more glamorous image.

South Side Chicago residents like Ormes were all too familiar with environmental pollution and its effects on health. Many parts of the South Side were low-income neighborhoods whose residents were mostly people of color, and these neighborhoods were well known as dumping grounds for the waste from more affluent communities and industry.[8] The Altgeld Gardens housing project, for instance, constructed just after World War II between 130th Street and the Calumet River, was built on a former landfill, and its notorious problems took years for remediation. Sewage treatment plants, rail yards, and coke ovens were located in parts of the South Side, with their stench sickening some residents as far as two miles away. In 1953 citizens united to protest a defective city landfill that released untreated runoff into swamps and lakes, perhaps not coincidentally paralleling Ormes's 1953–54 comic strip story of a chemical factory polluting the water around "Southville."

Colonel Fuller, the factory owner in the strip, is aptly named to suggest a denizen of the Old South who personifies the racist attitudes that blind him to Dr. Hammond's entreaties about the Fuller Chemical factory's pollution. When the colonel's beloved nephew Jamie falls desperately ill, it is Dr. Hammond's "serum" injection that saves him. Grateful Colonel Fuller eventually comes around to an enlightened friendship with Torchy and Paul, cleans up the pollution, and builds a sparkling new clinic. With the central drama now over and with eight weeks to go on her contract, Ormes filled the remaining episodes with a soap opera subplot of a beautiful newcomer in town who vies for Paul's attention. But Paul finally proposes to Torchy, no doubt just what readers desired but were afraid to ask for because of her history of heartache and because of fears that this would surely finish the series, which it did.

These plot lines—a world-class antidote serum mixed up in a rustic clinic, a hard-line bigot quickly reformed, and the disappearance of toxic factory waste in mere weeks—were the stuff of a positive, hopeful imagination. However improbable this swift resolution might have been, it enabled Ormes to reinforce her efforts for recon-

ciliation between the races in the manner of her *Chicago Defender* columns that had championed brotherhood nine years before. She could in this way make effective use of her considerable public stature and link it with the nascent civil rights movement in order to remind readers weekly about racial injustice in a compelling story. And finally, she came through for the fans of romantic fiction, who learned to expect a payoff of happiness after so much suffering in the name of love.

Four years after it was launched, the *Courier's* comic section proved too expensive to produce. On August 28, 1954, the Smith-Mann Syndicate that supplied both sections to the newspaper shuffled its comics into the black-and-white magazine section, abandoning the chromatic richness and punch of full color. The once full-page and splendidly colorful *Torchy in Heartbeats,* along with *Torchy Togs,* finished its career on a black-and-white half page, with, incidentally, an inglorious cropping of the paper doll that cut off her feet and the bottoms of two dresses. Other comics continued in the magazine section for several years.

While winding up the series and the pretty picture of Torchy triumphant, the artistically versatile Ormes continued drawing *Patty-Jo 'n' Ginger.* Her blunt social criticism spiced with humor continued, with some interruptions, for two more years. There is no record of why *Torchy in Heartbeats* ended. Because the newspaper's action comics continued in the magazine section it's possible to imagine that male editors discouraged what they may have viewed as a women's romance story. Or perhaps some of the serious themes in *Torchy in Heartbeats* were not what the editors believed readers wanted to see.

A representative selection of *Torchy in Heartbeats* and some *Torchy Togs* from all four years of the color comic section appear here, chosen to show Ormes's storytelling trajectory and a variety of her artwork. The original published pages measure ten and a half inches by fifteen inches. A few of these reproductions were digitally scanned, and others were digitally photographed from original newspaper format. Most of these examples appear for the first time since their original publication.

Torchy In Heartbeats

Top: January 6, 1951; *bottom:* January 13, 1951

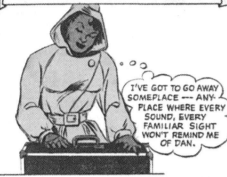

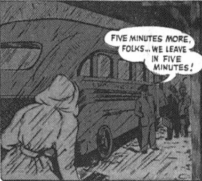

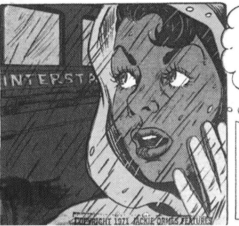

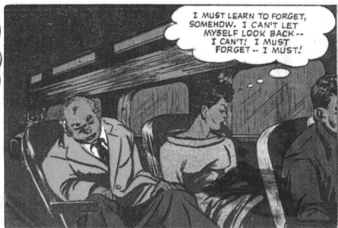

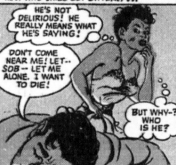

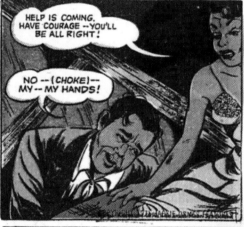

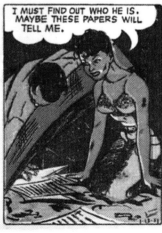

March 10, 1951

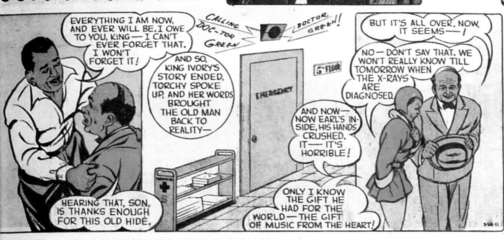

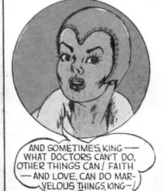

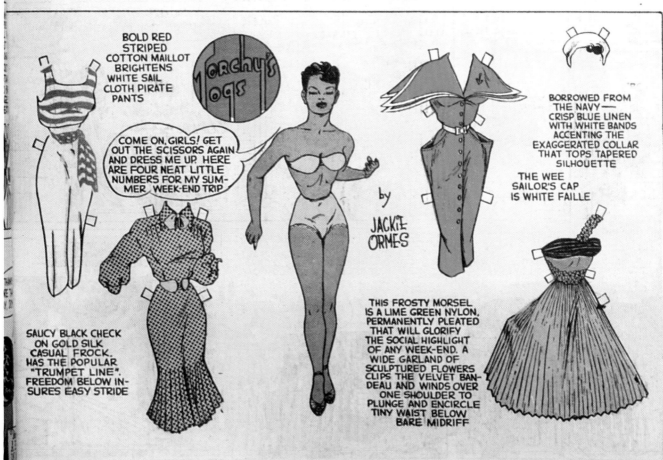

March 17, 1951

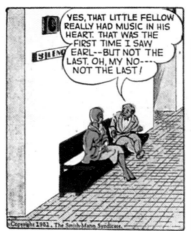

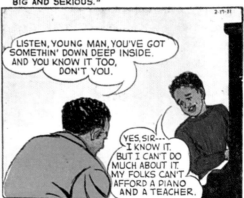

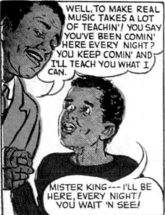

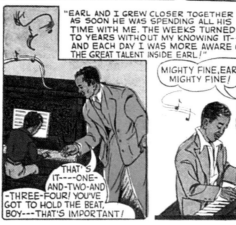

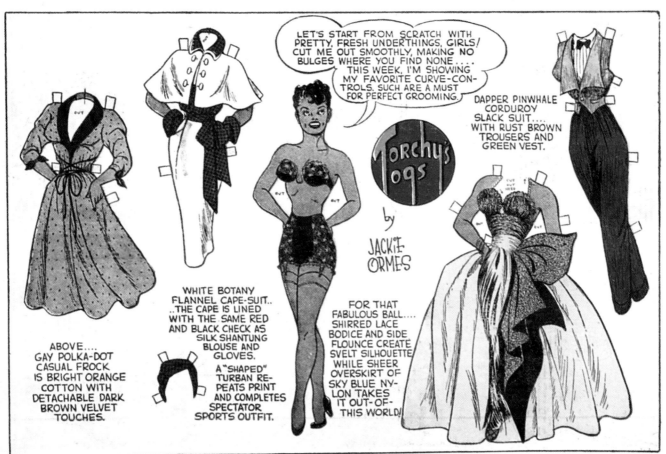

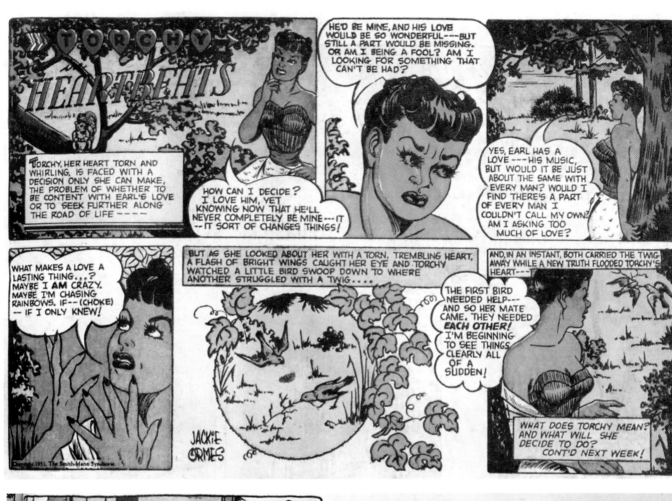

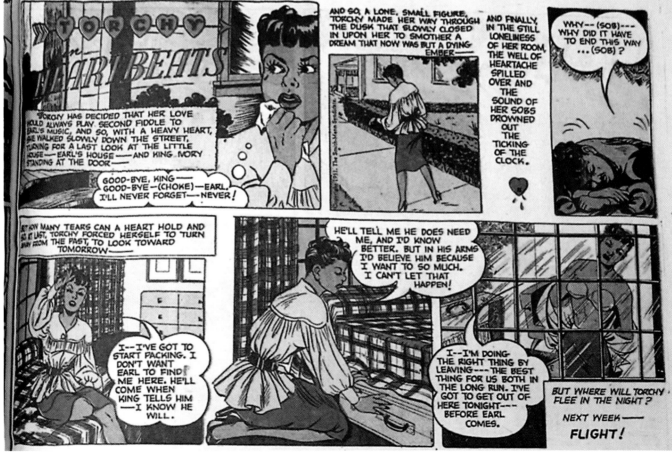

November 10, 1951

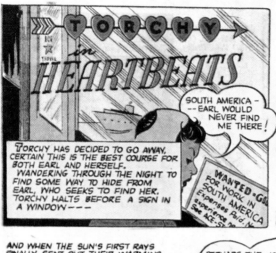

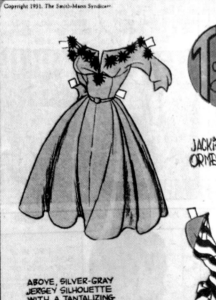

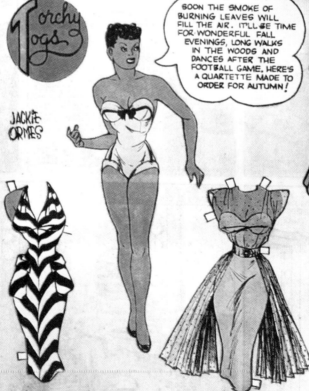

January 5, 1952

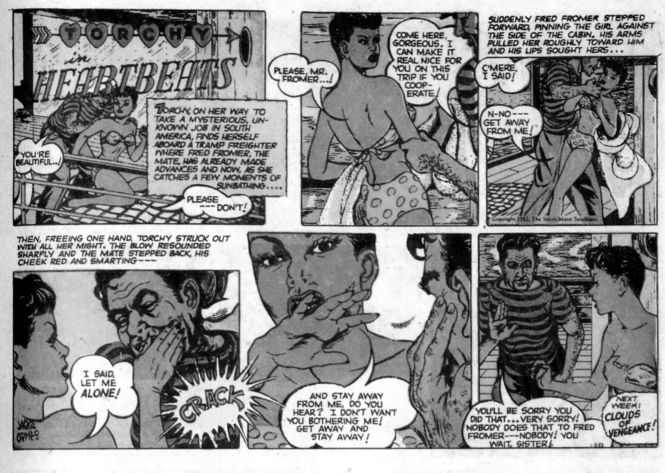

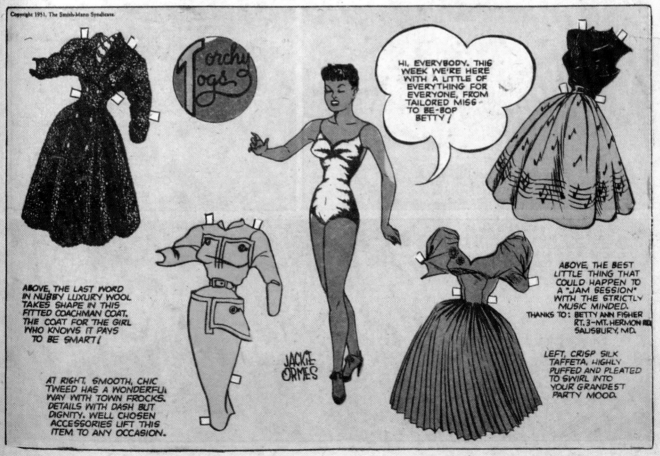

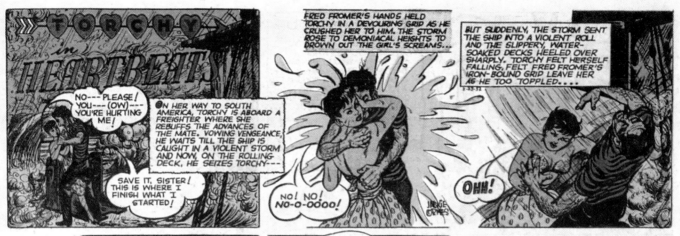

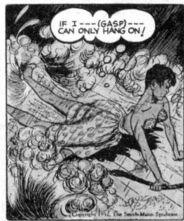

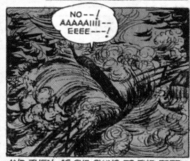

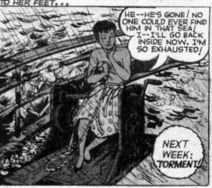

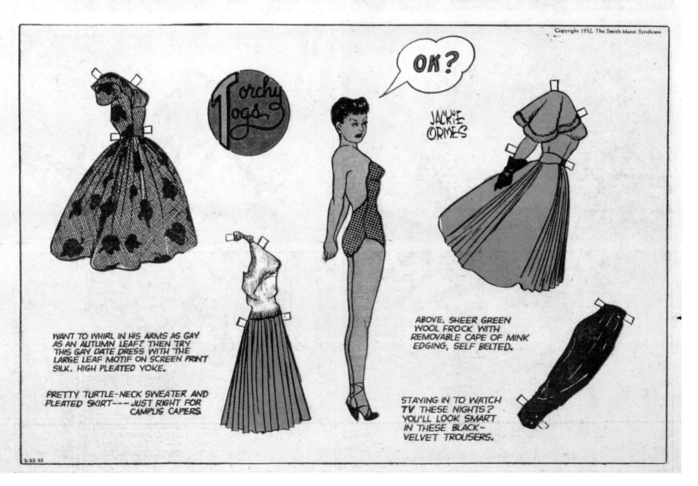

March 22, 1952

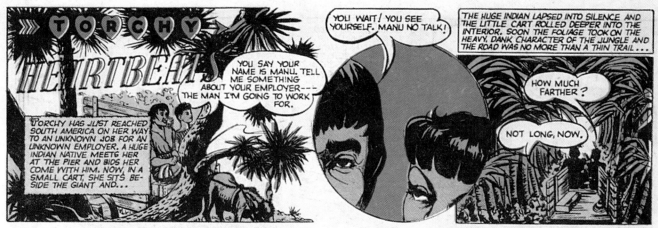

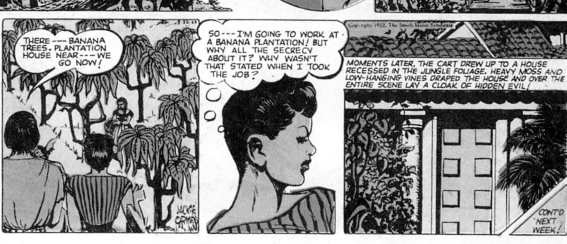

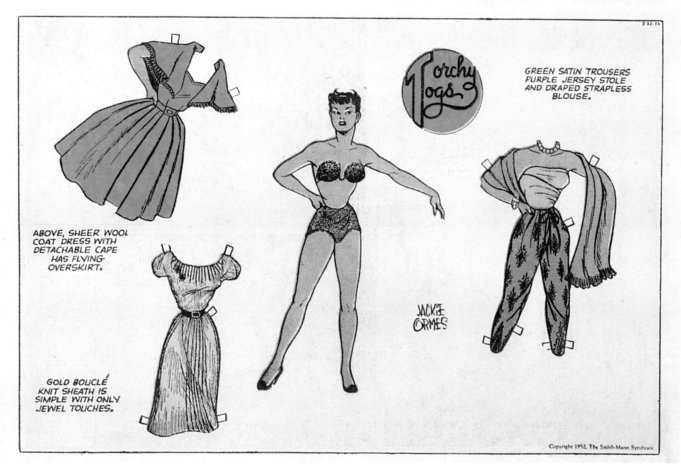

May 24, 1952

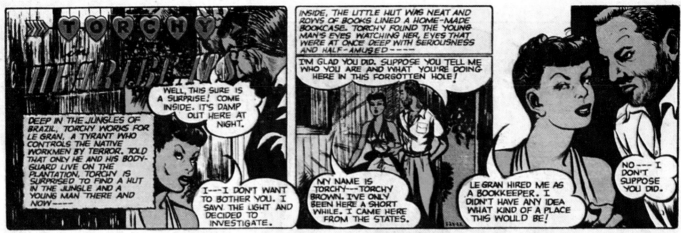

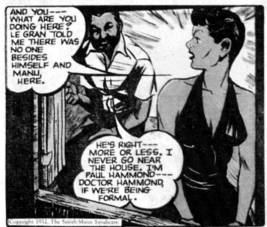

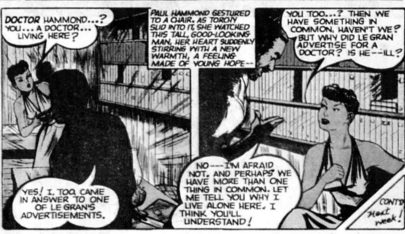

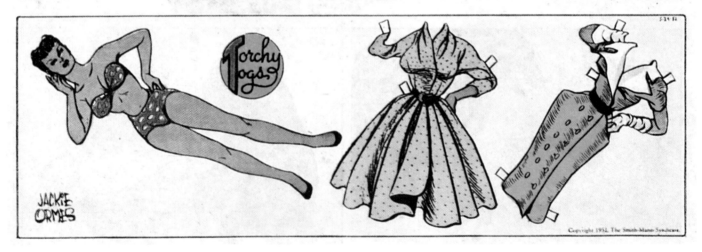

Top: July 12, 1952; *bottom:* August 23, 1952

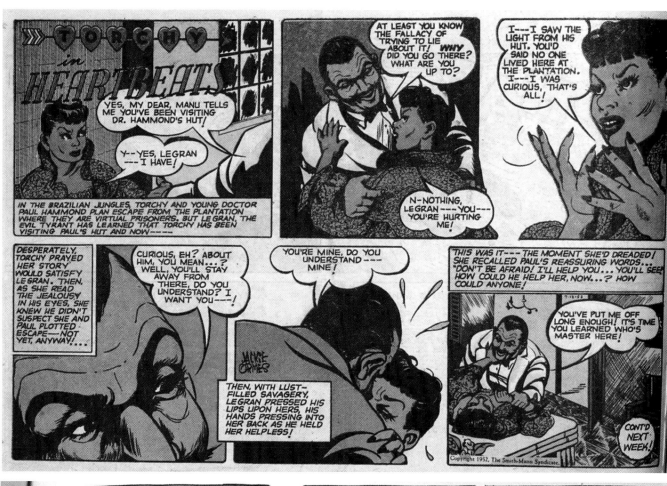

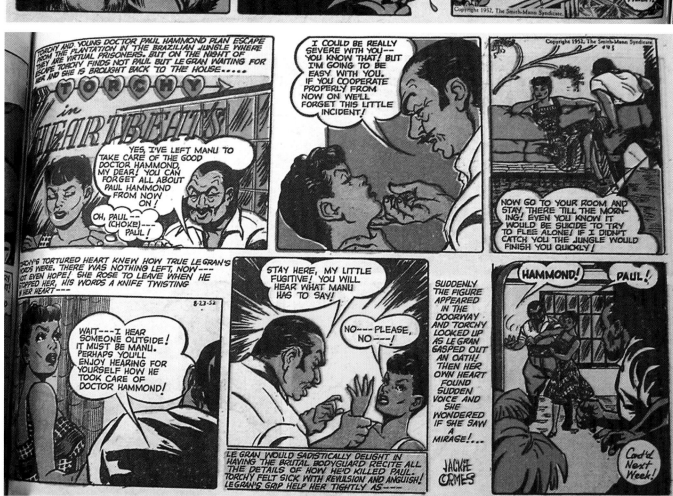

October 25, 1952

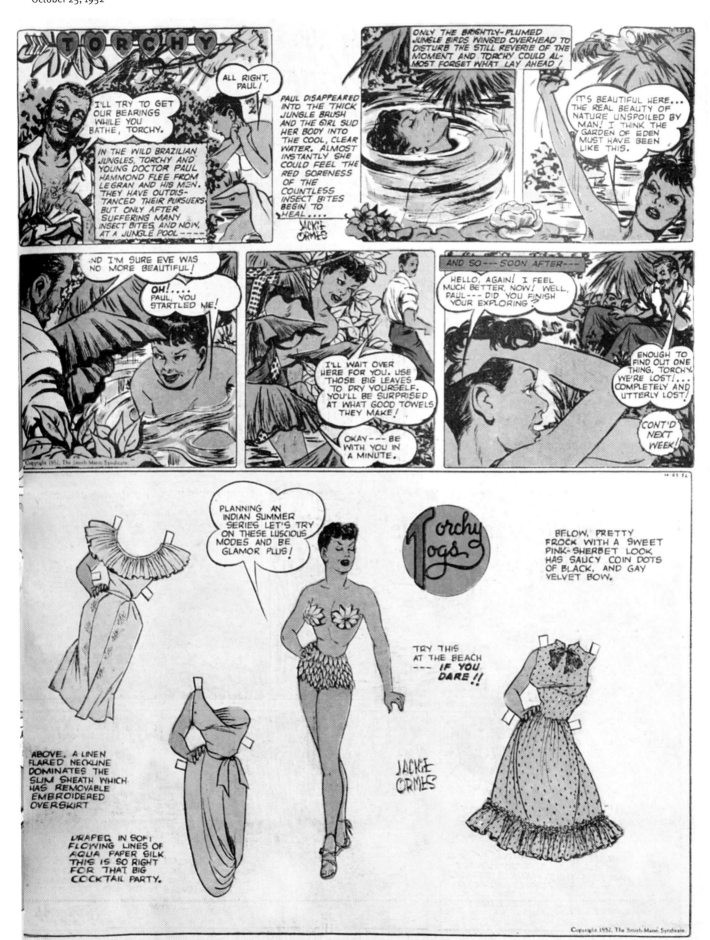

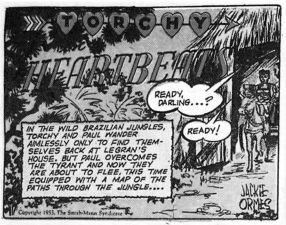

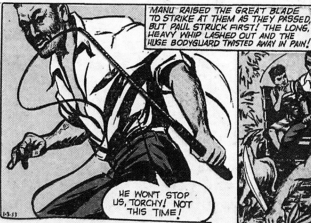

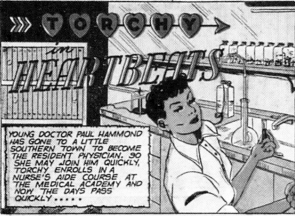

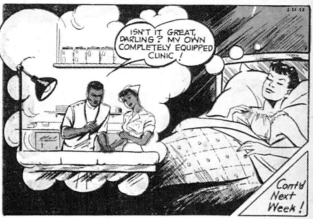

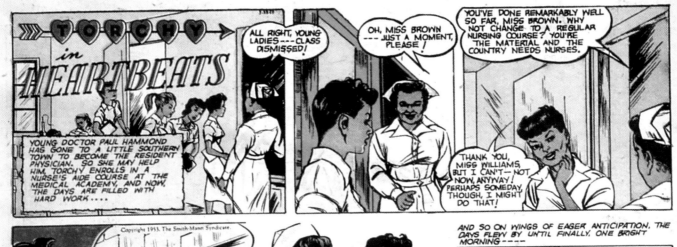

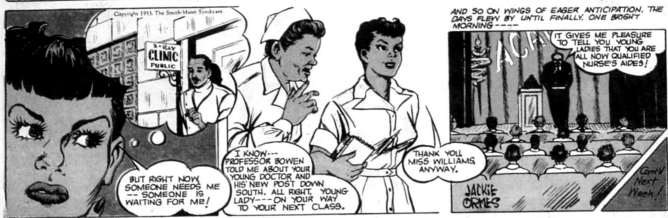

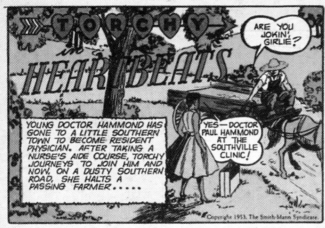

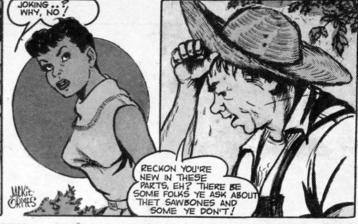

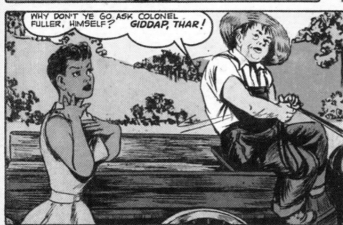

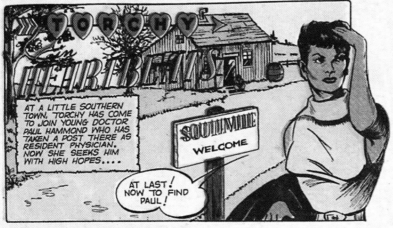

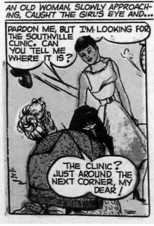

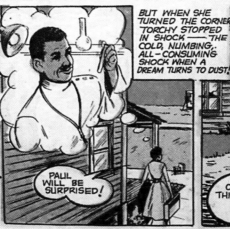

May 16, 1953

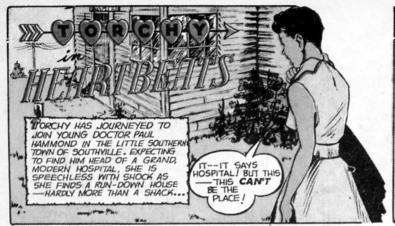

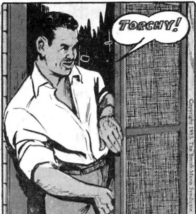

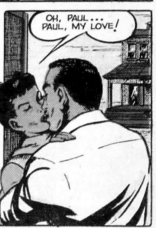

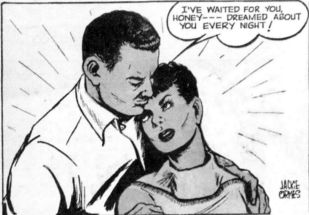

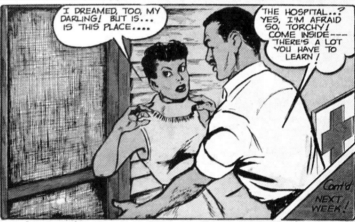

July 18, 1953

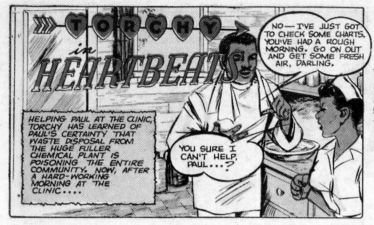

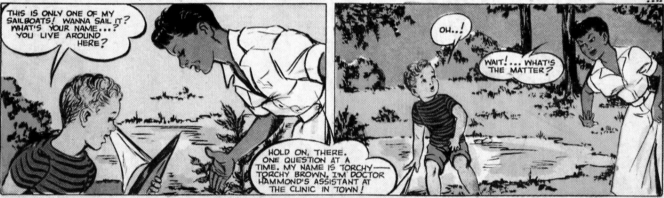

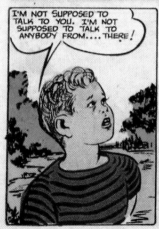

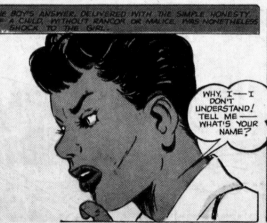

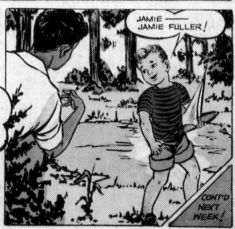

February 6, 1954

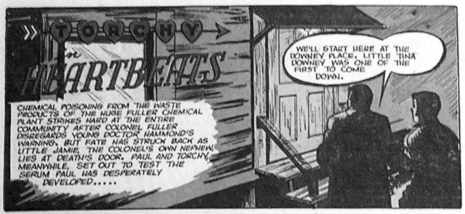

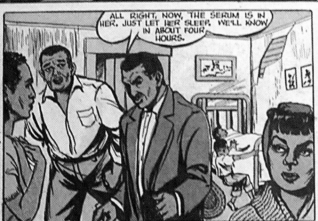

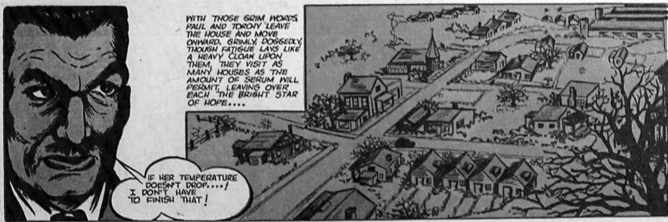

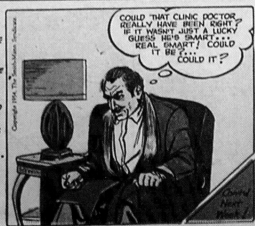

May 8, 1954

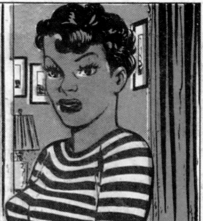

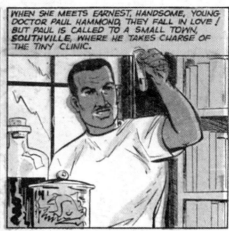

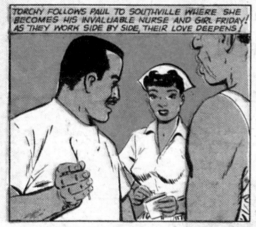

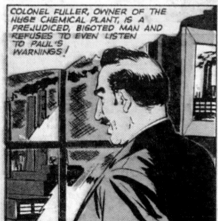

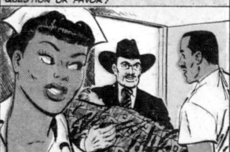

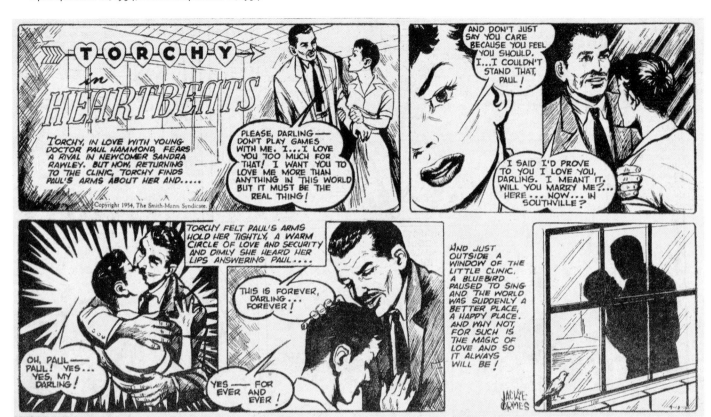

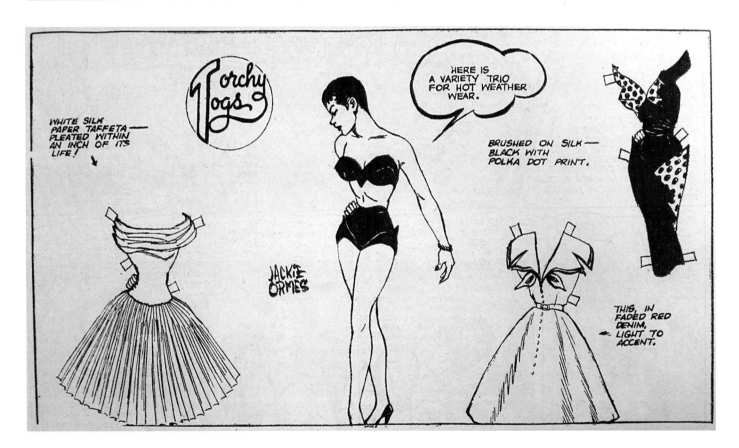

The color comic section was discontinued, and all comics moved into the black and white magazine section. In its last appearance, Torchy's feet and two dresses were cut off.

Chapter 8

THE PATTY-JO DOLL

If, as some researchers contend, toys are a marker of cultural significance and dolls an especially powerful emblem of personal identity, then even the youngest African American children at mid-twentieth century must have recognized their second-class citizenship. And if the rules of society are learned in games and in play, the scarcity of manufactured play materials reflecting the lives of African American children was yet another reminder of their relegation to the sidelines of American society. Poor children, whether black or white, fashioned play materials from items at hand: bats and balls made from sticks and nuts, for instance, and dolls made out of corncobs or rags. These children became acutely aware of their class status on playgrounds and during school social events, especially in the years of the Great Depression. But when African American youngsters of any class had the opportunity to compare their toys with those of white children, they and their parents knew that it was because they were black that theirs were the lesser quality playthings and that the game of life was indelibly rigged from the start.

Dolls are not just another toy to trip over on the nursery floor. They often have deeper implications that relate to a child's self-identification and occasionally attain profound personal significance for a child as best friend, companion, and comforter. An ancient and moving memorial of such an attachment can be seen in the ruins of Pompeii, where the ash-encrusted body of a girl is on display, forever poised in flight from the maelstrom of the erupting volcano, clutching her

"So she wanted to be a June bride . . . What'd you expect her to wear . . . **Lana Turner's** wedding gown?"

For the purposes of this book, dolls are defined as those miniature figures of humans primarily made to be toys and usually made for girls. The United Federation of Doll Clubs (UFDC), the authority in standards of doll research, has at times recognized exceptions to this generally accepted definition in exhibits and publications, including, for example, the following: nineteenth-century automatons used for grown-up parlor entertainment, novelties such as doll-topped teapot cozies, half dolls that once adorned ladies' powder puffs, and artist dolls made for display. UFDC draws the line at puppets, however, because puppets are made for staged performance. Museums are also known to extend the definition of doll to such figures as amulets, fertility images, and fashion mannequins.

Any discussion of the influence of dolls must also take into account various negative aspects of doll play. Some girls reject dolls altogether be-

cause of personal preference or parental influence. Feminist writers such as Miriam Formanek-Brunell have interpreted some aspects of doll play and the marketing of dolls as encouraging pernicious gender stereotyping and the commercialization of childhood (see Miriam Formanek-Brunell, Made to Play House: Dolls and the Commercialization of American Girlhood, 1830–1930 *[New Haven: Yale University Press, 1993]).*

Boys enjoy playing with and collecting action figures such as G.I. Joe, but the collecting and manufacturing world does not call those toys dolls, nor would most boys admit that they play with dolls. Teddy bears and other plush animals have always been acceptable for very young boys. Interestingly, more than a few doll collectors are men, and several men have earned prominent national reputations in the doll collecting and doll research world. Male doll artists are also well known, just as men have headed many of the largest doll manufacturing concerns as well as doll museums. Most significant among male designers is Bernard Lipfert, who made hundreds of dolls, including the Shirley Temple doll for the Ideal Novelty and Toy Corporation in 1934, the best-selling doll before Mattel's Barbie hit the scene. In 1936, a Fortune *magazine article called Lipfert "an industry monopoly" and described him in his Brooklyn basement studio, saying (in the reporter's rendition of his accent): "Effry doll zat you zee in zee stores iss born right there in zis little basement, without any mother, chost a fadder" ("Dolls—Made in America,"* Fortune, *December 1936, 106).*

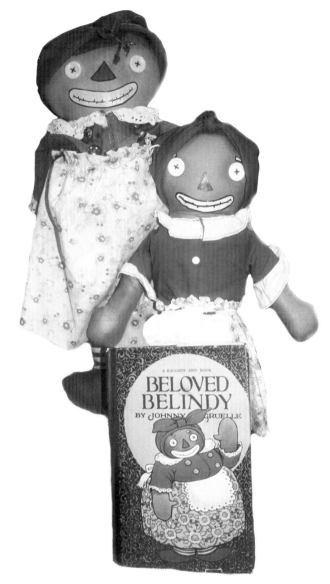

Beloved Belindy was the mammy for writer and illustrator Johnny Gruelle's Ann and Andy in his 1926 book *Beloved Belindy,* part of the popular *Raggedy Ann and Andy* series. The P. F. Volland company not only published the books but also made the earliest Raggedy Ann, Raggedy Andy, and Beloved Belindy fifteen-inch-high cloth dolls. In 1928 Beloved Belindys sold through the *Sears, Roebuck and Co.* catalog for $1.95.

Jackie Ormes

doll. Poignant also is a recorded memory of Emma Watson, a woman who was a child of former slaves, describing in dialect her playing with their slaveholder's daughter: "Miss Lee have a china doll with a wreath of roses round it head. We take turns playin' with it. I had a rag doll, and it jes' a bundle of rags with strings tied round it to give it shape."[1]

The so-called doll test by psychologists Drs. Kenneth and Mamie Clark in the late 1930s demonstrated the power of dolls as markers

of self-identification. When black children were asked about their preferences in dolls, most responded that white dolls were "prettier" or "nicer." The Clarks' study made history and changed the American education system in 1954, when then NAACP attorney Thurgood Marshall used their findings in arguing the *Brown v. Board of Education* case, which overturned segregation in public schools. Thereafter, the Clark study was widely interpreted as one indication of an epidemic of low self-esteem among African Americans.[2]

In recent years, scholars and artists have worked to reclaim the stereotyped images of dolls and figures such as Aunt Jemima, viewing them as representations of powerful, dignified women who survived in an era of slavery and, later, job discrimination.[3] Yet it is doubtful that many African American mothers in the late 1940s placed Aunt Jemima or Uncle Mose dolls, or other manufactured black dolls of the era, such as Beloved Belindy, in their children's hands. These included dolls with demeaning names like Cotton Joe and Baby Snowball, the dandified Negro Dude, and dollmaker Norah Wellings's grinning natives. Other black dolls were commercially produced in large numbers, including representations of the mammy figure, of children advertised as "Pickaninny" dolls, and of rustic old men, but they too were clearly aimed at white purchasers of novelties. Dolls called "Topsy" were as ubiquitous as mammy dolls, and though a few companies such as Nancy Ann Storybook made Topsys of equal quality to their white dolls, more often a Topsy doll was cheaply made and had the stereotyped three pigtails sticking up from the top of her head, banjo eyes, bare feet, and a plain muslin smock. Upscale manufacturers who prided themselves on achieving "realism" in better play dolls nevertheless used the same mold for their black dolls as for their white dolls and simply painted them brown. Had these manufacturers employed black sales representa-

An article in Playthings, *a toy industry journal, stated in 1909, "One of the chief demands for negro dolls comes from little white girls who desire these dark playmates to be used as servants in their doll establishments, as maids, coachmen, butlers and the like. It is a strange case, but none the less true, that a large number of negroes themselves spurn the efforts of toy manufacturers to provide children of the brown and black races with negro dolls. The children themselves do not seem to want them" ("Negro Dolls,"* Playthings, *June 1909, 67). Black-owned doll companies existed at this time, and most sold by mail order and ads placed in African American media, such as the* Pittsburgh Courier. *Evidence of actual manufacturing of dolls had yet to appear; apparently all the companies used white dolls and painted them brown.*

One of the earliest black-owned doll companies was the National Negro Doll Company (NNDC), managed by Richard H. Boyd, a National Baptist Church officer whose Philadelphia Assembly distributed black German dolls starting in 1908. "The fair complexion of the NNDC's dolls implied an acceptance of miscegenation as a pathway to race progress, which would, in turn, support children's development of race pride" (Sabrina Lynette Thomas, "Black Dolls as Racial Uplift: A Preliminary Report," Transforming Anthropology 3, no. 1 [2005]: 56). *The black Women's Convention in 1914 formed "Negro Doll Clubs" in "an attempt to instill in young black girls pride in their skin color" (Evelyn Brooks Higginbotham,* Righteous Discontent: The Women's Movement in the Black Baptist Church, 1880–1920 *[Cambridge, MA: Harvard University Press, 1993], 194). A company named Berry was established in*

The Patty-Jo Doll

1922 by Marcus Garvey and his Universal Negro Improvement Association (UNIA). "While the NNDC advertised dolls of a light complexion, the UNIA doll factory boasted of the dark, dusky hue that defined their dolls. . . . The dark complexion of the UNIA dolls promoted racial purity and an acceptance of African roots as elements of children's race pride" (Sabrina Lynette Thomas, "Black Dolls as Racial Uplift: A Preliminary Report," Transforming Anthropology *3, no. 1 [2005]: 56). Dolls with marks, tags, or buttons denoting NNDC, UNIA, or Berry have yet to be found or to appear in identification guides.*

Various records of the Lujon company place its likely dates from 1935 through at least 1949 (Myla Perkins, Black Dolls: An Identification and Value Guide, 1820–1991 *[Paducah, KY: Collector Books, 1993], 80). A small article entitled "Lujon Sun Tan Colored Doll Co." in* Playthings *states that "John C. Arthe, head of this firm, says that his 1937 line will include a wide range of models and prices in dolls of various shades of chocolate and brown. Mr. Arthe has been well known in doll circles for many years" (Playthings, April 1937, 270). The author owns a copy of a 1941 correspondence signed by Arthe that has "Lujon Colored Doll Co." on the letterhead, suggesting the company sometimes varied its name. Lujon placed an ad with photographs of dolls in another trade journal,* Toys and Novelties *("Lujon: Exclusive Colored Dolls // We Only Make High Class Colored Dolls," Toys and Novelties, March 1945, 297). Much later, an* Ebony *article calls "Lujohn [sic] . . . a memorable flop," since the company was one of those that practiced "painting white dolls a dark brown and 'passing' them off as 'Negroid'" ("Negro Dolls Popular with Public Since Birth in*

Jackie Ormes

tives, designers, or marketing executives, they would have been better advised about ways to design and promote their brand-name dolls to a black consumer market. *Playthings*, a monthly toy industry journal, listed only a few distributors of "Negro Dolls" in their index, and rarely did a company purchase prominent display advertising in the mainstream media for their dolls of color until the mid-1960s. Some toymakers such as Marcie Miniatures ran ads in *Playthings* that included a few dolls of color in their array of international novelty dolls, which were meant for children to collect in a variety of costumes, like "Negro Bride," "Negro Groom," "Negro Bridesmaid," and "Negro Nun," along with "Mammy—Straight from 'de lan' ob cotton.'" But their clothing was fixed to stay put and their headwear was so snugly attached that playing with clothing and hair was virtually impossible. Efforts to market black dolls by African American business people, cultural leaders, and at least one church group during the pre–civil rights era met with limited success. Such companies as Sun Tan Dolls and Lujon Colored Doll Company attempted to fill a need in the marketplace.[4]

Jackie Ormes had observed little black girls playing only with white dolls, looking as if they were nurses in training for white children. When she decided to create a doll that looked like a real little African American girl, her Patty-Jo character was ready-made for the job. Funny little boys and girls have been hopping off comic strip and cartoon pages and into children's hands as dolls for close to a hundred years, and hers was already recognizable to the African American community from the cartoon. Patty-Jo had just the kind of spunky and smart personality that Ormes wished her doll creation to project.

Some of the earliest comic character dolls were printed on fabric for consumers to cut out, sew, and stuff and were sold by mail for a few cents and a news-

paper coupon. Buster Brown and his dog, Tige, for example, promoted children's hosiery and shoes, and the cloth doll version of their likenesses helped advertise those wares. Such characters as the Yellow Kid, Skeezix, and Little Orphan Annie are a few of the legions of figures made in pocket-size ceramic bisque, frozen in position, colorfully painted, and sold for pennies. And there were also comic character dolls that any child would have considered a major acquisition. Ella Cinders, for instance, came from a strip of that name by Bob Counselman and Charles Plumb for the Metropolitan Newspaper Services syndicate in 1925, and the eighteen-inch composition comic character play doll made by the E. I. Horsman Company in 1928 and costing $2.75 was one of the most popular of Horsman's several comic takeoffs. About the same time that Ormes was launching her doll, the Ideal Novelty and Toy Company's "Sparkle Plenty" doll, drawn from the character in Chester Gould's long-running *Dick Tracy* comic strip (Chicago Tribune Syndicate, launched in 1931), came out in hard plastic, setting an industry record in its first year when sales grossed six million dollars. But in the mid-1940s such representations of black comic characters were limited to the small bisque figurines of such characters as *Gasoline Alley*'s banana-lipped Rachel (Frank King, Chicago Tribune Syndicate, 1918) or novelty dolls like Kewpie (Rose O'Neill, *Woman's Home Companion,* 1909), whose black version, called "Hottentot," was manufactured by the Cameo company. In 1939, a comic strip in the *Pittsburgh Courier* addressed the dearth of black dolls, when, in the words of cartoon and comics historian Steven Loring Jones, "Sammy Milai's curly-haired little boy 'Bucky' put a little Black girl's white doll under a sun lamp to make the play mother and her doll baby the same color."[5]

At some point Ormes experimented with a paper doll version of Patty-Jo. *"Patty-Jo" Cut-Outs by Jackie*

1919," Ebony, *January 1952, 51). Doll collectors are hard put to find Lujon dolls, a quest made difficult because apparently their only identification was a button with the words "COLORED DOLLS BY LUJON, N.Y." pinned onto the doll's clothing, which could have been easily lost ("Compo Corner,"* Doll Reader, *August 1991, 140). Another reason few of these dolls exist today is probably because few were made, with production dates spanning the difficult days of poverty and shortages during the Great Depression and World War II.*

An article in the New York Amsterdam News *describes the history of N. V. Sales Company, which distributed Sun Tan Dolls. The company was established in 1921 in Harlem by Walter B. Abbott, a relative who worked for Robert S. Abbott, founder of the* Chicago Defender. *Walter B. Abbott's son Walter Abbott told the interviewer that his father opened a New York office for the* Defender *in 1918 that lasted several years. (His editorial assistant happened to be Bessie Bearden, mother of artist Romare Bearden.) "When brisk competition from the* New York Age, *the* New York Amsterdam News *and the* Pittsburgh Courier *made it more profitable for the* Defender *to concentrate on its home base and close the New York Office, Abbott continued making dolls." Doll production ceased with the advent of World War II, according to the author, who was, coincidentally, a cartoonist for the black press (Mel Tapley, "Sun Tan Dolls: Pioneering Effort in Positive Images,"* New York Amsterdam News, *December 24, 1988, 30).*

In the mid-1940s, other pretty, inexpensive "Colored Dolls" were advertised in the Courier *and in* Ebony *magazine with such names as "Tonee—A Real Moving Sepia Doll by Alberta*

The Patty-Jo Doll

Associates" and "Harlem Dolls," showing up in ads by themselves or along with wigs and jewelry, especially around Christmastime. Montgomery Ward's Christmas catalog ran ads for black dolls (The Christmas Book, 1944, 68). Dolls in Ward's catalog as well as those in the African American publications were white dolls painted brown, and most were baby dolls, used in playing house rather than as a model of self-identification for a preschool or school-age girl.

A 1949 Buyer's Guide listing in Toys and Novelties gave the following companies as dealers of colored dolls: Francesse Doll Company, New York; Halpern Company J., Pittsburgh; Leslie-Henry Company, New York (at the same address as Lujon's salesroom); Lujon Colored Doll Company, New York; Rex Novelty Company, New York; Terri Lee Company, Lincoln, Nebraska; and Wolfset & Company, New York (Myla Perkins, Black Dolls: An Identification and Value Guide, 1820–1991 [Paducah, KY: Collector Books, 1993], 80).

The many and complex reasons why major manufacturers produced few black dolls and why smaller black companies' dolls lagged in popularity continue to be investigated, with no clear conclusions. Contributing factors may include consumer preference for high-status brand-name dolls or for play features available only in white dolls; children's ages at the time of testing; manufacturers' beliefs about marketability; and, of course, racism on the part of retail stores and assumptions about beauty by black consumers in the dominant white culture and the media.

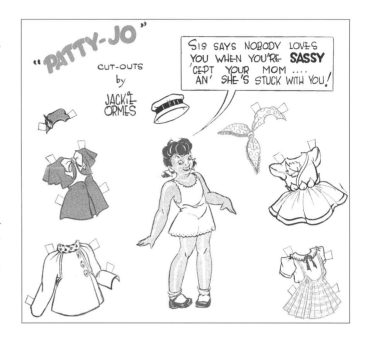

Ormes briefly explored the play value of paper dolls in these *"Patty-Jo" Cut-Outs* from an unknown magazine dated December 1946. *(Collection of the DuSable Museum of African American History, Chicago.)*

Ormes, with the little girl figure and four complete outfits, appeared in a December 1946 magazine aimed at the black community. But her entrepreneurial ambition reached much further than the occasional paper doll cutout. With the end of the war and the prospect of increased prosperity she recognized that American families would increasingly gain the means to purchase better toys and also that the African American market had been largely ignored by toy manufacturers. Searching for an animated, poseable figure, she started making doll prototypes herself, rejecting the first one, made of cloth, because it could not stand on its own. Her next effort was a clay doll whose model contained six articulating parts and featured an open, smiling mouth that seemed right.

A *Courier* article from May 1946 described Ormes working on her clay model at an art class and promised to keep readers apprised of the planned Christmas production date for the doll. A year later an industry

Jackie Ormes

trade journal, *Toys and Novelties*, reported on how her idea for a full-fledged Patty-Jo doll had unfolded:

> Fan letters and word-of-mouth popularity of the "Patty-Jo 'n' Ginger" feature led Miss Ormes to the idea of a Patty-Jo doll.... Her concept of the doll from the very beginning laid stress upon certain criteria that at times seemed unattainable. Patty-Jo must first of all be a Negro doll of which Negroes could truly be proud and be proud to own. (That there had never been such a doll in all manufacturing goes without saying. The obese doll figure in red bandana and voluminous apron with only a caricature of a face is too familiar to need comment.)[6]

When the interviewer asked about her hopes for a doll, Ormes replied, "No more rag Susies or Sambos—just KIDS!" She began an effort that would eventually produce one of the first high-quality American black dolls, a doll with an extensive wardrobe like those of the best-quality white dolls.

 Building on the established idea of dolls inspired by the comics, Ormes looked for other cues in the doll market. The Patsy doll, manufactured by the Effanbee doll company, was likely an inspiration to her. Patsy was a very popular white doll that could be specially ordered in brown and cost about the same as the "Negro Dolls" advertised in the *Courier*, in the $2.50–$9.00 range. The clay model pictured in the 1946 *Courier* article about Ormes looked a lot like the Patsy doll. Customers could buy dozens of articles of clothing for Patsy, a feature that undoubtedly appealed to style maven Ormes, whose Patty-Jo cartoon character appeared in a new outfit every week. When obstacles to the manufacture and marketing of her clay model became insurmountable, Ormes sought advice from market insiders, who suggested she approach the Terri Lee company, a new manufacturer whose line of dolls already included a black girl and a black boy along with their elaborate wardrobes.

 American doll making had turned a historic corner in the mid-1940s with the introduction of hard plastic that could be formed into "unbreakable" toys.[7] Ormes's research would likely have persuaded her that dolls made of the previously most widely used material, composition, a molded sawdust and glue mixture, had problems with chip-

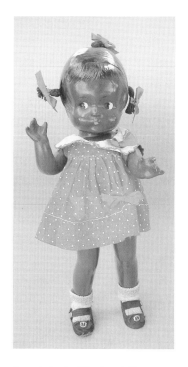

Patsy Jr. by the Effanbee doll company is a black version of its popular white Patsy series. For little African American girls in the 1930s who wanted dolls that looked like them, these were about as good as they could expect to find. Effanbee's Patsy series were well designed, made of quality materials, had extra clothes to purchase, and were somewhat affordable, but their black dolls were unavailable in most stores and had to be special ordered. Patsy Jr. is eleven inches high and is made of composition, or "compo," a mixture of sawdust and glue that was the primary material used in American doll manufacturing before the post–World War II era of hard plastic. (*Collection of Myla Perkins.*)

The Patty-Jo Doll

Although Terri Lee dolls were first made in 1946 of composition, a mixture of ground sawdust and glue, within a year the manufacturer switched to hard plastic. The earliest plastic dolls were made of a Celanese product, and at some point in 1948 the Terri Lee company changed over to Tenite II, a hard plastic produced by the Tennessee Eastman Company. Ormes promoted the Patty-Jo doll's durable plastic construction as one aspect of the revolutionary concept behind the doll. So confident was the Terri Lee company about the strength of this new material that its promotional literature offered free repairs at its mail-in doll hospital if any breakage occurred. The plastic rarely broke, but because of the vigorous play that dolls endured at the hands of their little owners, they sometimes needed new wigs, restringing, or face repainting.

The original model for the Terri Lee doll was sculpted by Gradwohl's niece Maxine Runci and modeled after Maxine's daughter, Drienne. The name Terri Lee came from Gradwohl's daughter, who as a child disliked her given name of Harriet and called herself Terri; the last name, Lee, was a family surname. The story of the Terri Lee company is told in Peggy Wiedman Casper's Fashionable Terri Lee Dolls (Cumberland, MD: Hobby House Press, 1988) and in Naomi Hencey's Terri Lee: From the 40s to the 60s (Battle Creek, MI: November House, 1984). Both books contain material on Jackie Ormes that is based on information she supplied the books' authors.

Jackie Ormes

ping, cracking, and crazing and that porcelain, another popular material for dolls, would easily shatter, causing many a tear to be shed. Little girls now clamored for hard plastic white dolls such as Plassie, Mary Hoyer, Nanette, or Nancy Lee, dolls that had huge wardrobes and hair that could be curled.[8]

Ormes had found herself in the right place at the right time when she entered the world of cartooning during the boom days of black newspapers, and once again her timing proved excellent: she was now ready to apply her talents to what would later be known as the golden age of hard plastic dolls. Within a year of the Terri Lee company's start in 1946, its owner, Violet Gradwohl, had introduced dolls of color along with its more heavily promoted white dolls, a visionary concept at the time. The company took its name from its preeminent white girl doll, Terri Lee, but the line also included ethnic dolls such as Guadalupe, Nanook, Bonnie Lou, and Benjie. Bonnie Lou and Benjie were two black dolls in the line that were not selling as well as the company had hoped. Gradwohl brought Ormes on board in hopes of capitalizing on Patty-Jo's and Ormes's name recognition within the black middle class and thereby boosting sales of the black dolls. With a redesigned face to resemble the cartoon character, the Bonnie Lou doll would now be transformed into Patty-Jo.

Ormes painted some of the faces herself and also trained factory artists to paint in the style of a Patty-Jo face. Her excitement over the arrangement is palpable in the cartoons. The black doll Benjie, already in the Terri Lee line, began to have walk-on parts in *Patty-Jo 'n' Ginger* and became one of Patty-Jo's small entourage of characters in the cartoon. Miniature Patty-Jos pop up in the cartoon as doll playmates for Patty-Jo, who herself is often dressed in Terri Lee clothing.

The Terri Lee company worked out a deal to pay Ormes 2.5 percent of the seven dollar wholesale price

of each doll sold by the company, or about seventeen and a half cents per doll. There was also an arrangement by which Ormes could sell dolls she painted herself and marketed through her own ads and word of mouth, yielding a profit of three dollars on each doll sold.[9] Ratcheting up the level of publicity, Ormes initiated what we now call "product placement" by including the doll in some of her *Patty-Jo 'n' Ginger* cartoons. On August 9, 1947, in the cartoon's first mention of the doll, Patty-Jo carried in her hand an order coupon with Ormes's own home address clearly visible. This bold bit of self-promotion appeared only one other time, but it's clear that the *Courier* was supportive of Ormes's venture and her entrepreneurial spirit, because they permitted the Patty-Jo doll to show up in the cartoon panel again and again. The *Courier*'s Chicago edition, published in Patty-Jo's and Ormes's hometown, ran a front-page article on August 30, 1947, about the toy's debut, complete with a photo. The caption and article read,

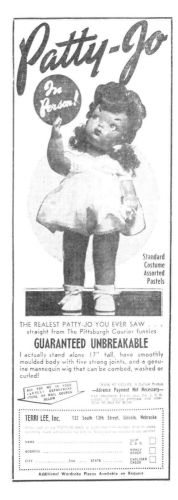

This ad in a November 1947 *Pittsburgh Courier* emphasizes the superior value of a "guaranteed unbreakable" doll made of plastic, a new product on the market. Her hair can be "combed, washed or curled," also a new feature for dolls' wigs, which were now made of manmade fibers like Nylon or Saran or, in the case of Patty-Jo, a Celanese product. According to the consumer price index, an $11.95 doll in 1947 would today cost about $119.24. In an era when the minimum wage was $0.45 an hour, this doll was decidedly intended for an upscale market. *(Courtesy of Terri Lee Associates.)*

> Donning her prettiest "party dress" is The Courier's "Patty Jo" who steps out of the cartoon that bears her name, straight into the Exposition of Negro Business at the Eighth Regiment Armory. Taking her place with the notables, "Patty Jo" and her creator Jackie Ormes, will be on hand to help Mayor Kennelly open the Expo and play hostess at the Courier booth. . . . When Mayor Martin H. Kennelly snips a gilded ribbon officially opening the Exposition at 3 p.m. Saturday afternoon, Patty Jo will lend him her own scissors, purloined without parental knowledge from her doll house sewing kit. Later that evening she'll parade her own creations in a fashion show . . . before 100,000 spectators. . . . But, more than anything else, Patty Jo will be revelling in the sheer joy of being her own three dimensional self. For this will be her first public appearance, her first precious moments away from the pen and ink which gave her birth. Created in the pages of The Courier and now one of its most famous cartoon characters, Patty Jo became a doll last week—the first of The Courier cartoon family to literally come to life.[10]

"We have placed Patty-Jo at some of the nation's best stores," Ormes wrote in reply to one customer, apparently describing the Terri Lee company's sales efforts. Other accounts attest to the marketing of Patty-Jo in upscale department stores from coast to coast. One California woman who was a child in the late 1940s recalled a special trip

The Patty-Jo Doll

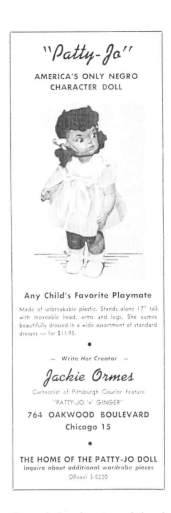

Ormes designed, wrote, and placed ads for her own direct mail business, even inviting customers to call her at home. This ad appeared in a program for a classical music concert by soprano Dorothy Maynor at Orchestra Hall in Chicago. Apparently Ormes was also permitted to sell Terri Lee "wardrobe pieces." *(Courtesy of Delores Towles.)*

Jackie Ormes

into downtown Los Angeles to see the Christmas window displays, where "A special display on Terri Lee included black and white dolls and fabulous very hand made snow boots trimmed in fur and other deluxe accessories." An African American woman in Tennessee who was selling a Patty-Jo doll in an estate sale in 2004 said her mother had bought the doll at a fine local store to be a companion for her on a long train trip. But Ormes's own marketing efforts—including articles in a few periodicals; an appearance on the children's TV show *Kukla, Fran, and Ollie;* direct mail ads; and word of mouth—were most effective for her. Letters ordering dolls directly from Ormes were found in her mementoes, where she had carefully saved orders received from Pennsylvania, Maryland, Massachusetts, New York, Wisconsin, Tennessee, Ohio, California, Hawaii, and Liberia.

From the start, the Patty-Jo doll was intended for a more affluent clientele, a black middle class that could afford the $11. 95 toy at a time when the minimum wage was only $0.45 an hour. The Patty-Jo doll's price, design, and accouterments of a huge wardrobe made it clear that she was fashioned for sophisticated consumers like those in Ormes's social and political circles who frequented the big department stores and who recognized value in a first-rate doll. In a memo to possible sales distributors, Ormes described Patty-Jo as a "Doll designed from popular cartoon character to symbolize wholesome Negro child. . . . Need for *this grade of Negro doll* unquestioned" (emphasis added). She looked for customers among the highbrow music crowd, for instance, and placed elegant, tastefully scripted ads for the doll in the pages of programs for Chicago's Orchestra Hall concerts by African American artists such as soprano Dorothy Maynor and folk-blues singers Josh White and Josh White Jr. In contrast, other ads appearing in the *Courier* or *Ebony* made the pitch directly in Patty-Jo's breezy language and specifically named the dollar amount she cost.

The doll's introduction was met with compliments from many quarters. The editor of *Negro Digest* lauded "the cute Patti-Jo [*sic*] dolls, which may be expensive but still are the first really original Negro dolls to hit the market," in a 1947 opinion piece. St. Clair Drake, a professor at Roosevelt College in Chicago, praised the concept of the Patty-Jo doll but complained about its price in an article titled "How I Told My Child about Race":

And why do all one's friends in the first year of the kid's life shower her with highly attractive blonde dolls and never think of a colored doll? (I'll admit that nobody in my set can afford a Patty Jo and that most of the rest of the junk is on the Aunt Jemima and Topsy side. Grandma in Virginia did send an Indian squaw that helped.) So, later on, the colored parent considers sneaking in a few colored dolls, shivering for fear the kid will say, "I don't want that old black doll." Doll makers, attention!...Even the Negro manufacturers act as if they think a really dark brown doll baby won't sell.[11]

Drake overlooked the fact that Patty-Jo was designed expressly to have an elite appeal: owning a Patty-Jo doll advertised class, prestige, and upward mobility. But beyond the vanity implied in a mere status symbol, a more complex meaning of pride and self-realization may also have been at work.

All Terri Lee dolls at this time were made from the same sixteen-inch molds, and so it was inevitable that Patty-Jo would have the same hard plastic chubby "toddler" body as other Terri Lee dolls did. But curiously, Terri Lee's fashions for its dolls often suggest an older child, as does the advertising copy in the company's catalogs, which puts the more fluent speech of older children in the mouths of these young dolls. But no matter—just as the cartoon Patty-Jo was known for her verbal flights on subjects beyond her years, her dressing up in older girls' clothing fit right in with the Patty-Jo doll's multilayered persona.

The most important feature of any black doll, and the one that children would immediately identify, of course, is its skin color. Chemists had not yet figured out how to mix color pigment into plastic, and when Terri Lee dolls came out of the molds snowy white or even green at times they were then spray painted the desired color, hence the term *painted plastic* for this era of Terri Lee dolls. Ormes and Gradwohl struggled to find the right shade for Patty-Jo. For their up-

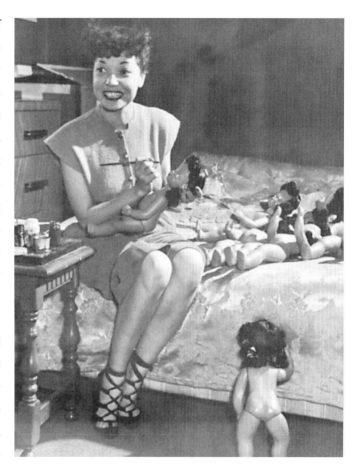

Some wigged dolls painted in the correct color according to her directions were sent to Ormes at her home address. Here she put on the finishing touches, transforming the blank face into Patty-Jo's signature expression. Ormes then could sell dolls herself, thereby realizing her best profit. Other dolls were painted by Lincoln, Nebraska, factory artists who were trained by Ormes. *(Courtesy of Delores Towles.)*

The Patty-Jo Doll

Woman Cartoonist Turns to DOLL DESIGNING
By MAXINE THOMPSON

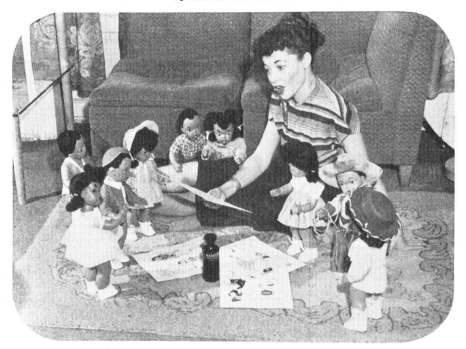

Jackie Ormes "shows" Patty-Jo and playmate Benjie some cartoons which inspired her Patty-Jo doll

Just before the Christmas season, in November 1947, Patty-Jo got a boost with toy merchandisers in an article in the industry trade magazine *Toys and Novelties*. In a photo accompanying the article, Ormes reads a *Patty-Jo 'n' Ginger* cartoon to Patty-Jo and Benjie dolls, who seem to be listening. A bottle of india ink sits on the floor; she used pen and ink in most of her cartoon work.

Jackie Ormes

scale doll they looked for a dark pigment that would be slightly lighter than other black dolls on the market. After sampling many browns, they ended up with a shade that had warm undertones and a satiny finish smooth to the touch, created from heavy, hard-wearing automotive paint.

Patty-Jo stands alone as the only comic character doll whose face was painted by the same artist who created the cartoon character. Every Terri Lee face was hand painted, giving each a distinctive look. The head and face, as well as all parts of the Patty-Jo doll, were made in the same molds as the white Terri Lee dolls. But unlike white dolls painted brown from other manufacturers, the unique contours and features of this face could be transfromed by painting to appear convincingly African American. Part of her contract called for Ormes to teach artists in the Lincoln, Nebraska, factory how to paint a Patty-Jo face on the dolls sold through the Terri Lee company. In the personal mail-order part of the deal, dolls with blank faces were sent to her Chicago home

studio and were hand painted by Ormes herself. When Ormes or the factory artists she trained painted on Patty-Jo's high arched eyebrows, mischievous eyes glancing askance, and bright rounded lips, her personality magically emerged.

Patty-Jo was the first black doll advertised as having hair that "may be shampooed . . . combed and recurled," a testament to the versatility of the new manufacturing substance, plastic. A plasticlike liquid compound could be extruded into solid strands that were sewed together and glued onto buckram caps to make wigs that were water friendly and stayed put.[12] As it happened, all Terri Lee dolls at this period, including the ethnic dolls, wore this rather stiff "mannequin wig" that had a texture not unlike some unprocessed African hair. To further enhance the child's ability to play with her doll's hair, this doll featured painted-on eyes, not the common metal and glass sleep eye mechanisms that were notorious for breaking and for rusting after being immersed in water. Playing with a doll's hair might have taken on special significance for African American girls accustomed to family rituals that focused on their own hair, sometimes using hair straightening products like oils and hot combs to achieve the "well groomed" look dictated by society at the time. In the few words she wrote and squeezed onto the Patty-Jo doll's small wrist tag and in advertisements she wrote, Ormes felt it was important to include a description of the play value in Patty-Jo's hair.

Children who amused themselves for hours dressing and undressing dolls hoped to receive ever more doll outfits as gifts from their parents. The entire array of Terri Lee clothing fit Patty-Jo. A *Terri Lee Fashion Parade* catalog came packed in every doll box, and on the first page the Terri Lee doll herself greeted the new owner:

> Hello there! . . . There is no doll in the world with a wardrobe as complete as mine. . . . My tiny garments are all hand sewn and tailored to fit, made by highly skilled seamstresses. . . . Only the most exclusive materials are used for them. Fine Celanese taffeta, soft flannels by J. P. Stevens, organdy dotted swiss, powder puff muslin, dimity and gingham by Dumari. Velveteen in my coat is made by Merrimack. The trimmings for all these beautiful garments are the very best we can obtain, satin ribbon, val lace, iridescent nail heads and real rhinestones, sequins, eyelet embroidery, furs, etc. You can also learn to

The Patty-Jo Doll

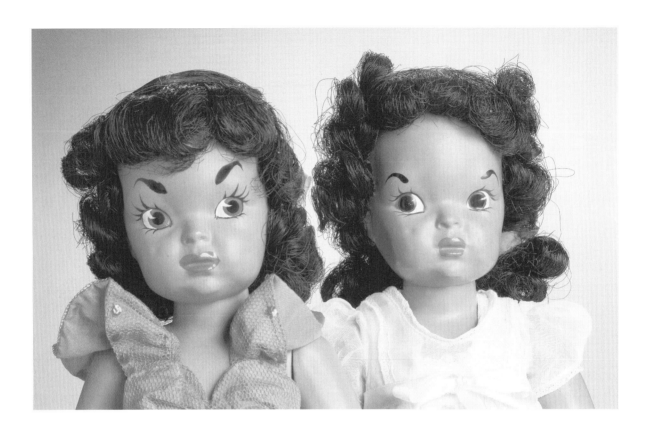

The Patty-Jo doll on the left was a gift from Ormes to her sister-in-law in the late 1940s. Because of this provenance, it's certain that Patty-Jo's face was painted by Ormes herself. Her serrated-edge eyebrows, long eyelashes, and wide lips resemble the earliest Patty-Jo cartoon character. The doll on the right may have been painted by Ormes and represents changes she made in the doll's features over time by softening the facial expression for contemporary consumer appeal. Factory artists also painted Patty-Jo faces, following a large drawing of the correct face Ormes left in the artists' factory work area. Connoisseurs debate which Patty-Jos in collections today were painted by factory artists and which by Ormes's own hand. *(Left: Collection of Gayle E. Ormes Hawthorne;* right, *collection of the author.)*

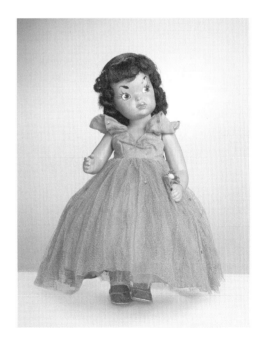

Patty-Jo dolls are sixteen inches high, made of hard plastic, and marked "TERRI LEE PAT. PENDING." *(Collection of Gayle E. Ormes Hawthorne; photo by Nick Say.)*

WHAT IS A REAL PATTY-JO DOLL?

A vintage Patty-Jo has these features:

1. TERRI LEE
 PAT. PENDING
 with backward "Ns" in raised letters on
 upper back

2. made of hard plastic

3. she resembles the cartoon character in all
 ways:

 face: short eyebrows with high arch, set wide
 apart, thick in the center; eyes almost
 always glancing to one or the other side;
 eyelashes long, curving; lips very full
 hair: two low pony tails in the back tied with
 ribbons, curly bangs in front; dark brown
 hair, almost black; mannequin wig of stiff,
 horsehair-like manmade fiber is glued
 onto buckram cap which is glued onto
 pate
 body: made from the basic Terri Lee mold;
 sixteen inches high

4. color: medium brown, satiny, lead-based
 paint

5. clothing has tag of loopy blue script
 printed on white satin: "Terri Lee"

6. made while Jackie Ormes was associated
 with the Terri Lee company, from
 August 23, 1947–December 31, 1949

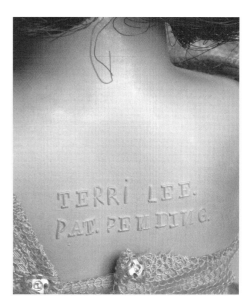

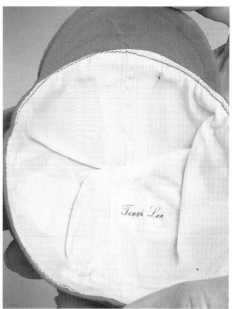

Thanks to Patricia "Pat" Rather for her documentation of most of these features in the *Daisy Chain*,
a Terri Lee collectors newsletter.

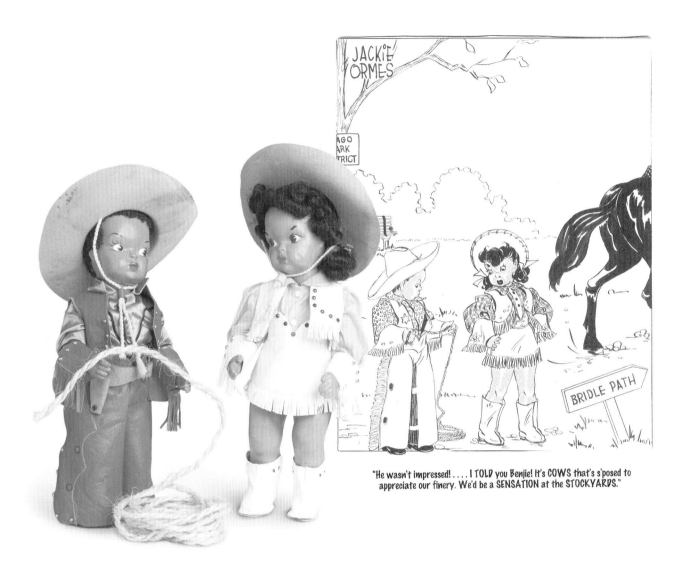

"He wasn't impressed! I TOLD you Benjie! It's COWS that's s'posed to appreciate our finery. We'd be a SENSATION at the STOCKYARDS."

Ormes often dressed her cartoon characters in costumes straight from the Terri Lee company's fashions line in order to promote her doll sales. Benjie, on the left, was a doll made by Terri Lee before Ormes joined up in late 1947; she adopted him as a character for her cartoon but had no connection with the design or sales of the Benjie dolls. Patty-Jo is on the right. Both dolls are made of hard plastic and are sixteen inches high. Patty-Jo was made between 1947 and 1949 and this Benjie probably about the same time. *(Dolls from collection of the author; photo by Nick Say.)*

snap or unsnap your own clothes by dressing me. Even the little tiny buttons will help you to learn to dress yourself. Also, please keep my clothes hung up nicely and your mother, I know, will show you how, by showing you how to care for your own clothes.[13]

Obviously not all parents could afford factory-made doll clothing, and some mothers depended on the several generic doll sewing patterns commercially available. For Ormes, style was a way of life, and

Jackie Ormes

she thrived on the fashion concepts that were represented in Terri Lee's wardrobe. Her sister reports that both Ormes and her mother, Mary, were skillful seamstresses and often enjoyed sewing together for Patty-Jo.

What seemed to be a perfect business relationship ended when Ormes's contract with the Terri Lee company was not renewed in December 1949 and the production of Patty-Jo dolls ceased after two years. For most of the following year the Terri Lee company ran an occasional Patty-Jo ad in the *Courier*, and even through the end of 1952 Patty-Jo was shown in the *Terri Lee Fashion Parade* catalog and in occasional magazine ads as the company reduced its inventory and prepared to move to its new location in Apple Valley, California. Soon Patty-Jo was dropped from the catalog, and Bonnie Lou reappeared, once again joining Benjie, who had stayed on all along. Although no sales figures remain to show how well Bonnie Lou and Benjie sold, the fact that they were advertised until 1962 suggests a moderate level of success and the Terri Lee company's, and its licensees', commitment to the concept of fine black dolls.

While Ormes's Patty-Jo was the first high-quality, realistic black child doll specifically targeted to the African American market, she had competition from black baby dolls. One example was Amosandra appearing in 1949, and fashioned after the baby on *Amos 'n' Andy*, a radio show that depicted a pair of bumbling men and a nagging wife.[14] Two years later and well after Patty-Jo ended, the Ideal Novelty and Toy Company produced Saralee, a less problematic and more appropriate baby doll. She was described in a 1951 *Life* magazine article entitled "Doll for Negro Children: New Toy Which Is Anthropologically Correct Fills an Old Need."[15] *Ebony* magazine reported praise for Saralee from the Toy Guidance Council: "By wiping out these stereotypes we may help to create an atmosphere in which healthier racial attitudes may grow."[16]

But Saralee and Amosandra were both baby dolls, and the girl child who wanted a toy playmate that looked like her and wore clothing like hers would have to wait for another step forward in doll manufacturing. A 1952 *Ebony* article nostalgically called the Patty-Jo doll the "Prettiest pioneer in the realistic doll line." Asserting that this doll best represented black girlhood, the article continued: "Foreign tourists

who want to take home an example of what Negroes in the United States are like frequently choose Patti-Jo[*sic*]."[17]

Dramatic events later overwhelmed the Terri Lee company, including a 1958 factory fire and, according to doll historian Peggy Wiedeman Casper, Violet Gradwohl's passion for thoroughbred Arabian horses that distracted her and sapped her resources. A bankruptcy liquidation sale in April 1960 sold off her Apple Valley factory and home (including furniture that had once belonged to Rudolph Valentino), but Gradwohl hung on by licensing Terri Lee molds and the brand name to different toy companies. In these days of crisis for the Terri Lee company, Gradwohl apparently approached Ormes in hopes that a reissued Patty-Jo might help restore the company's financial solvency.[18] A 1962 letter to Ormes from a friend says, "I'm real excited about the Patty-Jo dolls. Good luck." In the same year a *Chicago Defender* column mentions Ormes's doll and says that she would be "returning to the scene with a new and improved product soon."[19] Litigation between Gradwohl and the licensees on other matters ensued, however, eventually causing financial ruin. Finally in 1962 the manufacture of the original Terri Lee dolls came to a close, thus ending any chances for a rebirth for Patty-Jo in Ormes's lifetime.[20]

Perhaps it is just as well that Patty-Jo retired with her top billing intact. By the time Ormes contemplated a revival, market competition had become stiff among manufacturers of quality black play dolls. The civil rights movement was under way, education and jobs for blacks were slowly opening up, and the toy industry was responding not only to appeals for diversity but also to black consumers' increased purchasing power. When Remco Industries came out with an "ethnically correct" doll series in 1968, for instance, the head of the company emphasized the good business sense in making black dolls: "There's no tokenism in our decision. . . . We're not looking for thanks but for business. We're trying to fill what we believe is an unfilled market demand."[21] More black dolls appeared on display shelves in the same stores where African Americans had once been denied service, and black dolls began to pop up in mainstream advertising. Black dolls' time had come. Patty-Jo dolls survive today in collections as reminders of one woman's hopes and dreams, of her artistic talent, and of her vision that each American childhood should have the chance to be equal to any other.

CONCLUSION

Why do people read cartoons and comics? Robert Mankoff, the *New Yorker* cartoon editor, offered a response to this question when he spoke on the psychology of humor. "Cartoons present a different way to see life's problems," he said. "They deliver a kind of mental health service."[1] A good cartoon, Mankoff suggests, can refresh the mind. It brings the reader to a momentary halt and presents a new take on things. Cartoons can make people view events a little differently or inspire them to take action, even if that action is simply to clip out the joke and pass it on to others or tack it up in an office cubicle. A cartoon can be pleasantly simple and easy to read or complex, requiring extra effort on the part of readers. And among the many reasons people turn to cartoons, surely one of the most obvious is that they provide pleasure and amusement. My father would laugh on Sunday mornings as he read aloud from *Our Boarding House,* emphatically quoting Major Hoople's commentary on life's problems: "Egad!" Whether they are Sunday color comics in the mainstream press, Saturday inserts in the African American papers, or weekday black-and-white strips in regular pages, the funnies indeed provide "mental health service" with their offerings of reflection and refreshment—and a comic observation of the world.

Jackie Ormes's work crossed several thematic boundaries and presented readers with a variety of expectations and pleasures. Her wide range of styles and topics eludes easy categorization. For some, her most memorable achievements may be found in her participation in the tradition of American editorial cartoonists. Others will admire her pinup art and her bold invention of herself as an artist in that genre, so popular at the time. Her work can be appreciated for its messages of racial uplift, made especially interesting because they were aimed at a wide readership in a family newspaper. Ormes's cartoons also vividly document the material culture of the postwar period and show the

ways people dressed; how they furnished their homes; and their ambitions, pleasures, and pastimes. And, finally, the Patty-Jo doll will be most significant to some as an example of how Ormes contributed to black children's pride and self-identity.

Editorial cartoons in America date from Benjamin Franklin's first published cartoon in 1754. Civil War cartoonist Thomas Nast launched diatribes against the Confederacy and later excoriated New York politico William Marcy "Boss" Tweed, helping to bring him down. "In times of war and crisis, it seems, cartoonists reach their full potential," former Library of Congress prints curator Harry Katz observed, and indeed conditions in Ormes's day supplied plenty of crises for her to consider.[2] Widespread segregation as well as unfair laws and policies plagued African Americans. In the tradition of editorial cartoonists before her, Ormes used her drawing pen as her weapon.

Like her contemporaries Herbert Block ("Herblock") and Bill Mauldin in the mainstream press and Oliver Harrington in the black press, Ormes adopted wartime themes.[3] And later they confronted issues like the cold war, nuclear weapons, political corruption, and racial injustice. The *Pittsburgh Courier* placed Ormes's cartoons on the comics page, where, in fact, many of them belonged. But some of her work was so potent and so effective as political statement that it could well have found a spot alongside those masters of editorial cartooning.

Just as interesting are the ways much of her political commentary differs from that of editorial cartoonists. Clearly, Ormes was creating her own traditions. She generally eschewed the use of caricature of famous people, a favorite technique of Nast, Herblock, and others who appeared on editorial pages. Ormes most often spoke through ordinary people, characters who were not in the public eye. Patty-Jo, for instance, seems the least likely person to take on such topics as atom bombs or unfair employment policies, though she frequently spoke on these issues; the later Torchy, an unassuming nurse in a small clinic, became the adversary of a powerful industrialist. Through depictions of ordinary people doing and saying extraordinary things, Ormes established a deep sympathy with her characters and, by extension, with her public. Readers could relate to these characters and circumstances. And perhaps it is because she involved the whole

Conclusion

178

of African American society, and not just well-known personalities (though she did use a few), that Ormes's work is accessible to us today and claims our attention.

In some ways Ormes was ahead of her time, her work anticipating cartooning's traditions that were yet to come. Torchy's battle against industrial pollution in 1953–54 predates Walt Kelly's *Pogo*, which looked forward to ecology movements in the 1960s and 1970s. Garry Trudeau's *Doonesbury* and Aaron McGruder's *The Boondocks* are two influential newspaper comics that today employ the same type of sequential panel story telling to make direct political statements as Ormes did with *Torchy in Heartbeats*. This is not to say that Ormes had a direct influence on these cartoonists but rather that Kelly, Trudeau, and McGruder coincidentally arrived at topics and methods of cartooning in comic strips that Jackie Ormes had cultivated years before.

But Ormes was primarily a humorist. She kept her antennae tuned to the wide world around her, picking up signals about events, fads, manners, and language that could be used as material for humor. Part of her attraction for readers then as now is the playful and witty way she interpreted modern life in America. Postwar prosperity and growing consumerism provided setups for funny situations, such as Ginger constantly altering her hemline in order to obey the dictates of fashion stylists. The depictions of the shapely Candy, Ginger, and Torchy demonstrate the palpable allure of pinup art for Ormes and her sense of play (and creativity) in the way she invents fashionable clothing to complement their figures.

On one level, Jackie Ormes's work can be enjoyed as entertainment and a diverting way to consider a shared American past. But with the recovery of her work, students and researchers can now more fully consider Ormes in relation to cartoon and comics history, art history, American folk humor, and the black press. The work also enables connections that illuminate political history, black history, and aspects of popular culture. Those readers and researchers interested in body theory, fashion theory, and issues of African American feminism will find her art informative. Ormes's visual representations of modern life provide a rare glimpse into how progress was reported to African Americans and knowledge disseminated on a national scale. Ormes chronicled the look and sound of modernity in a weekly me-

dium available to all. She brought to vivid imaginative life the actuality of people's homes, city streets, shops, clothing, and language, as well as automobile, train, and, in 1937, even airplane travel. Finally, awareness of her Patty-Jo doll and her paper doll cutouts will reward readers with a special interest in the material culture and play history of African American children.

In a time when many American women restricted their activities to the domestic and social realms, Ormes stepped into a very public spotlight and stood her ground to work in a male-dominated newspaper world. With her byline appearing for a dozen years in an important African American newspaper, Ormes was a person whose opinions mattered and whose talent was admired. Her messages of strength, resourcefulness, and humor communicated strategies for people of color in their pursuit of the American dream. When the political associations that nourished Ormes's opinions became risky—and no doubt unpopular with some people—her strength of character helped her remain steadfast in her activism and hold close her friendships.

Many in America take for granted that independent and assertive women are now well accepted, commonplace even; that female talent will be rewarded; and that the glass ceiling holding women back from advancement has been shattered. Many prefer to think that the color bar that once restricted African American cartoonists to working only in the black press has been lifted as well. If the freedom of speech guaranteed in the Constitution reigns in our national press, then political opinion in cartooning should be unhampered by censorship. It would be easy to assume that, if Ormes lived and worked today, her satirical cartoons would appear on the editorial pages of the biggest daily newspapers in the country and her comic strips would be carried in the mainstream syndicates' Sunday funnies. But reality suggests otherwise. Trina Robbins, in her book *The Great Women Cartoonists*, points out that "Although the number of syndicated strips by women has risen from a low of about four in the early 1990s to about twenty in 2000, the subject matter tends to remain comparatively conservative. . . . and a good many of the strips are still about families."4 Ann Telnaes, a Pulitzer Prize–winning editorial cartoonist, commented on censorship and the posi-

tion of women in the profession in 2004: "People ask me, why aren't there more women political cartoonists? I'm beginning to think that the world is not ready for aggressive women. It's okay for guys to do editorials. But it kinda scares people when women speak out."[5] The number of nationally syndicated African American female cartoonists at present is nil, and the number of black male cartoonists, as well as cartoonists of color generally, remains small in the mainstream papers. Although their cartoons spanned several decades in newspapers that were read by Americans from coast to coast, you will probably not find the names of Harrington, Fax, Milai, Jackson, Holloway, Commodore, or Ormes in the index of most books on comics history; nor will you find a mention of the long history of these and other black cartoonists' comic strips and cartoons in the African American press. The accounts of the lives and the work of a host of other twentieth-century African American cartoonists will one day be gathered and written. And for this we will all be richer.

Jackie Ormes was generous with her materials and gave works of art and original cartoon drawings to philanthropic fund-raisers. She and her family were also known to send out original art and photographic slides that she had made of her comic strips for inclusion in cartoon art retrospectives or for possible use in publications. Most of these materials were never returned. Unfortunately, in many cases these lost slides and art are the only record of some of her work. As mentioned earlier, there are gaps in her materials, for instance, in the *Torchy in Heartbeats* series. Missing also are letters Ormes may have written to friends and family. It is my hope that this book will serve as a call for any extant Jackie Ormes materials to be donated to either the DuSable Museum of African American History in Chicago or the Cartoon Research Library at Ohio State University in Columbus. Contributing mementoes of Ormes's life and art, and the work of other cartoonists as well, would be a fitting tribute to the life and achievement of this extraordinary woman who gave so much through her work and her life.

Another goal of this book is to call for old African American newspapers with comic strips and cartoons or original art to be offered to the Cartoon Research Library. An additional repository is the Comic

Art Collection in the Special Collections at Michigan State University Library in East Lansing, which specializes in comic books, and they would welcome information about available African American comics, scrapbooks of comics and cartoons, and the like. The Center for Research Libraries in Chicago needs donations of financial help to properly document their newspapers. Digitally photographing or scanning all the *Courier* comic sections in their possession would allow more researchers to see them; the use of these materials is frequently limited due to the fragile condition of some of the paper.

Jackie Ormes always signed off at the end of the year with a holiday greeting to her readers. No matter what predicament Torchy might be in or what state of the world Patty-Jo might be worrying about, the sentiment was always upbeat and tender. In 1951, Ormes has Torchy extend her wishes for the new year:

> Torchy has signed to take a mysterious, unknown job in South America . . . on a dirty tramp freighter. . . . she returned to the deck. "The North Star! I'd almost forgotten—it's Christmas time! . . . long, long ago . . . there was one thing then, a thing that has never died in the hearts of man. . . . Yes, hope for a better world. Hope for a world where the brotherhood of man becomes a reality! Hope for a world where the words Peace On Earth and Good Will to Men are more than a phrase! . . . So, all you good friends, though there's no yule log burning here, there's always time to say,—Merry Xmas to you All!"

Torchy's adventures continue next week!

DON'T MISS IT!

CORRECTING THE RECORD

Jackie Ormes was born in 1911—not 1914, 1915, 1917, or 1918 as has been variously reported. It's possible that the confusion stems from information provided by Ormes herself in an attempt to shave a few years off her age—a rather common practice for women in earlier eras. (For instance, Zora Neale Hurston, the celebrated novelist of the Harlem Renaissance, regularly subtracted ten years from her age, a fact discovered only after her death.) Indeed, Patty-Jo herself might have laughed with her creator about "spinning a sticky stop," as the cartoon character once described the practice of inventing little lies that sometimes catch people up. It's important to correct the record about Ormes's exact age; we can now reckon, for instance, that at her graduation from high school in 1930 she was a believable nineteen years old, rather than twelve, and that her first nationally syndicated cartoon was produced at age twenty-six, not nineteen.

Some previous accounts have held that Ormes's father, William Winfield Jackson, was an artist. The source of this legend, appearing as early as 1950, could have been some writer's colorful imagination, or perhaps Ormes, as a writer of romantic sagas, embroidered the story herself. According to her sister, Delores, their father was neither an artist nor a writer but in fact owned an open-air movie theater and a printing business. According to Delores, their mother was creative and loved music and the arts, but neither parent demonstrated the musical, artistic, or literary talent that some sources imply they bequeathed to both girls.

Ormes, like many other cartoonists of the time, was mostly a self-taught artist. Her training at the School of the Art Institute of Chicago was confined to the early 1940s and was likely at the nondegree adult education program, since no transcript can be found. Several reports assert that she attended Salem Business College when she lived in that Ohio city, but a check of the records reveals that the only course that a fledgling reporter or cartoonist might use was a "penmanship" class.

Two family members close to her at the time confirmed that they had no recollection of Ormes taking such training in Ohio.

It's been stated in print that *Patty-Jo 'n' Ginger* ran until 1965, and the date was repeated whenever the cartoon was mentioned, sometimes by Ormes herself. However, I found no evidence to indicate that it appeared anywhere in publication after 1956.

Like many—perhaps all—important artists, Ormes often came up with an original version of an idea that was already in the air and did not actually invent some innovations attributed to her. The notion that Dale Messick's Brenda Starr comic character was an imitation of Jackie Ormes's Torchy Brown is not borne out by a review of comic strip history and chronology; the 1937–38 Torchy Brown bears little resemblance to Brenda Starr, who first appeared in 1940, ten years before the 1950 version of Torchy Brown was first published. Furthermore, in no episode of *Torchy in Heartbeats* is the character of Torchy ever a newspaper reporter, as has been stated in a few articles. Ormes herself was a reporter at one time, however, and it's not all that surprising that some writers seem to have confused Jackie Ormes, the creator, and Torchy, her fictional look-alike. On the other hand, Ormes was never a sports reporter as is sometimes claimed; she liked to attend boxing matches and was known to write human interest stories about events and personalities surrounding important fights.

Ormes did not create the basic body design of the Patty-Jo doll (originally called Bonnie Lou) or its clothing, both of which were part of the Terri Lee doll line before her relationship with the company began. Ormes did create the Patty-Jo cartoon character's face and painted it onto a brown version of the existing Terri Lee doll. She later introduced the Benjie character, already a Terri Lee doll, into her cartoon. Details on this relationship are described in chapter 8.

Patty-Jo was not the first black character doll. Golliwog, Beloved Belindy, and Topsy, for instance, are earlier black character dolls, all with origins in literature, and Rachel is an example of an earlier black doll from a character in the funny papers. Myla Perkins's books *Black Dolls: An Identification and Value Guide, 1820–1991* and *Black Dolls: An Identification and Value Guide, Book II* are identification guides to these dolls and more, with useful explanatory text. The Patty-Jo doll was pioneering in other ways, most notably as the first brown-skinned doll with an

extensive wardrobe and playable hair, all powerful play materials for African American children.

Ormes has been referred to as "the first black woman syndicated cartoonist." Perhaps a better title would be "the first and *only* black woman newspaper cartoonist of her time," a position she held for decades. That no one immediately followed the trail blazed by Ormes underscores her distinction. Contemporary cartoonist Barbara Brandon-Croft comes closest and is cited in some encyclopedia entries as a beneficiary of Ormes's pioneering efforts. In her youth, Brandon-Croft assisted her father, Brumsic Brandon Jr., with his strip *Luther*, launched in 1968, and later became a cartoonist in her own right. Today she is known for her *Where I'm Coming From* comic strip, which appeared for a time in the Universal Press Syndicate. However, a comparison of Brandon-Croft's to Ormes's experience is hardly useful: it was thirty-three years after Ormes quit that Brandon-Croft's strip started in 1989, and the strip was syndicated in mainstream papers versus Ormes's work during the era of black cartoonists in only African American papers. A more rewarding overview would be to situate each woman's unique achievements in her own era and to salute each for blazing her own trail.

Most of Jackie Ormes's work was not syndicated in the sense that is commonly understood today. Only *Torchy in Heartbeats* was carried by a syndicate (Smith-Mann Syndicate—SMS—described on pages 196–97); SMS's single customer for the color comics insert was the *Pittsburgh Courier*. Ormes drew *Torchy Brown in "Dixie to Harlem"* and *Patty-Jo 'n' Ginger* under independent contracts with the *Courier; Candy* appeared in the *Chicago Defender* on an unpaid trial arrangement made directly with that newspaper.

EXCERPTS FROM
THE FBI FILE OF JACKIE ORMES

Ormes's FBI file provides evidence that the Chicago FBI section was actively keeping tabs on dozens of people as subjects for investigation. They were interested not only in subjects who lived in Chicago but also in people who came to give speeches, promote books, and engage in fund-raising. Appearing in the document are names of several officers in the U.S. Communist Party and in the CP's Midwest and Chicago regions, as well as names of Chicago CP members and nonaffiliated persons who attended and participated in what were believed to be CP front events; more names, especially of those who were interrogated, are blanked out of the FBI report for reasons of confidentiality.

What follow are selections from the FBI file, with interpretations of some of the events reported in the file. This material is included for those interested in reading Ormes's own words regarding her political situation in the late 1940s and 1950s.

Though Ormes never was a member, her early attraction to the CP seems to have stemmed from her appreciation of the party's espousal of an antiracist society, as well as her affinity for artists and others in the party and for fringe groups who were all working toward egalitarian goals. It appears that she was a sympathizer rather than a party regular. In one interview, for instance, she denied ever having read the writings of Karl Marx, and there is no evidence in interviews or cartoons that she was attracted to the Soviet ideological line. Comments from family and friends and mementoes of her work for the Democratic Party in the 1960s and 1970s show that over time Ormes's political views moved from the far left to the liberal center of the spectrum. It is not clear what comrades may have thought about this stylish woman in her Dior-inspired designer clothes, leopard jacket, and iridescent green fingernails, as some family members remember her.

Some leftist artists and speakers who were CP members stayed at the Sutherland Hotel from time to time, but Earl Ormes, manager of the hotel, was never observed at a political event, and the FBI document specifically excludes him from the kind of associations that his wife sometimes had. In one interview, she stated that her husband "has no interest in politics." It's possible in fact that he was largely unaware of the challenges she confronted. Both the FBI and the CP preferred to shroud their contacts with her in secrecy. One report quotes an informant describing how the CP repeatedly, but unsuccessfully, attempted to recruit her: "The informant has explained that ORMES is very difficult to contact because of her many social activities and because her husband is almost always at the Sutherland Hotel at any time of day."

In any case, it's safe to assume that Ormes's participation in the interviews, the awareness that she was under FBI surveillance, and the pursuit by CP regulars must have worried her at times. That she felt a degree of anxiety over all of this is suggested in some of her replies to the agents. A 1953 interview described what appeared to be an effort by Ormes to deflect FBI attention when "subject advised that she is neither attending meetings of any type organization nor is she 'lending her name' to any organization as she felt to do so would ruin her reputation." Sensing her vulnerability, she nevertheless held her ground, answering questions with confidence. The same interview ends with the agents' observation of how she appeared to them:

> ORMES impressed the agents as a very friendly and intelligent person who is primarily an idealist and is trying to advance the best interests of the Negro people. ORMES is very social conscious and feels that she is in the upper strata of Negro Society. ORMES is well read and is noticeably pleased to be classified as an intellectual and a leader among the Negro people.

The reports were obviously subjective, depending on which agent was doing the interviewing and how the subject responded on a particular day. Another report chronicles a political debate between Ormes and other agents, where Ormes may have been pretending to be apolitical. The report concludes,

> As a result of the interview, it was apparent to the interviewing agents that

*Excerpts from the
FBI File of Jackie Ormes*

the subject is not very well informed or intelligent but rather, a pseudo-intellectual type person, flighty in temperament, and not inclined throughout the interview to seriously consider what the agents were attempting to clarify.

Ironically, the decade-long tracking of her activities by federal officials seems to have been instigated not because of her outspoken protest cartoons but because of her appearance at a forum in December 1948 at a bookstore where several author-speakers were CP members. About two hundred people attended: "The Commies were out in number," the FBI agent reported, "about two whites to three Negroes. Other names heard at the meeting included ... JACKIE ORMES (cartoonist), Pittsburgh Courier." From that time on, agents kept tabs on the activities of Ormes and her associates through what could easily be called governmental harassment. The 1953 FBI interview with Ormes outlines her position and demonstrates her courage: "ORMES denied having ever been a Communist or having been instrumental in the 'movement' in any position either Communist or 'front groups' activities; however, the subject stated that on many occasions she has aligned herself, theoretically, with the Communist Party because they, the Communist Party, had offered humanistic, social, and economic advantages to the Negro people ... [but] this did not necessarily mean that she subscribed to all the Communist beliefs."

In a February 27, 1956, interview with FBI agents, Ormes explained her past participation in art and performance groups such as the South Side Community Art Center, the Artists' Guild, the Cultural Club, and the Du Bois Theater Guild, all of which the FBI suspected of serving as Communist fronts. In some of her responses to this questioning she expressed strongly held opinions, while in others she suggested that one could be susceptible to and naive about certain organizations.

ORMES was asked how deeply she had been involved in the Communist Party movement. She remarked that although she had never been a Communist Party member as such, she had been involved "on the fringe" in many organizations which the public and the Government have apparently characterized as subversive or Communist. ORMES asserted that if her alignment with any such organization was considered tantamount to CP membership by the FBI or the CP, she had no defense....

Excerpts from the
FBI File of Jackie Ormes

ORMES directed the attention of the Agents to the previous interviews she had had with Bureau Agents during which she had stated she felt the Communist movement to be an innocuous one which, it seemed to her, constituted no apparent threat to the continued existence of this country's form of Government....

ORMES indicated that for some time she felt that the Communists were being investigated and persecuted because of their activities in breaking down racial barriers, exacting more benefits from capital interests for the working class and generally pressing for the advancement of common people, rather than for its supposed revolutionary aims and objectives....

ORMES pointed out that being a member of a minority group and a liberal she could clearly see where she might be misled by the programs of front groups without necessarily seeing the underlying objectives of such organizations. ORMES described this as appealing rather to the emotions than the intellect.

"Federal Bureau of Investigation: Freedom of Information/Privacy Acts, Release, Subject: Zelda Jackson Ormes" (Washington, DC: U.S. Department of Justice, 1948–58).

Excerpts from the
FBI File of Jackie Ormes

NOTES

INTRODUCTION

1. George Gene Gustines, "Girl Power Fuels Manga Boom in U.S.," *New York Times*, December 28, 2004, 7–8.

2. Liza Donnelly, *Funny Ladies: The New Yorker's Greatest Women Cartoonists and Their Cartoons* (Amherst, NY: Prometheus Books, 2005); and Trina Robbins, *Nell Brinkley and the New Woman in the Early 20th Century* (Jefferson, NC: McFarland, 2001).

3. Langston Hughes, Colored and Colorful, *Chicago Defender*, June 26, 1948, 14.

4. Steven Loring Jones, "Landmark Black Comic Strip," *Nemo: The Classic Comics Library*, January 1988, 55–56; and Susan Reib and Stuart Feil, "Torchy Brown Faces Life," *American Legacy* 2, no. 2 (Summer 1996): 25–32.

5. For the first eight months, the comic strip was titled *Torchy Brown Heartbeats*.

6. Art Spiegelman, "A Comic-Book Response to 9/11 and Its Aftermath," interview by Claudia Dreifus, *New York Times*, August 7, 2004, 19.

CHAPTER 1

1. U.S. Bureau of the Census, *Population in 1920*, vol. 1 (Washington, DC: U.S. Bureau of the Census, Department of Commerce, 1923), 126, 658. Although Simmons may have been a "Full" owner, the figure cited here is for "All owners" since he may have been a part owner who hired additional land to augment his own parcel as needed. It is possible also that he was not an owner but that he managed a farm. The census notes under "Colored" that there were "Part-owners 23, Managers 45" and "White Part-owners 8,777, Managers 4,445."

2. Ormes parodies the practice of requiring racial designation on school forms in *Patty-Jo 'n' Ginger*, September 9, 1949, reproduced here in chapter 6.

3. Jackie's other studies at Monongahela High School were the following: three years each of Latin and French; two years each of chemistry and

biology; and courses in Algebra I and II, Plane Geometry, Civics, Ancient History, Modern History, American History, and Problems of Democracy.

4. "P. O. D." stands for the class Principles of Debate. "Margin drawn just so" in English class refers to the days when students used ink pens to handwrite their formal essays on unruled paper, after first penciling in as guides the exact widths of margins at the top, sides, and bottom and later carefully erasing the pencil lines.

5. David Jackson, "The Amazing Adventures of Jackie Ormes," *Chicago Reader*, August 16, 1985, 16–25. Several quotes in this immediate section are found on the following pages: "Monongahela was like . . . ," 18; "It wasn't a ring at all . . . ," 18; "a great career . . . ," 18; "I was antiwar . . . ," 24; "I had never been to Dixie . . . ," 19; "Looks all right . . . ," 20; "Indeed Chicago . . . ," 20.

6. Her fascination with blood-spattering fights and her reporting on dramatic events in the court system and prisons as well as on raucous big-city politics seem curiously at odds with her pacifist postures. She patriotically supported war efforts such as rationing and Victory Gardens in her 1945 *Chicago Defender* cartoon *Candy* and her Social Whirl column. In the late 1940s and 1950s she criticized the Korean War as well as the arms race in *Patty-Jo 'n' Ginger*. By the time of the Vietnam War, Ormes was no longer cartooning; however, she organized Midwest Artists for Peace, a group that bought antiwar ads in newspapers.

7. Mary Dunlap Patterson, "Growing Up Black in Salem," in *People of Courage: African Americans in Salem, Ohio*, Jacqueline Frazier Rowser, ed. (Kent, OH: Kent State University), 71.

CHAPTER 2

1. Richard Wright, "How Bigger Was Born," in *Native Son* (New York: Perennial Library, 2003), xxvi.

2. Maren Stange, *Bronzeville: Black Chicago in Pictures, 1941–1943* (New York: New Press, 2003), xiii–xiv.

3. Wayne Miller, *Chicago's South Side* (Berkeley: University of California Press, 2000), ix.

4. St. Clair Drake and Horace Cayton, *Black Metropolis* (New York: Harcourt, Brace, 1945), 12.

5. Robert C. Puth, *Supreme Life: The History of a Negro Life Insurance Company* (New York: Arno Press, 1976), 53–54.

6. Thomas C. Fleming, "On to Chicago," in "Reflections on Black History,"

August 19, 1998, available at http://www.freepress.org/fleming/fleming 48.html.

7. Puth, *Supreme Life*, 153.

8. Roi Ottley, "Owners Invest $300,000 to Give South Side a First Class Hotel," *Chicago Tribune*, April 18, 1956, pt. 3, 12.

9. Craig H. Werner, "Chicago Renaissance," in *The Oxford Companion to African American Literature*, William L. Andrews, Frances Smith Foster, and Trudier Harris, eds. (New York and Oxford: Oxford University Press, 1997), 132–33.

10. Melanie Anne Herzog, *Elizabeth Catlett: An American Artist in Mexico* (Seattle and London: University of Washington Press, 2000), 26.

11. "Subject: Jackie Ormes, 4/25/54, Office Memorandum, US Government, Federal Bureau of Investigation: Freedom of Information/Privacy Acts, Release, Subject: Zelda Jackson Ormes" (Washington, DC: U.S. Department of Justice, 1948–58).

12. Jackson, "The Amazing Adventures of Jackie Ormes," 22.

13. Zelda J. Ormes, "Eliminate Segregation at Gt. Lakes Navy Center," *Pittsburgh Courier*, June 30, 1945, 1.

14. Bill V. Mullen, *Popular Fronts: Chicago and African-American Cultural Politics, 1935–46* (Urbana: University of Illinois Press, 1999). See also Harold Cruse, *The Crisis of the Negro Intellectual* (New York: Morrow, 1967), and Mark Naison, *Communists in Harlem during the Depression* (Urbana: University of Illinois Press, 1983).

15. Herzog, *Elizabeth Catlett*, 27.

16. Mullen, *Popular Fronts*, 85.

17. The Smith Act, or Alien Registration Act of 1940, made it a crime to advocate the violent overthrow of the U.S. government or to belong knowingly to a group advocating it. FBI director J. Edgar Hoover advised President Harry Truman in 1948 that the Smith Act be used against the Communist Party and its sympathizers. Truman did so to counter Republican complaints that he was "soft" on Communism. Under this law, citizens could be put under government surveillance and questioned about their activities, political beliefs, and organizations and, finally, could be prosecuted.

18. The Progressive Party was a name given to several political parties, and in general they have all stood for liberal social, political, and economic reform. In the late 1940s and 1950s, the Progressive Party included former Republicans as well as several left-wing groups, including the Communists. In the early 1950s their platforms especially embraced peace move-

ments. The Progressive Party disbanded in 1955, under the threat of Communist subversion.

19. Jackson, "The Amazing Adventures of Jackie Ormes," 18.

20. Mullen, *Popular Fronts*, 111.

21. Telephone interview with Chester Commodore, by the author, November 2003.

22. In early twentieth-century kid and flapper comics, "The artists Rose O'Neill, Grace Drayton, Ethel Hayes, Nell Brinkley and their contemporaries had no trouble getting published under their own names. However, a male pseudonym did seem to be required for action strips [and] . . . the women of the 1940s seemed to believe their success depended at least in part upon a male name." Trina Robbins, *The Great Women Cartoonists* (New York: Watson-Guptill Publications, 2001), 63.

23. Coulton Waugh, *The Comics* (New York: Macmillan, 1947), 305.

24. Dale Messick's *Brenda Starr, Reporter* comic strip first appeared in 1940 through the Chicago Tribune Syndicate. It became a daily feature, with a Sunday color comic, often with accompanying paper dolls. Brenda Starr exemplified the modern woman: fashionable, independent, action oriented, and career minded. Trina Robbins, *A Century of Women Cartoonists* (Northampton, MA: Kitchen Sink Press, 1993), 62–67.

Mary Petty had a four-decade career with the *New Yorker* starting in 1927. Petty gently satirized upper-crust New York society women in her single-panel gag cartoons. "Mary Petty Exhibit," available at http://lubinhouse.syr.edu/gallery/pettyExhibit.html.

25. Maxine Thompson, "Woman Cartoonist Turns to Doll Designing," *Toys and Novelties*, November 1947, 116.

26. Roland E. Wolseley, *The Black Press, U.S.A.* (Ames: Iowa State University Press, 1971), 322; Gene Roberts and Hank Klibanoff, *The Race Beat: The Press, the Civil Rights Struggle, and the Awakening of a Nation* (New York: Random House, 2006), 78.

27. Thompson, "Woman Cartoonist Turns to Doll Designing," 116.

28. Peggy Wiedman Casper, *Fashionable Terri Lee Dolls* (Cumberland, MD: Hobby House Press, 1988), 74.

29. Casper, *Fashionable Terri Lee Dolls*, 7–8.

30. Steven Loring Jones, "From 'Under Cork' to Overcoming: Black Images in the Comics," in *Ethnic Images in the Comics: An Exhibition in the Museum of the Balch Institute for Ethnic Studies*, Charles Hardy and Gail F. Stern, eds. (Philadelphia: Balch Institute, 1986), 26; Jones, "Landmark

Black Comic Strip," 56–66; Robbins, *A Century of Women Cartoonists*, 116.

31. Robert D. Bullard, *Dumping in Dixie: Race, Class, and Environmental Quality* (Boulder, CO: Westview Press, 1994), 29.

32. E. Frances White refers to *Righteous Discontent: The Women's Movement in the Black Baptist Church, 1880–1920* by Evelyn Brooks Higginbotham (Cambridge, MA: Harvard University Press, 1993). White, *Dark Continent of Our Bodies: Black Feminism and the Politics of Respectability* (Philadelphia: Temple University Press, 2001), 36.

33. Jackson, "The Amazing Adventures of Jackie Ormes," 25.

34. "Accomplishments of Women Latest in Film Series," *Chicago Defender*, May 9, 1953, 19. A Web cast of the Jackie Ormes section from *One Tenth of a Nation* is available at http://www.jackieormes.com.

35. African American athlete Althea Gibson was on her way to winning the U.S. national women's tennis championship in 1957 and 1958, and she also won singles and doubles at Wimbledon in those years. It's no wonder she felt happy.

 "The scientists have split the atom; now the atom is splitting us" is one oft-repeated quote from author and raconteur Quentin Reynolds, a white man, who made his fame as a World War II correspondent. He occasionally wrote for John H. Johnson's *Negro Digest*, as did poet Carl Sandburg.

 Jazz musician Oscar Peterson was famous in his own right, but he was also known for his accompaniments with Louis Armstrong, Ella Fitzgerald, Nat King Cole, and Duke Ellington, to name a few.

36. Radical black activist, educator, and philosopher Angela Davis was arrested on charges of conspiracy in an aborted attempt to free a prisoner from a California courtroom on August 7, 1970. She was later acquitted and resumed writing and teaching as a professor in the University of California system. Joan C. Elliott, "Davis, Angela," in *The Oxford Companion to African American Literature*, William L. Andrews, Frances Smith Foster, and Trudier Harris, eds. (New York and Oxford: Oxford University Press, 1997), 201–2.

CHAPTER 3

1. Roland E. Wolseley, "The Vanishing Negro Press," *Negro Digest*, December 1950, 67.

2. Roberts and Klibanoff, *The Race Beat*; Aurora Wallace, *Newspapers and the Making of Modern America* (Westport, CT: Greenwood, 2005); Patrick Scott

Washburn, *The African American Newspaper: Voice of Freedom* (Evanston, IL: Northwestern University Press, 2006).

3. Smith-Mann Syndicate (SMS) was founded by Ben B. Smith and John J. Messman in early 1950 and had a New York City address. Information about SMS is elusive partly because the SMS name has only been found in the *Courier* comic section and because other documentation of SMS is scanty. Indeed, an *Editor & Publisher* (*E&P*) article suggests that the *Courier* was SMS's only comics customer, "The Syndicate prepares a weekly comics section for the *Pittsburgh Courier* . . ." The same article announces the creation of *Carousel*—a different SMS supplement that has not yet been found—and it again mentions the *Courier*, "Mr. Smith . . . originated the Negro comics supplement which SMITH-MANN services to the Pittsburgh Courier." The article describes how subscribing newspapers will receive *Carousel* "in mat form or as a pre-printed four-color supplement" (Erwin Knoll, "Smith-Mann to Launch Comics Supplement," *Editor & Publisher*, July 21, 1951, 43). Original hard copies of the *Courier*'s comic section appear to also have been preprinted, as evidenced by its tabloid size, and by the quality of paper and types of fonts that are different from the regular pages. From 1951–58 *E & P*'s *Syndicate Directory* listed SMS in the "Syndicated Features" section. The first listing in 1951 includes twenty-three features offered by Smith-Mann, including all eight that ran in the *Courier*'s comic section at this time (*The Chisolm Kid, Don Powers, Guy Fortune, Heartbeats, Lohar, Mark Hunt, Neil Knight, Scanning the Skylanes*); other features listed have yet to be found in publication (*Alan O'Dare, Animal Almanac, Casey Kelly, Dan Freedom, Flint Steel, Flint Steel's Log Book, Funtime, Minute Meals, Pawprints, Rajah, Space Trails, Stars by Sari, Storyland, Through the Cookinglass, Yesterday and Today*) (*26th Annual Directory of Syndicated Features, Editor & Publisher*, July 28, 1951, 19, 21, 28–30). In addition, a mention of SMS appears in the papers of Richard J. O'Melia, general counsel to Senator Joseph McCarthy during the Senate hearings on un-American activities. It is an undated handwritten note concerning support for McCarthy, and the only reference to the business in question is the name "Smith-Mann Syndicate" written at the top of the note (Richard J. O'Melia Collection, Notre Dame University Libraries). Assumedly, Smith-Mann was a subject of investigation by government agencies during the mid-1950s, and it is possible that this kind of pressure on a small syndicate may have helped to put it out of business. In Ormes's personal scrapbook

of clippings, she rubber-stamped "Jackie Ormes Features" over every Smith-Mann mark, indicating her ownership of copyright.

Steven Loring Jones cites a syndicate from the early to mid-1940s: "The Continental Features Syndicate, . . . organized and run by the Black entrepreneur Lajoueaux H. Stanton, was one of the few national distributors of Black comics." Jones, "From 'Under Cork' to Overcoming," 25.

4. Henry Louis Gates, Jr., and Evelyn Brooks Higginbotham, eds., "Harrington, Oliver," in *African American Lives* (New York: Oxford University Press), 377.

5. M. Thomas Inge, ed., *Dark Laughter: The Satiric Art of Oliver W. Harrington* (Jackson: University Press of Mississippi, 1993), xx–xxii.

6. Inge, *Dark Laughter,* xxxix.

7. Jones, "From 'Under Cork' to Overcoming," 25.

8. Pamela B. Nelson, "From Subhuman to Superhuman: Ethnic Characters in the Comics," in *Ethnic Images in the Comics: An Exhibition in the Museum of the Balch Institute for Ethnic Studies,* Charles Hardy and Gail F. Stern, eds. (Philadelphia: Balch Institute, 1986), 12.

9. "What the People Think," *Pittsburgh Courier,* March 14, 1953, 11.

10. Inge cites Harrington haranguing his critics in the *People's Voice,* May 2, 1942, xxvii–xxviii: "With characteristic perverseness peculiar to maniacs, Southern Congressmen and cartoonists, I do not consider my cartoons low, degrading, or otherwise odoriferous to the sensitive masses. I still obstinately believe that there are some imbeciles left among us who find time in between bone-pulverizing bombings, mass murder and other sadistic forms of civilized recreation, to laugh. Pee Wee, Bootsie and company are harmless, fun-loving beings, eternally catching hell but still coming up with a smile."

In his essay on Harrington's 1943–51 *Jive Gray* strip, literary and cartoon scholar Edward Brunner credits that comic strip and *Dark Laughter* as offering more than entertainment. "But Harrington's primary goal, it bears repeating, was to construct a framework that could display heroic black figures, notably but not exclusively young males, acting in a positive light, out of which they and other African Americans could speak authoritatively, with forcefulness." Edward Brunner, "'This Job Is a Solid Killer': Oliver Harrington's *Jive Gray* and the African American Adventure Strip," *Iowa Journal of Cultural Studies* 6 (Spring 2005): 53.

11. "Negro Villain in Comic Book Killed by Youngsters," *Chicago Defender Weekly Magazine,* May 5, 1945, 1.

12. John Updike, "The Fourth Decade, 1955–1964," in *The Complete Cartoons of the* New Yorker, Robert Mankoff, ed. (New York: Black Dog & Leventhal, 2004), 240.

13. Robert C. Harvey, in *Children of the Yellow Kid*, is not alone in assuming that Turner was "The first African-American cartoonist to produce a nationally distributed comic strip raising racial consciousness," overlooking not only Ormes's protest comics but also those of Oliver Harrington and others in such black newspapers as the *Chicago Defender* and the *Pittsburgh Courier*, which were also nationally distributed. Harvey is, of course, referring to the dailies and Turner's pioneering work in those mainstream newspapers. Robert C. Harvey, *Children of the Yellow Kid: The Evolution of the American Comic Strip* (Seattle: Frye Art Museum, 1998), 147.

14. Pierre Couperie and Maurice Horn, *A History of the Comic Strip* (New York: Crown Publishers, 1968), 143.

15. Most of these cartoonists are known for more than one comic strip that appeared in several different African American newspapers. Only one title from their various oeuvres is cited here. Details on these cartoonists and others can be found at Tim Jackson's Web site, Salute to Pioneering Cartoonists of Color, available at http://www.clstoons.com.

 Elton Fax had an especially varied artistic career. He authored or illustrated a large number of books and articles on subjects including Dr. George Washington Carver, Marcus Garvey, Sitting Bull, black artists, and West African travels. Lynn Moody Igoe and James Igoe, "Fax, Elton Clay," in *250 Years of Afro-American Art: An Annotated Bibliography* (New York: R. R. Bowker, 1981), 667–70.

16. Patrick McDonnell, Karen O'Connell, and Georgia Riley de Havenon, *Krazy Kat: The Comic Art of George Herriman* (New York: Abradale Press, Harry N. Abrams, 1999), 30. For an interpretation of how *Krazy Kat* may have embodied Herriman's sensitivity to matters of race, see Robert C. Harvey, *The Art of the Funnies* (Jackson: University Press of Mississippi, 1994), 179.

17. An analysis of dialogue as well as other comic strip narrative techniques and the meanings they convey can be found in Scott McCloud's *Understanding Comics: The Invisible Art* (Northampton, MA: Kitchen Sink Press, 1993). Robert C. Harvey chronicles comics history in America and discusses "the visual-verbal blend principle . . . the first principle of a critical theory of comic strips," in *The Art of the Funnies*, 3–20.

CHAPTER 5

1. Mullen, *Popular Fronts*, 111.
2. Jackson, "The Amazing Adventures of Jackie Ormes," 24.

CHAPTER 6

1. Thompson, "Woman Cartoonist Turns to Doll Designing," 26.
2. Robbins, "Explanations," *The Great Women Cartoonists*, and "Explanations and Definitions," *A Century of Women Cartoonists*; Jones, "From 'Under Cork' to Overcoming," 26; Reib, "Torchy Brown Faces Life," 25–32.
3. Maureen Honey, "The 'Varga Girl' Goes to War," published in a collection of essays for the exhibit "Alberto Vargas: The Esquire Pinups" at the Spencer Museum of Art, University of Kansas, September 29–December 30, 2001, available at http://www.ku.edu/~sma/vargas/honey.htm.
4. Examples may be found in the *Chicago Defender*, May 23, 1942, and March 25, 1945.
5. Joanne Meyerowitz, "Women, Cheesecake, and Borderline Material," *Journal of Women's History* 8, no. 3 (Fall 1996): 18–21.
6. Tim Jackson, "E. Simms Campbell," in Salute to Pioneering Cartoonists of Color.
7. bell hooks, *Art on My Mind* (New York: New Press, 1995), 96.
8. Jackson, "The Amazing Adventures of Jackie Ormes," 18.
9. One example of a comic strip of the long-running big sister–little sister type is Ernie Bushmiller's *Nancy*, although the female characters involved were actually an aunt and her niece. The strip, distributed by United Features Syndicate, was originally named *Fritzi Ritz* and was drawn by cartoonist Larry Whittington. When Whittington left to work on another strip, Bushmiller took over *Fritzi Ritz*. Bushmiller introduced the character Nancy, Fritzi's niece, in 1933. The comic's title was changed to *Nancy* from *Fritzi Ritz* in 1938 when the kid niece began to get all the good lines. Nancy's pal, Sluggo, tags along after her and bears up under her authoritarian rule.
10. Mike Lukovich and Mike Peters, "Political Cartoonists Cast an Eye Back on 2005," interview by Renee Montagne, *Morning Edition*, National Public Radio, December 28, 2005. Lukovich works for the *Atlanta Journal-Constitution*, and Peters works for the *Dayton Daily News*; both cartoonists' works are syndicated.

1. Robbins illustrates with pages from *Love at First Sight*, *Complete Love*, and *Lovers' Lane* how "Another genre in which women were welcome was the burgeoning field of romance comics, which had started in 1947. With few exceptions, the stories in these books were hackneyed and clichéd, but the art was often stylish and elegant, allowing women artists to draw what they seemed to prefer drawing: graceful closeups of women's faces." Robbins, *The Great Women Cartoonists*, 92.

2. Contents of the magazine section were similar to *Ebony* magazine, featuring celebrities, leaders, and stories of racial uplift, along with advertisements for various products. Owned and published by John H. Johnson, *Ebony* started in 1945 and was partly created to capitalize on the growing African American consumer market. In November 1951, Johnson launched *Tan Confessions*, a women's magazine with stories that brought together sexuality, domesticity, and product consumerism. More on this subject can be found in Noliwe M. Rooks, *Ladies' Pages* (New Brunswick, NJ: Rutgers University Press, 2004).

3. Nicholson Baker, *Double Fold: Libraries and the Assault on Paper* (New York: Random House, 2001), 22–25.

4. David Jackson goes on to quote Ormes, saying that when she first drew for the *Courier* in 1937 there were only two other cartoonists, Wilbert Holloway, who drew *Sunnyboy Sam*, and one other cartoonist, apparently referring to Samuel Milai. "Holloway was raggedy as a batch of sauerkraut," Ormes said, "but he always had 'lottery winning numbers' hidden in the drawing. So he got fan mail from all over the place: 'I hit the number! I got it outa your cartoon! Now there was a lot of news in the *Courier* about segregation and such but these things never made it into the comics. They didn't deal with it at all." Jackson, "The Amazing Adventures of Jackie Ormes," 24.

5. Inge, *Dark Laughter*, xxx–xxxi, and Brunner, "This Job is a Solid Killer," 37.

6. William Barlow, "Commercial and Noncommercial Radio," in *Split Image: African Americans in the Mass Media*, Jannette L. Dates and William Barlow, eds. (Washington, DC: Howard University Press, 1990), 202.

 Durham also produced a true soap opera, *Here Comes Tomorrow*, about a black South Side family, broadcast on Chicago's WJJD for about a year in 1946. Nationally broadcast soap operas, like *All My Children*, had a few roles for black actors and actresses, but they were limited in scope. For

more information on Richard Durham's radio broadcasts, see Judith E. Smith, *Visions of Belonging: Family Stories, Popular Culture, and Postwar Democracy, 1940–1960* (New York: Columbia University Press, 2004), 208–15.

7. Ossie Davis, foreword to *Black Cinema Treasures Lost and Found*, by G. William Jones (Denton: University of North Texas Press, 1991).

8. David Naguib Pellow, *Garbage Wars: The Struggle for Environmental Justice in Chicago* (Cambridge, MA: MIT Press, 2002), 4. Pellow states, "Previously known as the 'slaughterhouse to the world,' Chicago was the undisputed capital of the meat packing industry . . . the leading source of water and land pollution during that era, making the 'Windy City' one of the filthiest places in the world." He presents evidence of poor waste management, including a surprising amount of complicity on the part of the victims: "I argue that environmental racism unfolds in ways that are more complex, more disturbing, and more unsettling than most written accounts of environmental justice (EJ) struggles reveal. Not only are industry and government often guilty of perpetrating these acts of injustice, but many times our own community leaders, our own neighbors, and even environmentalists are deeply implicated in creating these problems" (3).

CHAPTER 8

1. George P. Rawick, ed., *The American Slave: A Composite Autobiography*, vol. 5, *Texas Narratives* (Westport, CT: Greenwood, 1977), 147.

2. The Clarks' doll test was repeated by Darlene Powell Hopson and Derek S. Hopson more than thirty years later. In spite of advances in civil rights and racial consciousness, their results differed little from those of the Clarks' study. Children's persistent white doll preferences "were greeted with shock and despair around the world" when the Hopsons presented these results to the American Psychological Association in 1987. The researchers "turned the results around," however, with children preferring the black dolls when they ran the test again, this time introducing the children to the dolls with positive words about the attractiveness of the black ones. Darlene Powell Hopson and Derek S. Hopson, *Different and Wonderful: Raising Black Children in a Race-Conscious Society* (New York: Prentice Hall Press, 1990), xix–xxii.

"I would hesitate to make any claims about black children's racial pride based on studies of younger children alone . . . [since] . . . some studies suggest that racial pride tends to increase through childhood, and crystallize at about the junior high school level," Judith Porter, another

researcher, observed when discussing the Hopsons' experiment. Daniel Goleman, "Black Child's Self-View Is Still Low, Study Finds," *New York Times*, August 31, 1987, A13.

William Cross discusses several subsequent studies that challenge the Clarks' hypothesis. He notes, however, that "the effect of the 1954 Supreme Court desegregation decision was the intellectual canonization of the self-hatred thesis." William E. Cross Jr., *Shades of Black: Diversity in African American Identity* (Philadelphia: Temple University Press, 1991), 129.

3. Betye Saar, "In Service (A Version of Survival)," and Lizetta LeFalle-Collins, "Surviving Servitude," both in *BETYE SAAR In Service: A Version of Survival, March 9–May 6, 2000*, exhibition catalog (New York: Michael Rosenfeld Gallery), 3, 5–7.

4. Mel Tapley, "Sun Tan Dolls: Pioneering Effort in Positive Images," *New York Amsterdam News*, December 24, 1988, 23.

5. Jones, "From 'Under Cork' to Overcoming," 25.

6. Thompson, "Woman Cartoonist Turns to Doll Designing," 116.

7. "Plastics from Head to Toe," *Modern Plastics*, January 1950, 167. Hard plastic dolls eventually led manufacturers down another road of no return as the introduction of plastic led to the many related types of vinyl that are used in doll making today.

8. Plassie was made by the Ideal Novelty and Toy Company (1942 and 1946), Mary Hoyer's plastic body was manufactured by the Fiberoid Doll Company (1946), and Nanette and Nancy Lee were made by the Arranbee Doll Company (1947).

9. Casper, *Fashionable Terri Lee Dolls*, 74.

10. "Patty-Jo Steps Out of Courier Cartoon," *Pittsburgh Courier*, August 30, 1947, 1, 4.

11. St. Clair Drake, "How I Told My Child about Race," *Negro Digest*, April 1951, 30.

12. The industry quickly caught on to doll hair made of sensational new products like Saran and Nylon that enhanced what they call "play value." Dolls such as Toni (made by Ideal Novelty and Toy Company), whose marketing was closely linked to the Toni home permanent wave hair product, began to top the late 1940s best-seller list. Previously, doll hair had been made of human hair, mohair, or other animal fur, or the imprint of what was meant to be hair was molded into the head material and painted. Patty-Jo's wigs were made of Celanese, a plastic fiber.

13. Collectors today have found and documented multiple colors of over

350 different costume styles tagged "Terri Lee." Ranging from golfing attire to formals—and even a real mink coat—to dozens of 1940s and 1950s "school dresses," the clothing fulfilled children's and parents' life fantasies very effectively and kept them coming back to buy more.

14. Amosandra was made by the Sun Rubber Company. An *Ebony* article looks favorably on this black baby doll, which sold for $2.98. They describe her as "winsome" and recount her history: "Amosandra made her appearance in stores on Valentine's Day, 1949, a week after the birth of a child bearing the same name to Amos and Ruby Jones, fixtures on the Amos 'n' Andy radio show. Despite a crippling snowstorm, on the first two days of Amosandra's debut, Macy's department store in New York reported a total sale of 200 of the new dolls. Seventy-five percent of the purchasers were white. Before the end of 1949, approximately 250,000 Amosandras were sold, with the total climbing to 2,000,000 by the end of 1951." "Modern Designs for Negro Dolls," *Ebony*, January 1952, 46–48.

15. Saralee was made by the Ideal Novelty and Toy Company in 1951. "Doll for Negro Children: New Toy Which Is Anthropologically Correct Fills an Old Need," *Life*, December 17, 1951, 61–62. The article continues, "recently Sara Lee Creech of Belle Glade, Fla. decided to have a doll made that would be anthropologically correct and something a Negro child could be proud of. . . . To be sure that the doll would be just right, Miss Creech photographed and carefully measured scores of Negro children in her home town and got sculptress Sheila Burlingame interested in the project. Mrs. Burlingame, who has done many statues of Negroes, used Miss Creech's material for reference in creating four head models which are a fair sample of anthropological characteristics of U.S. Negroes. Then a jury, including Dr. Ralph Bunche, Walter White and Eleanor Roosevelt, met to determine the exact shade of the doll's skin."

16. "Negro Leaders Laud New Trend in Doll Designing," *Ebony*, January 1952, 50. The article goes on to say that pigment used on Patty-Jo and later on Benjie "was lighter than that found on other colored dolls, and her clothes were among the most beautiful and expensive on the market."

17. "Modern Designs for Negro Dolls," 46.

18. Casper, *Fashionable Terri Lee Dolls*, 7, 78, 140–43.

19. Everybody Goes When the Wagon Comes, *Chicago Defender*, February 10, 1962, 10.

20. In 1997, Violet Gradwohl's nephew formed a company, Terri Lee Associates. Among its series of dolls is a Patty-Jo reissued from original Terri

Lee manufacturing molds, and a resculpted likeness called Patty-Jo sold by Kmart starting in August 2007. Information can be found on their Web site, http://www.terrilee.com.

21. Myla Perkins, *Black Dolls: An Identification and Value Guide, 1820–1991* (Paducah, KY: Collector Books, 1993), 103.

CONCLUSION

1. Robert Mankoff spoke in a lecture series on humor for the Psychology Department at the University of Michigan, Ann Arbor, in 2003.

2. Harry Katz, "An Historical Look at Political Cartoons," *Nieman Reports* 58, no. 4 (Winter 2004): 45.

3. Paul P. Somers Jr., *Editorial Cartooning and Caricature: A Reference Guide* (Westport, CT: Greenwood Press, 1998).

4. Robbins, *The Great Women Cartoonists*, 140.

5. Ann Telnaes spoke on editorial cartooning at the Festival of Cartoon Arts held at the Cartoon Research Library at Ohio State University on October 16, 2004.

SELECTED BIBLIOGRAPHY

Aardema, Verna. *More Tales from the Story Hat.* Illust. Elton C. Fax. New York: Coward-McCann, 1966.

Andrews, William L., Frances Smith Foster, and Trudier Harris, eds. *The Oxford Companion to African American Literature.* 1st ed. New York and Oxford: Oxford University Press, 1997.

Baker, Nicholson. *Double Fold: Libraries and the Assault on Paper.* New York: Random House, 2001.

Barkley Brown, Elsa. "Ormes, Zelda Jackson 'Jackie.'" In *Black Women in America: An Historical Encyclopedia,* Darlene Clark Hine, ed., Elsa Barkley Brown and Rosalyn Terborg-Penn, assoc. eds., vol. 2, *M–Z,* 903. Brooklyn, NY: Carlson Publishing, 1993.

Blackbeard, Bill, and Martin Williams. *The Smithsonian Collection of Newspaper Comics.* 4th printing. Washington, DC: Smithsonian Institution Press, 1977.

The Black Press: Soldiers without Swords. Produced and directed by Stanley Nelson. San Francisco: Half Moon Productions, California Newsreel, 1998. VHS.

Brown, Warren Henry. *The Social Impact of the Black Press.* New York: Carlton Press, 1994.

Brunner, Edward. "'This Job Is a Solid Killer': Oliver Harrington's *Jive Gray* and the African American Adventure Strip." *Iowa Journal of Cultural Studies* 6 (Spring 2005): 36–57.

Brunner, Edward. "'Shuh! Ain't Nothin' to It!': The Dynamics of Success in Jackie Ormes's *Torchy Brown." MELUS* 32, no. 3 (Fall 2007): 23–49.

Bryson, Winifred Octavus, Jr. "Negro Life Insurance Companies: A Dissertation in Economics." Philadelphia: University of Pennsylvania, 1948.

Bullard, Robert D. *Dumping in Dixie: Race, Class, and Environmental Quality.* Boulder, CO: Westview Press, 2000.

Butcher, Margaret Just. *The Negro in American Culture.* New York: Alfred A. Knopf, 1957.

Cameron, Elisabeth L. "Playing with Dolls." In *Isn't S/he a Doll? Play and Ritual in African Sculpture,* Elisabeth L. Cameron, ed., 17–41. Los Angeles: UCLA Fowler Museum of Cultural History, 1996.

Casper, Peggy Wiedman. *Fashionable Terri Lee Dolls.* Cumberland, MD: Hobby House Press, 1988.

Caswell, Lucy Shelton. "Oliver Harrington: A Biographical Sketch." In *Cartoons and Ethnicity*, 67–70. Columbus: Ohio State University Libraries, 1992.

Chicago Defender. March 3, 1945–July 21, 1945. National Edition. Chicago: Department of Photoduplication, University of Chicago Library. Microfilm.

The Christmas Book, 68. Chicago: Montgomery Ward, 1944.

Clark, Kenneth B. *Prejudice and Your Child.* Boston: Beacon Press, 1955.

Coleman, Dorothy S., Elizabeth A. Coleman, and Evelyn J. Coleman. *The Collector's Encyclopedia of Dolls.* New York: Crown Publishers, 1968.

Collins, Lisa Gail. "Brown Crayons and Black Dolls." In *The Art of History: African American Women Artists Engage the Past*, 99–123. New Brunswick, NJ: Rutgers University Press, 2002.

Collins, Lisa Gail. "Economies of the Flesh: Representing the Black Female Body in Art." In *Skin Deep, Spirit Strong: The Black Female Body in American Culture*, Kimberly Wallace-Sanders, ed., 99–127. Ann Arbor: University of Michigan Press, 2002.

Couperie, Pierre, and Maurice Horn. *A History of the Comic Strip.* New York: Crown Publishers, 1968.

Craig, Maxine Leeds. *Ain't I a Beauty Queen? Black Women, Beauty, and the Politics of Race.* New York: Oxford University Press, 2002.

Craven, Thomas, ed. *Cartoon Cavalcade.* Chicago: Consolidated Book Publishers, 1944.

Cross, William E., Jr. *Shades of Black: Diversity in African-American Identity.* Philadelphia: Temple University Press, 1991.

Cruse, Harold. *The Crisis of the Negro Intellectual.* New York: William Morrow, 1967.

Danky, James P., ed., and Maureen E. Hady, assoc. ed. *African-American Newspapers and Periodicals: A National Bibliography.* Cambridge, MA: Harvard University Press, 1998.

Davis, Bob. "Protesting Doonesbury's Dismissal." *Nieman Reports* 57, no. 3 (Fall 2004): 83–84.

Davis, Ossie. Foreword to *Black Cinema Treasures Lost and Found*, by G. William Jones. Denton: University of North Texas Press, 1991.

Doll Reader. "Compo Corner." August 1991, 140.

Donnelly, Liza. *Funny Ladies: The New Yorker's Greatest Women Cartoonists and Their Cartoons.* Amherst, NY: Prometheus Books, 2005.

Dowd, D. B. "Pulp Fiction: The Art and Heart of the Superhero Comic Book." *Belles Lettres* 5, no. 1 (Sept.–Nov. 2004): 20.

Dowd, D. B. "The Rubber Frame: Speaking about How Comics Speak." Interview by Gerald Early, Center for the Humanities, Washington University. *Belles Lettres* 5, no. 1 (Sept.–Nov. 2004): 22.

Drake, St. Clair. "How I Told My Child about Race." *Negro Digest,* April 1951, 27–30.

Drake, St. Clair, and Horace Cayton. *Black Metropolis.* New York: Harcourt, Brace, 1945.

Early, Gerald. "Her Picture in the Papers: Remembering Some Black Women." In *Tuxedo Junction: Essays on American Culture,* 83–112. New York: Ecco Press, 1989.

Ebony. "Modern Designs for Negro Dolls." January 1952, 46–48.

Ebony. "Negro Dolls Popular with Public Since Birth in 1919." January 1952, 49.

Ebony. "Negro Leaders Laud New Trend in Doll Designing." January 1952, 50.

Eisner, Will. *Comics and Sequential Art.* Guerneville, CA: Eclipse Books, 1985.

Elliott, Joan C. "Davis, Angela." In *The Oxford Companion to African American Literature,* William L. Andrews, Frances Smith Foster, and Trudier Harris, eds., 201–2. New York and Oxford: Oxford University Press, 1997.

Favor, J. Martin. *Authentic Blackness.* Durham: Duke University Press, 1999.

"Federal Bureau of Investigation: Freedom of Information/Privacy Acts, Release, Subject: Zelda Jackson Ormes." Washington, DC: U.S. Department of Justice, 1948–58.

Fleming, Thomas C. "On to Chicago." From "Reflections on Black History," August 19, 1998. Available at http://www.freepress.org/fleming/fleming 48.html.

Formanek-Brunell, Miriam. *Made to Play House: Dolls and the Commercialization of American Girlhood, 1830–1930.* New Haven: Yale University Press, 1993.

Fortune. "Dolls—Made in America." December 1936, 103–9, 196, 199–200.

Funny Ladies. Produced and directed by Pamela Beere Briggs. New York: New Day Films, 1991. VHS.

Gates, Henry Louis, Jr., and Evelyn Brooks Higginbotham, eds. "Harrington, Oliver." In *African American Lives,* 376–77. New York: Oxford University Press, 2004.

Goldstein, Nancy. "Patty-Jo: A Terri Lee Doll Created by Jackie Ormes: The First Black American Woman Cartoonist." *Doll News* 56, no. 4 (Summer 2007): 42–49.

Goldstein, Nancy. "Torchy Togs Paper Doll Cutouts, Created by Jackie Ormes, the First Black American Woman Cartoonist." *Doll News* 57, no. 2 (Winter 2008): 2–7.

Goleman, Daniel. "Black Child's Self-View Is Still Low, Study Finds." *New York Times*, August 31, 1987, A13.

Hardy, Charles, and Gail F. Stern, eds. *Ethnic Images in the Comics: An Exhibition in the Museum of the Balch Institute for Ethnic Studies.* Philadelphia: Balch Institute, 1986.

Harvey, Robert C. *The Art of the Funnies: An Aesthetic History.* Jackson: University Press of Mississippi, 1994.

Harvey, Robert C. *Children of the Yellow Kid: The Evolution of the American Comic Strip.* Seattle: Frye Art Museum, 1998.

Hencey, Naomi. *Terri Lee: From the 40s to the 60s.* Battle Creek, MI: November House, 1984

Higginbotham, Evelyn Brooks. *Righteous Discontent: The Women's Movement in the Black Baptist Church, 1880–1920.* Cambridge, MA: Harvard University Press, 1993.

Honey, Maureen. "The 'Varga Girl' Goes to War." Published in a collection of essays for the exhibit "Alberto Vargas: The Esquire Pinups," Spencer Museum of Art, University of Kansas, September 29–December 30, 2001. Available online at http://www.ku.edu/~sma/vargas/honey.htm.

hooks, bell. *Art on My Mind.* New York: New Press, 1995.

Hopson, Darlene Powell, and Derek S. Hopson. *Different and Wonderful: Raising Black Children in a Race-Conscious Society.* New York: Prentice Hall Press, 1990.

Huizinga, Johan. *Homo Ludens: A Study of the Play-Element in Culture.* Boston: Beacon Press, 1955.

Igoe, Lynn Moody, and James Igoe. "Fax, Elton Clay." In *250 Years of Afro-American Art: An Annotated Bibliography,* 667–70. New York: R. R. Bowker, 1981.

Inge, M. Thomas, ed. *Dark Laughter: The Satiric Art of Oliver W. Harrington.* Jackson: University Press of Mississippi, 1993.

Jackson, David. "The Amazing Adventures of Jackie Ormes." *Chicago Reader,* August 16, 1985, 16–25.

Jackson, Tim. Salute to Pioneering Cartoonists of Color. Chicago: Creative License Studio, 1999. Available at http://www.clstoons.com.

Jones, Steven Loring. "From 'Under Cork' to Overcoming: Black Images in the Comics." In *Ethnic Images in the Comics: An Exhibition in the Museum of the*

Balch Institute for Ethnic Studies, Charles Hardy and Gail F. Stern, eds., 21–29. Philadelphia: Balch Institute, 1986.

Jones, Steven Loring. "Landmark Black Comic Strip." *Nemo: The Classic Comics Library*, January 1988, 56–66.

Katz, Harry. "An Historical Look at Political Cartoons." *Nieman Reports* 58, no. 4 (Winter 2004): 44–46.

Knight, John S., editor and publisher. *26th Annual Directory of Syndicated Features, Editor & Publisher*, 84 no. 31 (July 28, 1951): 19, 21, 28–30.

Knoll, Erwin. "Smith-Mann to Launch Comics Supplement," *Editor & Publisher*, John S. Knight, editor and publisher, 84 no. 30 (July 21, 1951): 43.

LeFalle-Collins, Lizetta. "Surviving Servitude." In *BETYE SAAR In Service: A Version of Survival, March 9–May 6, 2000*, exhibition catalog, 5–7. New York: Michael Rosenfeld Gallery, 2000.

Levine, Lawrence W. "The New Negro and the Realities of Black Culture." In *Explorations in American Cultural History*, 89–90. New York: Oxford University Press, 1993.

Life. "Doll for Negro Children: New Toy Which Is Anthropologically Correct Fills an Old Need." December 17, 1951, 61–62.

Lukovich, Mike, and Mike Peters. "Political Cartoonists Cast an Eye Back on 2005." Interview by Renee Montagne. *Morning Edition*, National Public Radio, December 28, 2005.

Markstein, Donald D. "Toonopedia: A Vast Repository of Toonological Knowledge." Available at http://www.toonopedia.com.

McCloud, Scott. *Understanding Comics: The Invisible Art*. Northhampton, MA: Kitchen Sink Press, 1993.

McDonnell, Patrick, Karen O'Connell, and Georgia Riley de Havenon. *Krazy Kat: The Comic Art of George Herriman*. New York: Abradale Press, Harry N. Abrams, 1999.

Meyerowitz, Joanne. "Women, Cheesecake, and Borderline Material." *Journal of Women's History* 8, no. 3 (Fall 1996): 9–35.

Miller, Wayne F. *Chicago's South Side, 1946–1948*. Berkeley: University of California Press, 2000.

Modern Plastics. "Plastics from Head to Toe." January 1950, 166–67, 267.

Mullen, Bill V. *Popular Fronts: Chicago and African-American Cultural Politics 1935–46*. Urbana: University of Illinois Press, 1999.

Naison, Mark. *Communists in Harlem during the Depression*. Urbana and Chicago: University of Illinois Press, 1983.

Nelson, Pamela B. "From Subhuman to Superhuman: Ethnic Characters in

the Comics." In *Ethnic Images in the Comics: An Exhibition in the Museum of the Balch Institute for Ethnic Studies*, Charles Hardy and Gail F. Stern, eds., 11–14. Philadelphia: Balch Institute, 1986.

Newkirk, Pamela. *Within the Veil: Black Journalists, White Media*. New York: New York University Press, 2000.

O'Sullivan, Judith. *The Art of the Comic Strip*. College Park: University of Maryland Department of Art, 1971.

O'Sullivan, Judith. *The Great American Comic Strip: One Hundred Years of Cartoon Art*. Boston: Little, Brown, 1990.

Ottley, Roi. "Owners Invest $300,000 to Give South Side a First Class Hotel." *Chicago Tribune*, April 18, 1956, pt. 3, 12.

Pellow, David Naguib. *Garbage Wars: The Struggle for Environmental Justice in Chicago*. Cambridge, MA: MIT Press, 2002.

Perkins, Myla. *Black Dolls: An Identification and Value Guide, 1820–1991*. Paducah, KY: Collector Books, 1993.

Perkins, Myla. *Black Dolls: An Identification and Value Guide, Book II*. Paducah, KY: Collector Books, 1995.

Pittsburgh Courier. May 1, 1937–April 30, 1938; September 1, 1945–September 22, 1956. National Edition. Ann Arbor, MI: University Microfilms.

Puth, Robert C. *Supreme Life: The History of a Negro Life Insurance Company*. New York: Arno Press, 1976.

Rather, Pat. "Jackie Ormes and Patty Jo." *Daisy Chain* 9, no. 2 (May 1999): 3.

Rather, Pat. "What Does a Genuine Jackie Ormes Patty Jo Face Look Like?" *Daisy Chain* 13, no. 3 (August 2003): 4.

Rather, Pat. "Will the REAL Patty-Jo Please Step Forward." *Daisy Chain* 13, no. 3 (August 2003): 1–3.

Rawick, George P., ed. *The American Slave: A Composite Autobiography*. Vol. 5, *Texas Narratives*. Westport, CT: Greenwood, 1977.

Reib, Susan, and Stuart Feil. "Torchy Brown Faces Life." *American Legacy*, 2, no. 2 (Summer 1996): 25–32.

Robbins, Trina. *A Century of Women Cartoonists*. Northhampton, MA: Kitchen Sink Press, 1993.

Robbins, Trina. *Girls to Grrrlz: A History of [Women's] Comics from Teens to Zines*. San Francisco: Chronicle Books, 1999.

Robbins, Trina. *The Great Women Cartoonists*. New York: Watson-Guptill Publications, 2001.

Robbins, Trina. *Nell Brinkley and the New Woman in the Early 20th Century.* Jefferson, NC: McFarland, 2001.

Robbins, Trina. *Paper Dolls from the Comics.* Forestville, CA: Eclipse Comics, 1987.

Roberts, Gene, and Hank Klibanoff. *The Race Beat: The Press, the Civil Rights Struggle, and the Awakening of a Nation.* New York: Random House, 2006.

Robinson, Jerry. *The Comics: An Illustrated History of Comic Strip Art.* New York: G. P. Putnam, 1974.

Rooks, Noliwe M. *Hair Raising: Beauty, Culture, and African American Women.* New Brunswick, NJ: Rutgers University Press, 1996.

Rooks, Noliwe M. *Ladies' Pages.* New Brunswick, NJ: Rutgers University Press, 2004.

Rowser, Jacqueline Frazier, ed. *People of Courage: African Americans in Salem, Ohio.* Kent, OH: Institute of African-American Affairs, Department of Pan-African Studies, Kent State University, 2001.

Saar, Betye. "In Service (A Version of Survival)." In *BETYE SAAR In Service: A Version of Survival, March 9–May 6, 2000,* exhibition catalog, 3. New York: Michael Rosenfeld Gallery, 2000.

Schroeder, Alan. *Josephine Baker.* New York and Philadelphia: Chelsea House, 1991.

Simmons, Charles A. *The African American Press.* Jefferson, NC: McFarland, 1998.

Singer, Jerome. "Imaginative Play in Childhood." In *The Future of Play Theory: A Multidisciplinary Inquiry into the Contributions of Brian Sutton-Smith,* Anthony D. Pellegrini, ed., 187–219. Albany: State University of New York Press, 1995.

Smith, Judith E. *Visions of Belonging: Family Stories, Popular Culture, and Postwar Democracy, 1940–1960.* New York: Columbia University Press, 2004.

Spiegelman, Art. "A Comic-Book Response to 9/11 and Its Aftermath." Interview by Claudia Dreifus. *New York Times,* August 7, 2004, 19.

Stange, Maren. *Bronzeville: Black Chicago in Pictures, 1941–1943.* New York: New Press, 2003.

Stevens, John D. "Reflections in a Dark Mirror: Comic Strips in Black Newspapers." *Journal of Popular Culture* 10, no. 1 (Summer 1976): 239–44.

Sutton-Smith, Brian. *Toys as Culture.* New York: Gardner Press, 1986.

Tapley, Mel. "Sun Tan Dolls: Pioneering Effort in Positive Images." *New York Amsterdam News,* December 24, 1988, 23.

That's Black Entertainment: African-American Contributions in Film and Music, 1905–

1944. Vol. 1. Produced by Chris Capilongo and Sharon Reinckens. Holly-
wood, CA: OnDeck Home Entertainment, 1997. VHS.

Thomas, Sabrina Lynette. "Black Dolls as Racial Uplift: A Preliminary Re-
port." *Transforming Anthropology* 13, no. 1 (2005): 55–56. Available at http://
www.AnthroSource.net.

Thompson, Maxine. "Woman Cartoonist Turns to Doll Designing." *Toys and
Novelties,* November 1947, 116–18.

Updike, John. "The Fourth Decade, 1955–1964." In *The Complete Cartoons of the
New Yorker,* Robert Mankoff, ed., 240–41. New York: Black Dog & Leven-
thal, 2004.

U.S. Bureau of the Census. *Population in 1920,* vol. 1. Washington, DC: U.S. Bu-
reau of the Census, Department of Commerce, 1923.

Walker, Brian. *The Comics since 1945.* New York: Harry N. Abrams, 2002.

Wallace, Aurora. *Newspapers and the Making of Modern America.* Westport, CT:
Greenwood, 2005.

Wallace, Michele. *Invisibility Blues.* New York and London: Verso, 1990.

Washburn, Patrick Scott. *The African American Newspaper: Voice of Freedom.* Evan-
ston, IL: Northwestern University Press, 2006.

Washburn, Patrick Scott. *A Question of Sedition: The Federal Government's Inves-
tigation of the Black Press during World War II.* New York: Oxford University
Press, 1986.

Waugh, Coulton. *The Comics.* New York: Macmillan, 1947.

Werner, Craig H. "Chicago Renaissance." In *The Oxford Companion to African
American Literature,* William L. Andrews, Frances Smith Foster, and Trudier
Harris, eds., 132–33. New York and Oxford: Oxford University Press, 1997.

White, E. Frances. *Dark Continent of Our Bodies: Black Feminism and the Politics of
Respectability.* Philadelphia: Temple University Press, 2001.

Wolseley, Roland E. *The Black Press, U.S.A.* Ames: Iowa State University Press,
1971.

Wolseley, Roland E. "The Vanishing Negro Press." *Negro Digest,* December
1950, 64–68.

Wright, Richard. *Native Son.* New York: Perennial Library, 2003.

PRIMARY SOURCES:
JACKIE ORMES ART AND ARCHIVES

CARTOONS AND COMIC STRIPS

The juvenile Jackie Ormes's cartoons appeared in the 1929 and 1930 editions
of *The Flame,* the yearbook of Monongahela High School, Monongahela,

Pennsylvania. Available in the Genealogy Room, Monongahela Area Library, Monongahela, Pennsylvania.

Candy appeared in the *Chicago Defender* from March 24 to July 21, 1945. Available on microform at the Department of Photoduplication, University of Chicago Library, and online through http://bsc.chadwyck.com.

Patty-Jo 'n' Ginger appeared in the *Pittsburgh Courier* from September 1, 1945, to September 22, 1956. Available on microform from University Microfilms, Ann Arbor, Michigan.

Torchy Brown in "Dixie to Harlem" appeared in the *Pittsburgh Courier* from May 1, 1937, to April 30, 1938. Available on microform from University Microfilms, Ann Arbor, Michigan.

Torchy Brown Heartbeats, later called *Torchy in Heartbeats*, appeared in a color comic section of the *Pittsburgh Courier* from August 19, 1950, through August 21, 1954. Many of these comic sections, as well as the subsequent black and white *Torchy*s from August 28, 1954, through September 18, 1954 (the last *Torchy* comic strip), that appeared in the magazine section, can be found in original newspaper format, Chicago Edition, at the Center for Research Libraries, Chicago. Various *Torchy in Heartbeats* from February 13, 1954, through September 18, 1954, can be found on microform from University Microfilms, Ann Arbor, Michigan.

JOURNALISM

"Eliminate Segregation at Gt. Lakes Navy Center" appeared in the *Chicago Defender*, on June 30, 1945, and is available on microform at the Department of Photoduplication, University of Chicago Library, and online through http://bsc.chadwyck.com.

Social Whirl was a regular column in the *Chicago Defender* from March 3 to July 21, 1945, and is available on microform at the Department of Photoduplication, University of Chicago Library and online through http://bsc.chadwyck.com.

PERSONAL EFFECTS

Some of Jackie Ormes's personal papers, memorabilia, and souvenirs pertaining to her volunteer and commercial work are archived in the Jackie "Zelda" Ormes Collection at the DuSable Museum of African American History, Chicago.

ACKNOWLEDGMENTS

I am deeply grateful for the help of others who contributed to this project. Many people came forward with enthusiasm to help in my search for information on the life and art of Jackie Ormes, on American newspaper and cartoon history, and on the history of dolls.

Special thanks, again, to several persons whose generous assistance I described in the preface: Delores Towles, Vivian (Ormes) Mason, Gayle Ormes Hawthorne, and Tim Jackson.

E. Selean Holmes, at the time chief curator and director of curatorial services, and Theresa Christopher, registrar, at the DuSable Museum of African American History, made it possible to discover more about Ormes's life through personal materials housed in the DuSable archive.

Bernard F. Reilly, president of the Center for Research Libraries (CRL) in Chicago, made available newspapers in the CRL archive that had not been seen in decades. This library provides a repository and service that are not found elsewhere. The staff of CRL's Stack Management Department, especially Patricia J. Finney, department head, worked with care, good humor, and diligence to bring out reams of fragile documents and provided generous space, time, and solitude to photograph them. Thanks are due also to Kevin Wilks, head of CRL Access Services, and Michelle Carver, of the Stack Management Department, who assisted in these efforts.

For crucial financial support, I am most grateful to the Mosaic Foundation of Rita and Peter Heydon; to Malcolm Whyte, founder of the Cartoon Art Museum of San Francisco; and for the United Federation of Doll Clubs/ Theriault Scholarship for the Study of American Dolls.

Photographer Nick Say captured from newspaper many *Patty-Jo 'n' Ginger* cartoons and color *Torchy in Heartbeats* comics and paper dolls. Nick also worked his digital magic on blotchy, scratched microfilm cartoons to better reveal facial expressions and dialogue. Jillian Downey, Senior Production Coordinator, and John Grucelski, Production Manager, University of Michigan Press, made decades-old cartoons and comics readable again while preserving their integrity, arranging them attractively on the pages. Edward Brunner deserves special thanks for his lively discussions and his cogent

analyses. Others who deserve many thanks are the following: Marcia Bailey; Mary Bisbee-Beek; Darlene Bolig; Margaret Burroughs; Peggy Wiedman Casper; Lucy Caswell, curator at the Cartoon Research Library of Ohio State University; Patti Fertel; Ruth Garrison; Pat Girbach; Stephanie Grohoski; Allan Holtz; Jane Hough; Don Jensen; Karen Johnson; Steven Loring Jones; Samuel Joyner; Glenda Kitto; Susan Kornfield; J. Fred MacDonald; Christina Milton; Nancie Anne Lutz-Moran; Melinda Morrissey; Elaine Tappin; Jerrie Moir; Peggy Ell; Mary Keiller; Joe Mooney; Cynthia Musser; Myla Perkins; Ed Shanahan, director, and Nancy Stoicovy, Monongahela Area Public Library; Barbara Paulish, Monongahela High School staff; David Shaffer, Salem Historical Society; Eric Rabkin; Clara Rice; Pat Schoonmaker; Randall Scott, librarian of the Comic Art Collection, Special Collections Division at Michigan State University Libraries; Gwen Simmons; Charles Smith; Linda Strodtman; Steven Trybus; and Sean Ulmer. It was a privilege to interview Chester Commodore and to exchange other correspondence with this generous man and colleague of Jackie Ormes before his death in January 2004. Special thanks to Trina Robbins for her advice and enthusiasm. Alan Wald gave an early draft a careful reading and offered valuable suggestions. Helen Marlborough Roper and Harry Roper provided me with warm hospitality and much-needed encouragement during several research trips to Chicago. Also, a belated thanks to my sister Norma Krueger, who always shared her comics with me.

Judie Miles, a fellow collector and doll historian, introduced me to her contacts, materials, and information and gave me encouragement. Patricia "Pat" Rather is the fellow doll collector and historian who originally led me to search for details of Ormes's life, cartoons, and dolls, and to her I am deeply indebted.

My editor, LeAnn Fields, was instrumental in bringing an early, rather fuzzy vision for this project into focus over its five-year gestation. LeAnn suggested interviews and ways to shape the text and was an enjoyable co-enthusiast of Ormes's work.

How can you miss, when making a book like this, if your offspring is a computer whiz and your spouse is a professor of English and editor of a scholarly literary journal? Our son Jonathan helped rescue from cyberspace many a lost image or document and showed me ways to organize my work. Also, I thank our son Andrew for his interest and support.

However, I am most indebted to my husband, Laurence Goldstein. Larry's know-how from more than thirty years as editor of the *Michigan*

Quarterly Review was invaluable. His encouragement, support, patient read-ing of the drafts, suggestions, and great good humor made possible this telling of the Jackie Ormes story.

INDEX

References to illustrations are in italics.

Abbott, Walter B., 163
African American newspapers. *See* black press
Afro-American, 18, 25, 53
Amos and Andy, 57; *Amos 'n' Andy*, 175
Amsterdam News, New York, 53, 55, 163
Andrews, William L., et al., 193n9
Armstrong, Rolf, 80
Ashe, Edd, and *Guy Fortune*, 62
Associated Negro Press, 58
Aunt Jemima, 161, 169

Baby Snooks (Fanny Brice), 84
Baker, Josephine, 66, *74*
Baker, Nicholson, 132–33
Ballantyne, Joyce, 83
Barlow, William, 200n6
Bass, Charlotta, 53
Betty (Bill Chase), 5
Black History Month, 122
Black Metropolis, 22
black press
 cartoons and comic strips, 53–65
 circulation, 39–40
 editorial cartoons, 32–33, 61
 editors, 53
 government scrutiny of, 54, 117
 largest, 53
 Ormes's significance in, viii, 57
 See also *Afro-American*; *Amsterdam News, New York*;
 Chicago Defender; Ormes, Jackie: as reporter;
 Pittsburgh Courier
Block, Herbert "Herblock," 178
Bobby Sox (Marty Links), 86
Boondocks, The (Aaron McGruder), 179
Bootsie (*Dark Laughter*). *See* Harrington, Oliver
 Wendell
Boyd, Richard H., 161
Brandon, Barbara, 185
Brandon, Brumsic, Jr., 59, 185
Brenda Starr, Reporter (Dale Messick), 35, 38, 44, 86, 184
Bringing Up Father (George McManus), 60, 68, 69
Brinkley, Nell, 1–2
Bronzeville, 21–23, *25. See also* South Side Chicago

Brooks, Gwendolyn, 24
Brown and Bigelow, 8
Brown v. Board of Education, 128, 161, 201n2
Brunner, Edward, 197n10, 200n5
Bucky (Samuel Milai), 5, 61, 163
Bullard, Robert D., 45
Bunche, Dr. Ralph, 203n15
Bungleton Green (Jay Jackson), 33
Burroughs, Margaret, 24, 50
Bushmiller, Ernie, 199n9

Campbell, E. Simms, 82
Candy, 32–33, 63, 75–76, *77–78*, 81
 as character, 32–33, 75
 dates of publication, 3
 name of Candy, 75
Caniff, Milton, and *Terry and the Pirates*, 64, 134
Capp, Al, 1, 104
Cartoon Research Library, 181
cartooning
 in black press, 54–58, 61–62
 editorial, 85, 177–78
 process for publication, 62–65
 thematic cycles, 53
 See also syndicates
cartoonists
 black cartoonists, discrimination against, 34, 55,
 62, 82, 185
 in black press, 55–56, 61–62, 198n13, 198n15, 200n4
 mainstream press and inclusion, 59
 See also individual names of cartoonists; Salute to Pio-
 neering Cartoonists of Color; women
cartoons and comic strips
 big sister–little sister type, 199n9
 dialogue in, 198n17
 difference between, 63, 85
 humor in, 38
 microfilming and destruction, 132–33
 popularity, 60
 romance comics, 199n1, 199n2
 thematic cycles, 53
 See also black press; individual titles; *Pittsburgh*
 Courier
Casper, Peggy Wiedman, 42–43, 166, 176
Cayton, Horace, 22

Index

219